SACRED SPACES

HISTORIC HOUSES OF WORSHIP IN THE CITY OF ANGELS

SACRED SPACES

HISTORIC HOUSES OF WORSHIP IN THE CITY OF ANGELS

B

BALCONY PRESS

Published in the United States of America 2003
Design by Studio Mousetrap
Imaged by Pace + Navigator, City of Industry California
Printed in Singapore

Sacred Spaces © 2003 Robert Berger
Library of Congress Catalog Card Number: 2003102716
ISBN 1-890449-21-0

Table of Contents

Table of Contents

Preface

The quite exhausting but truly fascinating part of this project was the research. Over the past three and a half years I visited over 300 historic houses of worship in the city, built before 1952. Wandering through neighborhoods that seemed as foreign as distant lands, looking for steeples, crosses and domes vaulting towards the sky, I began to appreciate the vast web of Los Angeles, its wide range of ethnicities and constantly changing demographics.

When I realized the enormous scope of L.A.'s rich religious heritage, it became obvious that putting confines on the project was necessary. The selection process was a difficult one. In a city this size, a comprehensive coverage would be nearly impossible and quite voluminous. This book does not pretend to be a comprehensive list of all historic houses of worship in L.A., but rather a sampling of architectural styles from various time periods from various religions, from a broad variety of neighborhoods. The criteria for inclusion evolved into houses of worship, older than 50 years, which had architectural or historic significance, or were just plain fun to look at.

Once the selection process was somewhat complete, getting access to the properties became a daunting task. Many sites were very accommodating but others became an exercise in sheer persistence. In the end, my rejections were few. Once I was granted access that's when the fun began. Exploring the interiors, some cavernous and some mysteriously intimate, looking for unusual details and angles was endlessly exciting. The chore became finding electrical outlets that would support our lighting gear.

The incredible range of neighborhoods, religions, craftsmanship, along with various stages of upkeep and disrepair, always kept us on our toes. One week it was gilded reredos and Della Robbia statues and the next, it was animal carcasses and pigeon droppings.

Being a third generation Angeleno, I am obsessed with the history of architecture in Los Angeles. In a city not known for its reverence of history or buildings, I feel the continually changing landscape should be captured on film before it is transformed into something totally unrecognizable. From my previous book, *The Last Remaining Seats: Movie Palaces of Tinseltown,* I have learned how buildings can transport you in time. The houses of worship are one of the few existing forms of architecture in the city that can lead you back into the 19th century. The 1890s Plaza around Olvera Street or multi-ethnic 1920s Boyle Heights come alive in the photography of the buildings and their history.

I hope this book will bring you, the reader, into houses of worship that you would not normally attend because of differing religious faiths or because the properties lie outside the sphere of your daily travels. Revealing an aesthetic common ground for differing cultures and religions and seeing our common history, I feel, can greatly benefit the multicultural society that we have in the City of Angels. – R.B.

Introduction

The city, urban historian and theorist Lewis Mumford reminds us, had significant origins in the shrine. In ancient times, places of worship were strategically sited, and long before the city evolved as an institution such intensified places of worship gathered into themselves an intensity of use and meaning that can only be described as pre-urban. Not only were these shrines busy places en route to becoming cities, they were also localizations of transcendent identities that helped unify worshippers into a growing matrix of common identity, values, and folkways.

Thus the ancient shrine – like irrigation works, citadels, and granaries – helped create the spatial vocabulary and built environment of urban civilization. Down through the millennia, this connection of the city to the shrine remained constant, whether we look to the ziggurats of Mesopotamia, the temple cities of Egypt, Acropolis-centered Athens, Pantheon-centered Rome, the cathedral-centered cities of medieval Europe, or the splendid churches of the Baroque city.

Not only did the shrine help form the city, it helped as well to shape the shared public identity, hence the politics, of early urban civilization. When our ancestors gathered together in places of worship, standing side by side before the shrine, they experienced a sense of shared identity that went beyond family, kinship, or tribe. The shrine was helping them to deal in a more sophisticated manner with the seen as well as the unseen world. From this perspective, the shrine was an early instance of politics, whose very name derives from polis, the Greek word for city. So, too, did the shrine – via its festivals and liturgical cycles – engender literature, especially the drama. Hence, the tragedies of ancient Athens, together with the re-birth of the drama from medieval Christian liturgical cycles.

All this – at first glance – might seem rather remote when one comes to consider the city of Los Angeles. L.A., after all, is in so many ways – or so they tell us – the very essence of the a-historical, present-tense city, set down on the southern shore of California by forces unknown, activated by a rage for the here-and-now and a sense of devouring futurity. Guess again! The very naming of Los Angeles by Roman Catholic Spain in honor of Mary, Queen of the Angels, suggests the persistence of the shrine in the founding of this city in September 1781, as does the church established immediately adjacent to the first plaza. Spanish Colonial cities established under the Law of the Indies (and Los Angeles was the only city in Alta California to have such foundations) were intended to serve the salvation and well-being of the first settlers and those who followed in both the sacred and the profane aspects of life. At the core of Spanish Colonial Los Angeles, then, was a religious motivation and a shrine.

In later years, as this book suggests in photography and text, as Los Angeles became Mexican, then American, and in our own time at once Mexican again, and a world city, an ecumenopolis, the shrine persisted, flourished, and diversified itself as the great religious traditions of the world arrived in the city. So many religious traditions are represented in this book because, quite simply, the peoples of the world have brought the religions of the world to the City of Angels. A Catholic city in the Spanish and Mexican

eras remained Catholic through the American era, but not exclusively so; indeed by the turn of the century some 300 spires, the majority of them Protestant, were rising into the skies of the metropolitan region. By the 1920s, in fact, Los Angeles could have been fairly described as a significantly Protestant place. By the mid-1940s, it could be fairly described as an epicenter of Jewish faith and culture as well. Also flourishing was Orthodoxy in its various polities and, as this book also shows, other religious traditions arriving from Asia and the Middle East, not only Buddhism, which is a world religion, but the more specialized faiths of Theosophy, and Vendantism. (A very necessary exploration of the Islamic tradition in Southern California appearing mostly within the last few decades is woefully needed, and perhaps this book will point in that direction.)

Sacred Spaces, then, is not only a profound reminder of the very nature of the city as an institution in history, specifically its connection to the shrine, it is also a very delightful book, fun to read in so many ways. On the one hand, we encounter a roll call of the great architects and architectural traditions of a city that is increasingly being recognized for the quality of its architectural design. From this perspective, the peoples of the world were bringing to Los Angeles not only their religious traditions but their architectural traditions as well. On the other hand, note how many times we are told just exactly what movie was filmed in this or that church or synagogue or what famous movie star was married or buried there or what noted film folk belonged to this or that congregation. What fun! Even the synagogues, churches, and temples of Los Angeles enjoy their connection to — and are authenticated by — The Business!

Reading this book, enjoying these photographs, each of us will have our favorites; indeed, many of us will belong to one or another of the faith communities and sacred spaces under consideration. But even if we do not belong to one or another of these places of worship, we can respect the force of tradition – and, of equal importance, the forces of faith, hope, and charity – that have gone into the making not only of these sacred spaces but the larger city that nurtures and sustains them. True Los Angeles is about getting and spending, but what city is not? True as well: Los Angeles can be, and has been, a fearsome and devouring place. But true as well – and this is perhaps a greater truth – Los Angeles has been, as these pages attest, a place where men and women have kept alive the great faith traditions of the human race. Here in the City of Angels (and most theological traditions have one form of angel or another) the transcendent has not been entirely forgotten. Turning the pages of *Sacred Spaces*, we can almost sense as a palpable, physical presence the in-gatherings of multiple faith communities for purposes of worship that have occurred in these shrines across the decades. From these buildings reverberate a composite and ecumenical prayer that we can almost hear, like the distant music of a choir of unseen angels. The music of these hymns represents the theological and musical traditions of all the peoples of the earth. The words themselves are in every language of the planet. Holy! Holy! Holy! sings this unseen choir. Life is holy, and so is the city that enhances and nurtures life, that makes men and women (as Aristotle tells us) more human by bringing them together.
– *Kevin Starr*
State Librarian of California

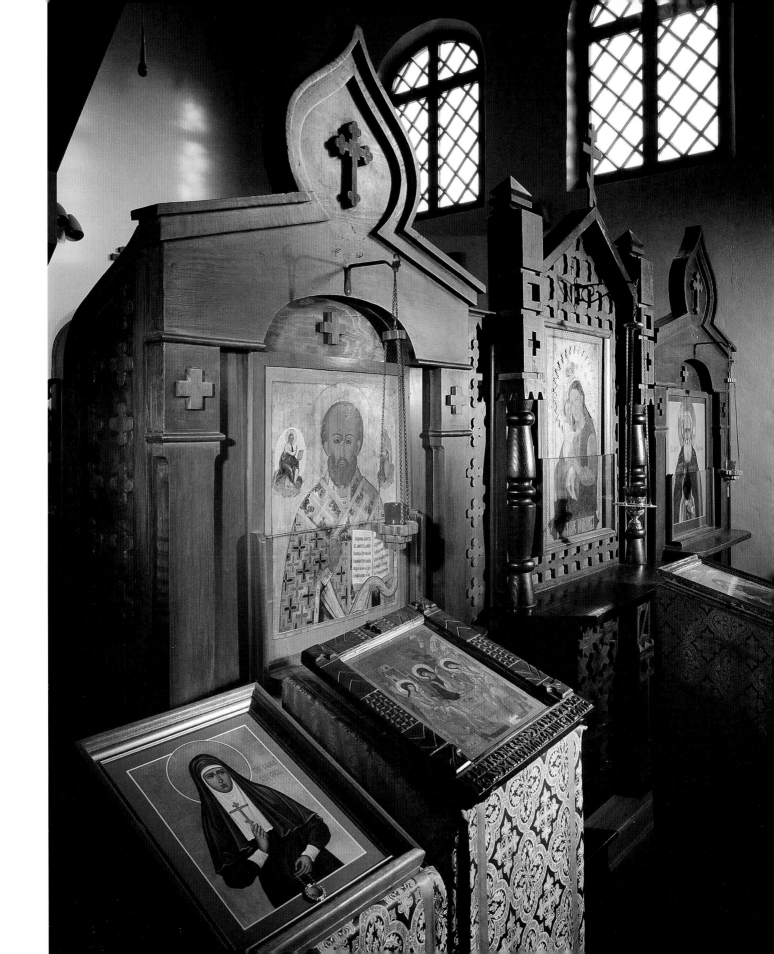

Holy Virgin Mary
Russian Orthodox Church

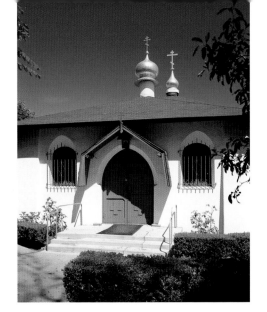

A unique component of the architectural heritage of Los Angeles, the Holy Virgin Mary Russian Orthodox Church is a genuine artifact of Russian culture. It was completed in 1932 in the Old Pskov style of fourteenth-century Russian architecture to serve a parish composed of some 250 émigré families who left their homeland in the wake of the revolution of 1917 and found refuge in Southern California. It stands in a garden originally planted with birches, maples and pines to recall the woods of the Russian countryside.

The church's early parishioners included many notables such as the composer Sergei Rachmaninov, film actor Ivan Lebedeff, Nicholas Kobliansky, another film actor and later also a technical director for the movies; and Alexander Toluboff, who worked in Hollywood as an art director and production designer. In later years, screen star Natalie Wood is said to have worshipped at this church.

Toluboff contributed the design for this church in its original form. Given his occupation, it is perhaps not surprising that his design was theatrical. In the late 1930s, he was nominated three times for the Academy Award for Best Art Direction. Construction of the church began in 1926 and proceeded slowly in large part through the labor of the parishioners themselves. Over the years, several additions have been made to the original structure, with its pyramidal roof topped by an onion-domed cupola. The first extension was completed in 1946. Later additions included a chapel and bell tower. Finished between 1960 and 1964, both were designed by architect Sergei N. Koschin, one of Richard Neutra's collaborators in the 1950s.

Worshippers either stand or kneel during Russian Orthodox services so the interior is sparsely furnished. Its chief feature is the iconostasis, characteristic of Russian Orthodox churches, which separates the nave from the sanctuary. Among the icons that compose it, an especially large one is reputed to have been made as a birthday gift in 1917 for Czar Nicholas II.

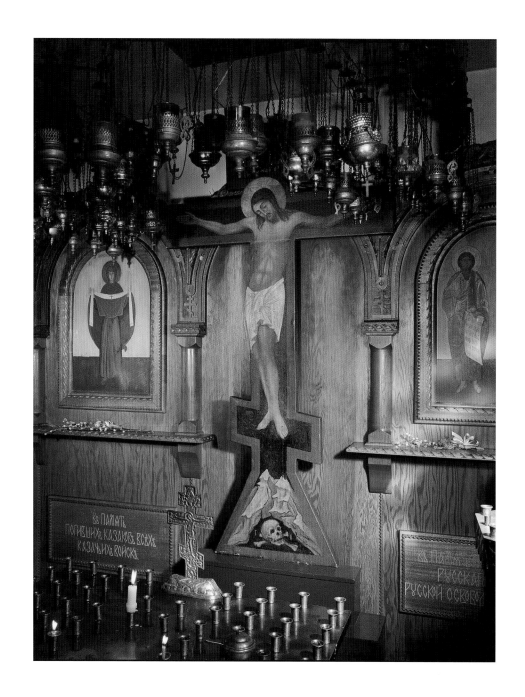

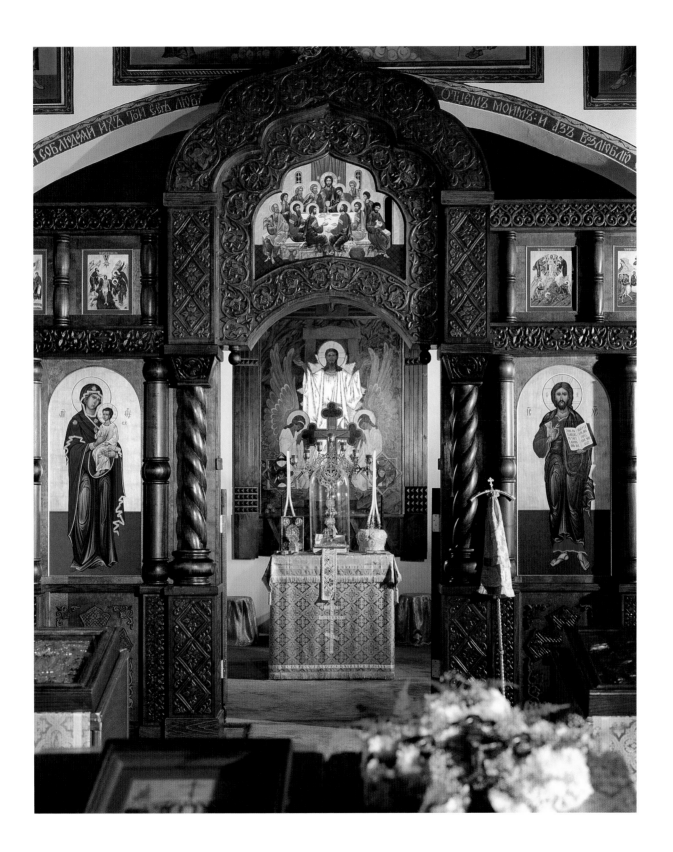

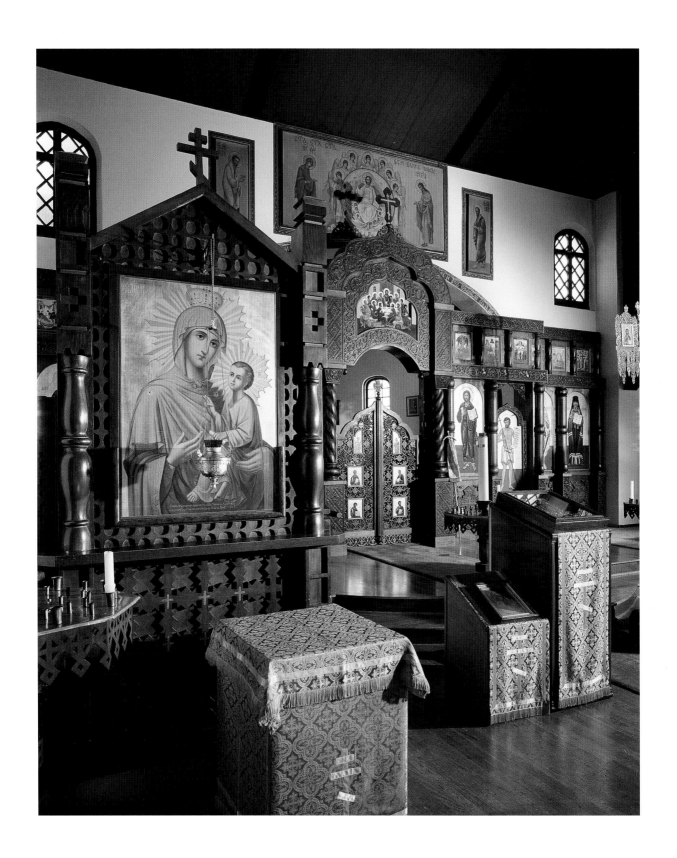

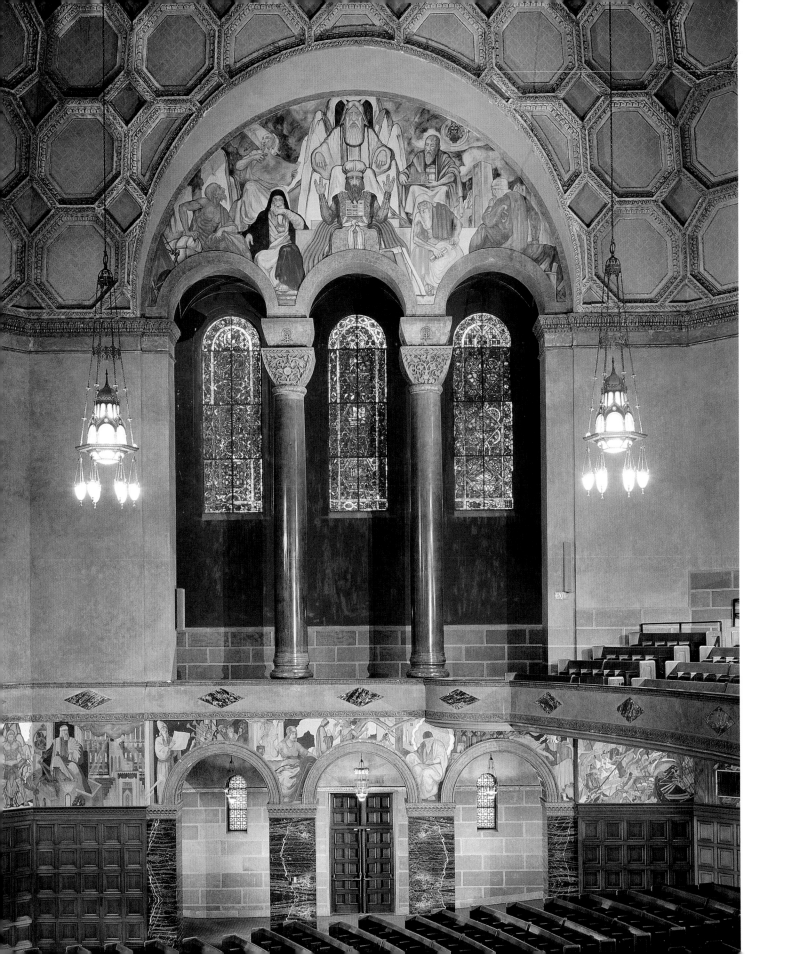

Wilshire Boulevard Temple
Congregation B'nai Brith

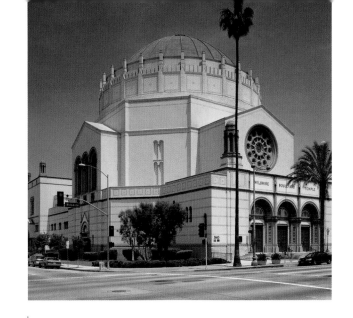

One of America's most impressive synagogues, the Wilshire Boulevard Temple is the third permanent home of Congregation B'nai Brith. B'nai Brith was founded in 1862 and is the oldest Jewish congregation in Los Angeles. Orthodox in its early years, it emerged by 1900 as a reform congregation after a stormy period of transition in the 1890s.

Reform was clearly the ascendant alternative for Los Angeles Jews over the early decades of the twentieth century. By 1921, Congregation B'nai Brith had outgrown the temple it had erected in 1896 on the northeast corner of 9th and Hope Streets. As most of its members had moved out of downtown into the burgeoning western suburbs, the Congregation sought property in that direction. In 1921 and 1922, it acquired parcels comprising a suitable site for a new synagogue on the corner of Wilshire Boulevard and Hobart Avenue.

In May 1925 the congregation's building committee approved the preliminary plans that had been developed since January 1924 by the firm of Edelman & Barnett in association with Norton & Wallis. The principal designer, Abram M. Edelman, was the son of B'nai Brith's first rabbi, Abraham Wolf Edelman. He had earlier been the architect of the temple on Hope Street. A revised plan, completed in mid-1927 by Edelman and associates Allison & Allison, was eventually selected for execution. (S. Tilden Norton had resigned as architect in October 1925 in order to be able to serve on the Building Committee.) Both the preliminary and final designs called for an octagonal structure of reinforced concrete, surmounted by a low dome on a high octagonal drum. In the design as executed, pedimented wings appended to the drum reduced its apparent height. Seating 1800 people, the new synagogue was first used for services on February 15, 1929 and dedicated on June 8th of that year.

The Wilshire Boulevard Temple is the last in a series of centrally planned American synagogues that began with the construction of Temple Tifereth Israel in Cleveland in 1894. Of later buildings in the series, the 1924 Temple Isaiah in Chicago and the 1926 Temple Emanu-El in San Francisco, with their domes on octagonal drums, relate closely to Edelman's masterpiece on Wilshire Boulevard.

The vaguely Byzantinesque exterior of the Wilshire Boulevard Temple, with details and a polychromatic treatment reminiscent of the architecture of early Renaissance Florence, is nevertheless an essentially modern composition. With its dome 100 feet in diameter, it is a marvel of engineering as well of architectural art of a high order.

The interior, whose acoustics were perfected by renowned physicist Vern O. Knudsen of UCLA, is richly finished and appointed. The bema and Ark are integrated into a single architectural unit of black marble and carved walnut. Behind and above it is a chamber accommodating the 4,102 pipes of the synagogue's Kimball organ. The walls are of marble, with walnut wainscoting. Stained-glass windows, created by the Oliver Smith Studios of Bryn Athyn, Pennsylvania, bathe the sanctuary in deeply colored light. Around the perimeter of the auditorium, murals painted by Hugo Ballin depict the story of the Jewish people from the Creation through the time of the Prophets. The murals were a gift of Hollywood's Warner Brothers – Jack, Harry, and Abe. Many other Jewish leaders of the motion picture industry also belonged to Congregation B'nai Brith and contributed to its extravagant construction and equipment.

From the day it was opened, the Wilshire Boulevard Temple was recognized as one of the great treasures of southern California. Its reputation as a work of remarkable beauty soon spread around the world. One of countless visitors, a Prince of Siam in 1931 dropped by unannounced to see it for himself.

Rabbi Edgar F. Magnin, who had seen this synagogue to completion, continued to lead its congregation through the 1930s. Noted for his outreach to the Christian and other communities of Los Angeles, Magnin promulgated a Judaism that many in the secular world took to be the epitome of Jewish belief. Similarly, in no small degree due to his association with it and in spite of its quite unusual splendor, this same population took the Wilshire Boulevard Temple to be the quintessential synagogue.

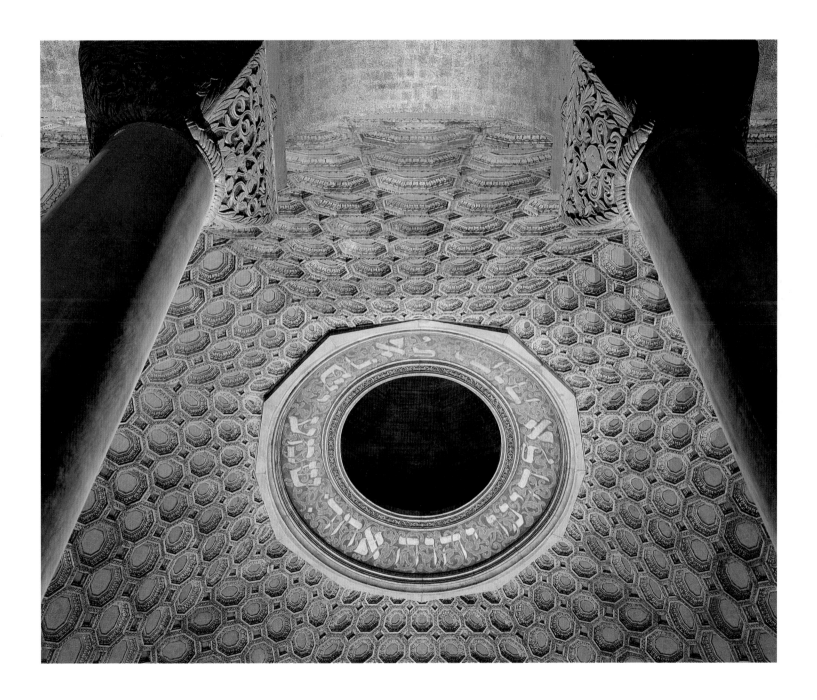

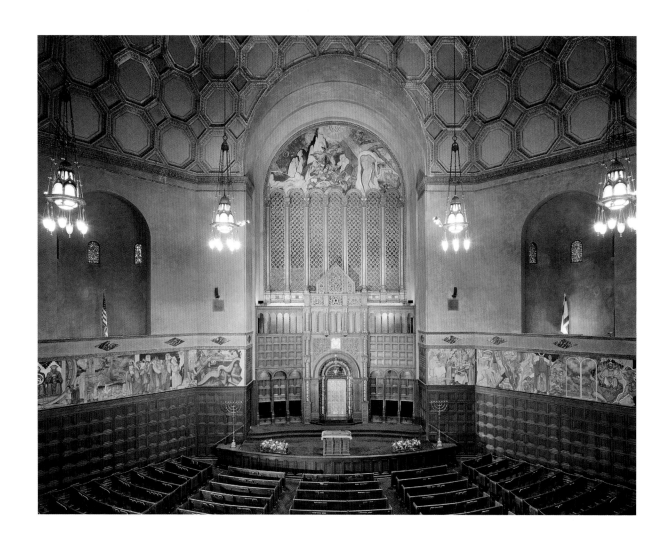

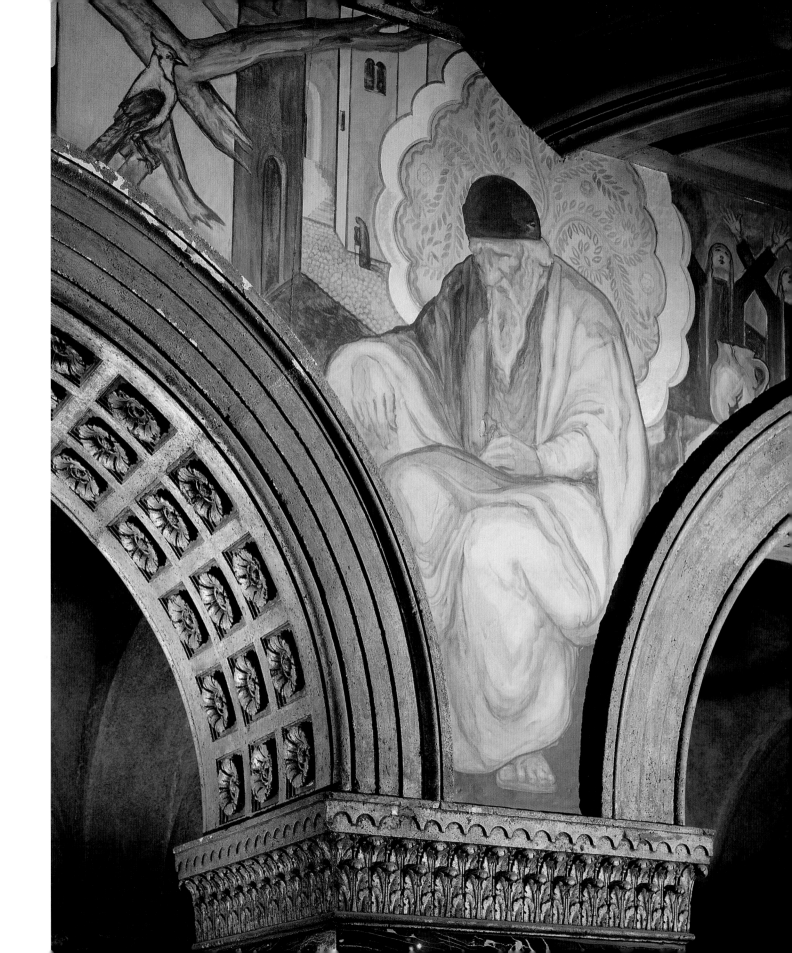

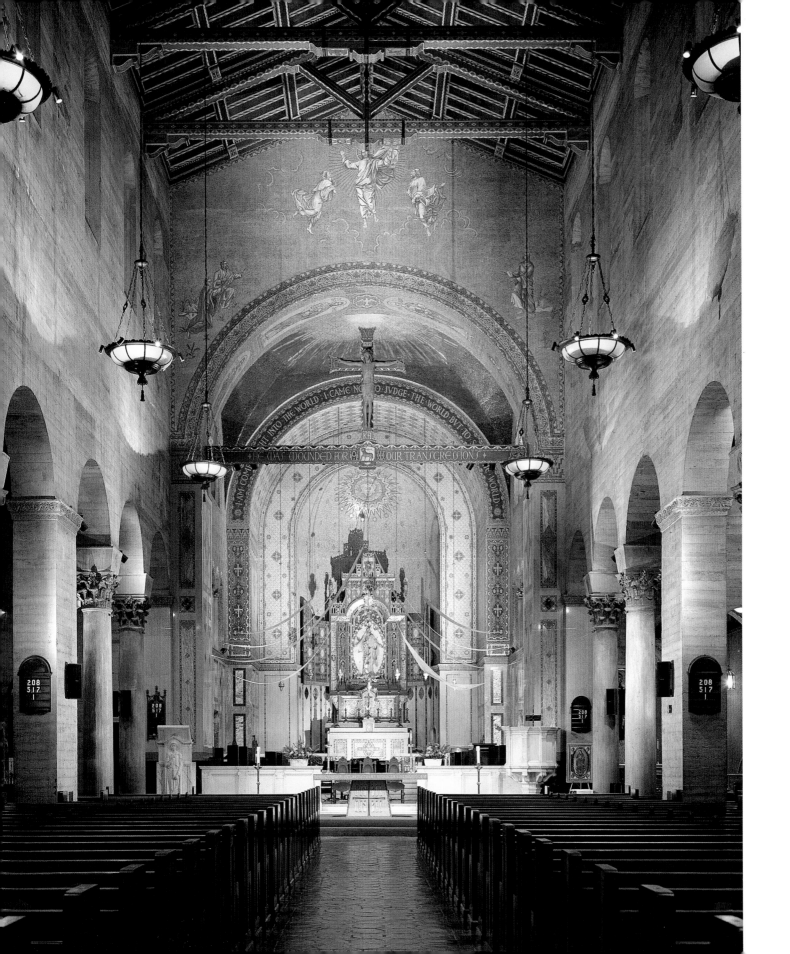

St. John the Episcopal Church

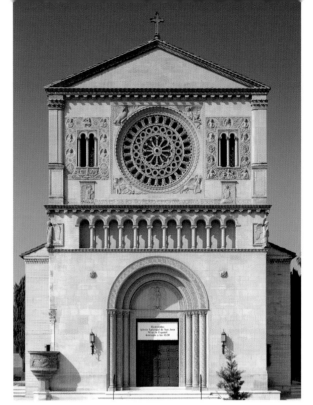

Built to serve the most exclusive residential district in early-twentieth-century Los Angeles, Saint John's now stands seemingly stranded between Figueroa Street and the Harbor Freeway. Its completion in late 1924 culminated a long period of planning and design intended to result in a monument of superior and lasting quality. In 1919, the Los Angeles firm of Montgomery & Montgomery proposed an English Gothic-style church. Apparently that design did not suit the congregation, for in 1920, it commissioned alternative plans from one of the country's leading neo-gothicists, Bertram Grosvenor Goodhue of New York. Finally, in mid-1921, the congregation organized a limited competition among six local architectural offices. Five competitors submitted designs.

The winning design by Davis & Davis in the Italian Romanesque Revival style was perceived as replicating that of Goodhue's Saint Bartholomew's church in New York. Ground was broken in January, 1923, and construction of the church in reinforced concrete continued for almost two years. The completed church has at different times been compared to the sixth-century church at Toscanella, Italy, and the eleventh-century church of San Pietro in Tuscania, Italy. A distinctive feature of its exterior is an outdoor pulpit attached to the northeast corner of the sanctuary.

Like the rest of the ornaments of the church's tufa stone façade, it was sculpted by Salvatore Cartiano Scarpitta best known for his work on the LA City Hall and the Biltmore Hotel.

The interior, seating over 1,000 people, is highly ornamented, with decorations and furnishings rich in both color and iconography. Mosaics cover many of the wall surfaces; a carved wooden crucifix surmounts the rood beam spanning the chancel arch. A carved triptych depicting Christ in glory presides over the marble altar (a gift of the Milbank family) that holds bronze candlesticks and a cross set with semiprecious stones. The overwhelming splendor reveals not only the religious devotion of the congregants of Saint John, but also the vast extent of the wealth and prominence of many of them in Los Angeles society.

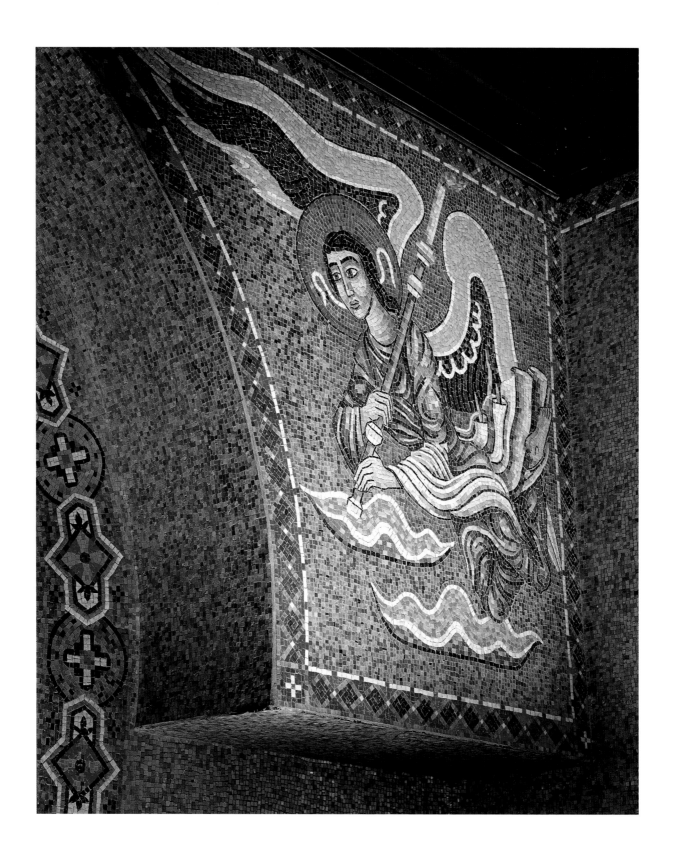

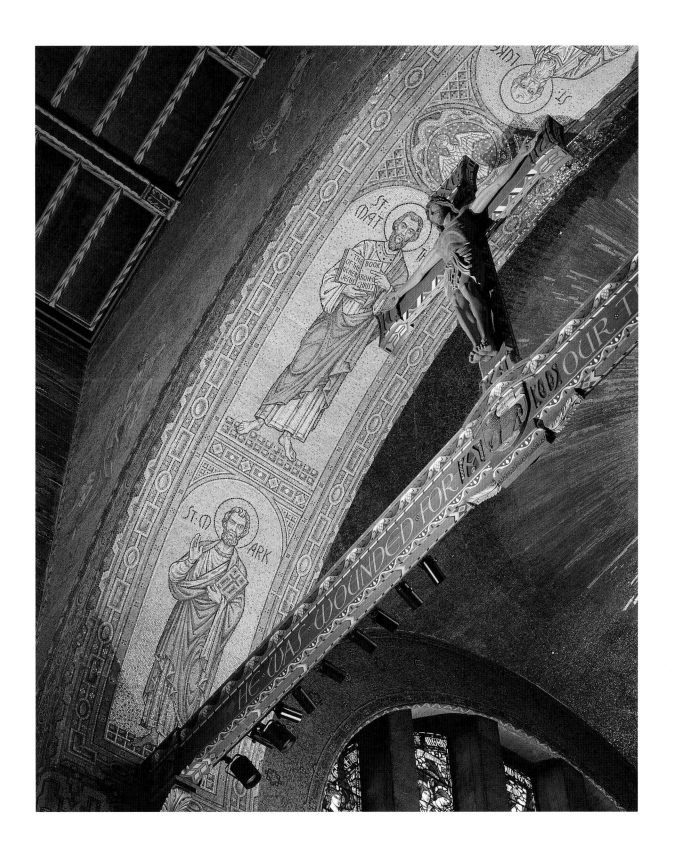

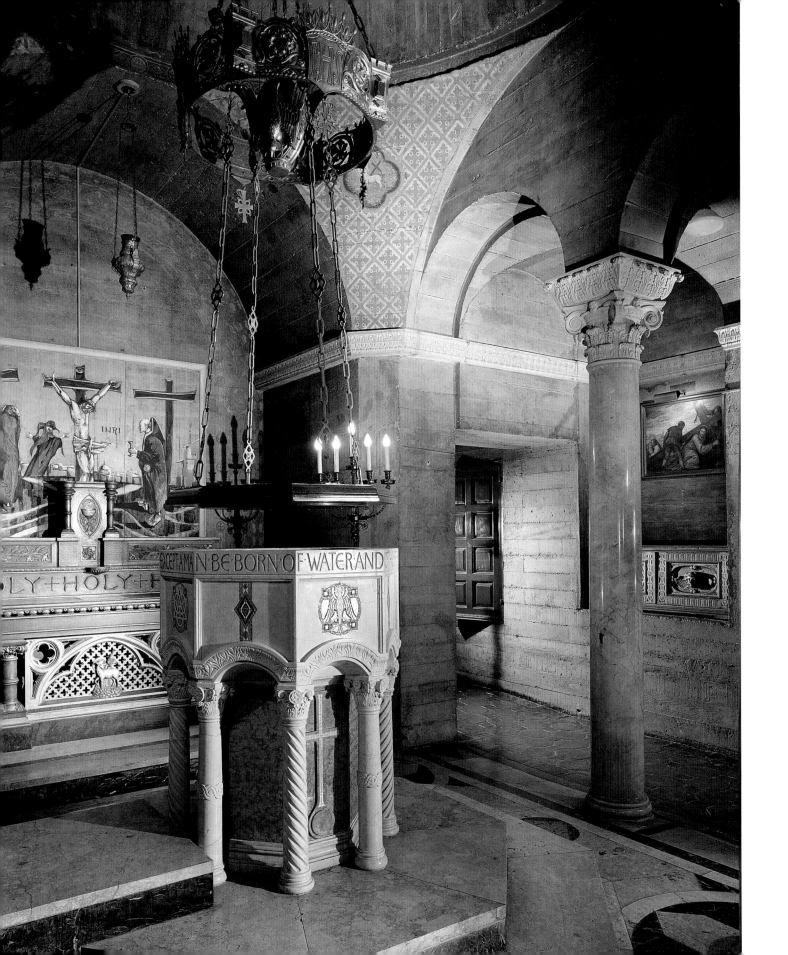

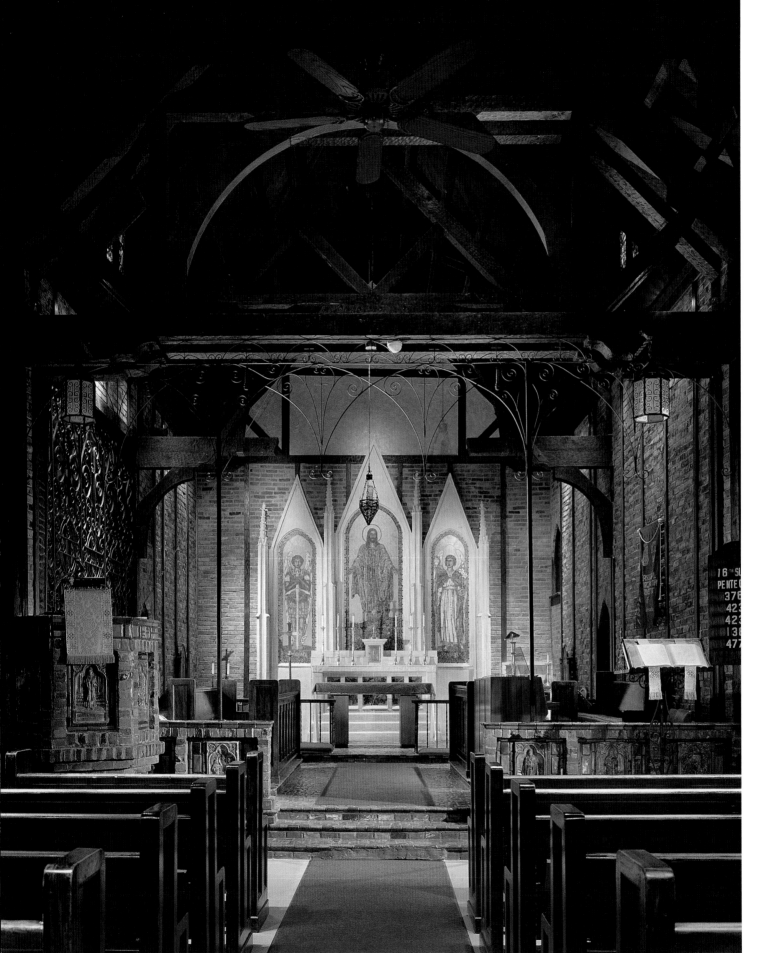

Church of the Advent
Episcopal Church

With its clinker brick exterior, this diminutive Gothic revival church brings the picturesqueness of rural England to an unlikely corner of west Los Angeles. It is one of the last works of Arthur B. Benton, one of California's leading Arts and Crafts architects. Benton is best remembered for his design of the Mission Inn in Riverside, but he also had well over a dozen Episcopal churches to his credit, including this one, his last church commission, completed in 1924.

Here, Benton gave his design an organic cohesion by exposing the brick structure of the walls on the interior as well as the exterior. The altar rail is also of brick, inset with figurative tile panels. A wrought-iron rood screen sets off the chancel from the nave. Lancet windows, set with stained glass, enhance the intimacy of the sanctuary by minimizing the intrusion of the urban world outside.

The first vicar, the Reverend Kenneth Mearl Crawford, is credited with having personally executed some of the masonry work to which the Church of the Advent owes so much of its character. Originally built to serve the needs of a mission, the building became a parish church in 1948. A number of celebrities helped alleviate the financial challenges soon faced by the fledgling parish. They included Norton Simon, the famous art collector, and Nat King Cole, who gave a memorable benefit concert at the Shrine Auditorium.

The Church of the Advent was declared Los Angeles Historic-Cultural Landmark 561 in 1991. It suffered serious damage during the earthquake in January, 1994. The subsequent restoration, designed to preserve the original appearance and atmosphere of the church, was completed in 1996.

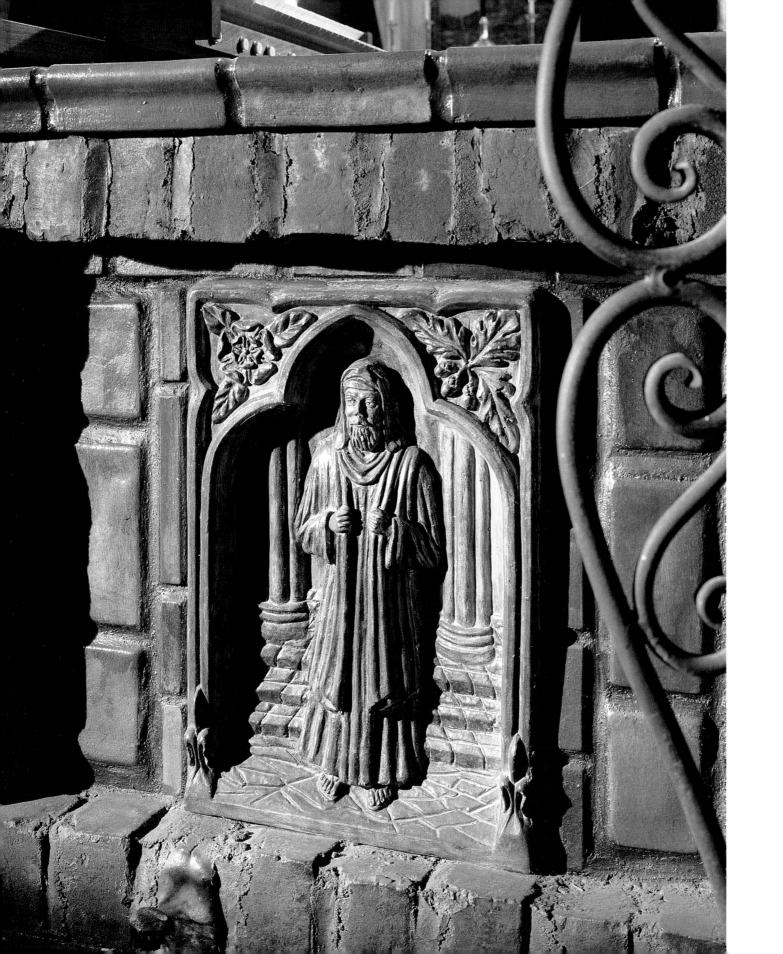

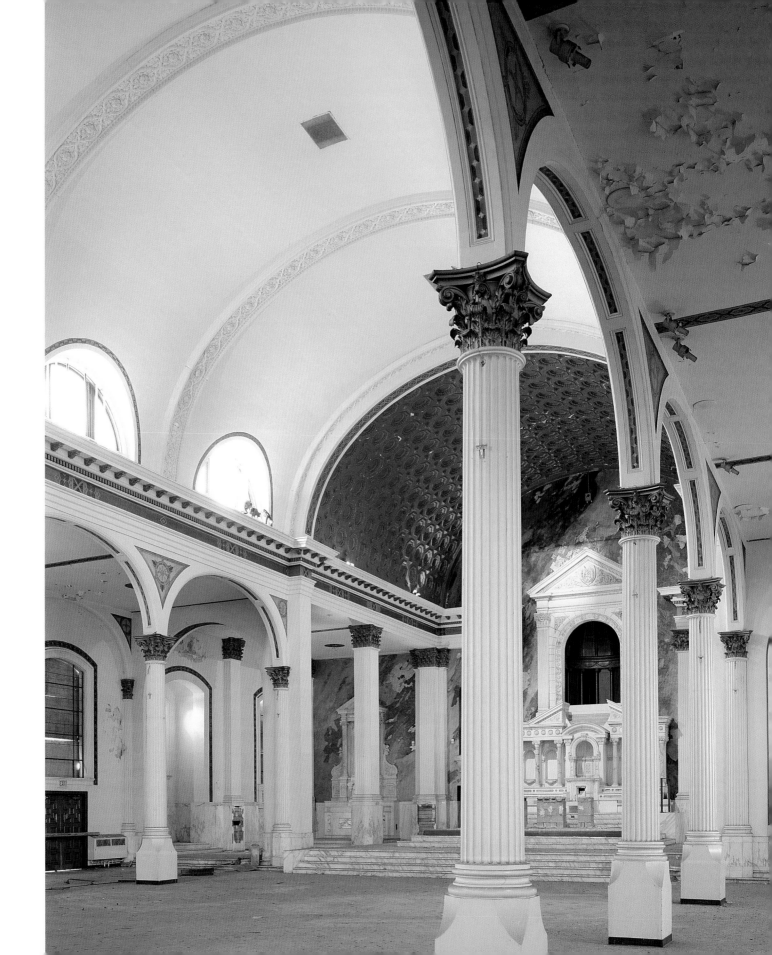

Saint Vibiana Cathedral

The establishment of a Roman Catholic Cathedral in Los Angeles marks the beginning of the settlement's transition from small town to city, thus beginning its process of becoming a metropolis of worldwide significance. The impetus for that establishment was the relocation of the residence of the Bishop of Monterey, Thaddeus Amat, from Santa Barbara to Los Angeles in 1859. Planning for the construction of a new cathedral began in 1868. In accordance with the wishes of Pope Pius IX, it was to be dedicated to Saint Vibiana and enshrines the relics of her martyrdom recently excavated in Rome. The cathedral's cornerstone was laid on October 3, 1869, but before construction proceeded, the appropriateness of the original site was called into question and a new site was selected in 1871. Architect Ezra F. Kysor, one of the first professional architects to practice in Los Angeles, then adapted the original plans to the new site. In doing so, he reduced the size of the basilican structure but remained faithful to the model provided by the baroque church of San Miguel del Mar in Barcelona on both the cathedral's exterior and its barrel-vaulted interior.

Supervised by Kysor and Walter J. Matthews, work on the new structure proceeded slowly; it neared completion only in 1876. A distinctive feature was the graceful bell tower at the east end, designed in a more fanciful neo-baroque manner than was the main body of the church. Further evidence of Kysor's creativity was found in his design for the west front, where a rose window replaced the statue of the patron saint that figures above the central entrance of the Barcelona church. Elegantly furnished, the completed Cathedral of Saint Vibiana stood as one of the most sophisticated pieces of architecture in southern California.

Embellishment of the interior continued at intervals over the next century. A monumental new marble altar was consecrated in 1894. In 1898, stained-glass windows were installed and electric lighting was added.

In 1922, the diocese engaged architect John C. Austin to plan and supervise structural renovation and expansion of Saint Vibiana. Austin veneered the red brick exterior with Indiana limestone and added a narthex and

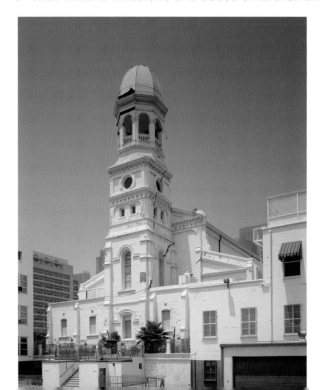

baptistry to the west end. That addition entailed the erection of a new stone façade, a rather simplified and sensibly more sober version of the one it replaced. A second modernization was carried out in 1953. In 1969, the sanctuary was reorganized in accordance with the liturgical prescriptions of Vatican II.

Severe damage to Saint Vibiana's in the 1994 earthquake provided an opportunity for the archdiocese to pursue for a third time efforts to build a new and grander cathedral on the scale of the world city that Los Angeles had become since the 1870s. Earlier proposals, in 1907 and 1943, had failed due to funding problems. Despite opposition from preservation groups to the abandonment of the historic cathedral, the City of Los Angeles took the building off its list of Historic-Cultural Monuments in 1996. In the same year, Spanish architect Rafael Moneo emerged the winner of a limited competition for the design of Saint Vibiana's replacement on a prominent site at the intersection of Temple Street and Grand Avenue. This monumental concrete structure, incorporating many elements and furnishings from the old cathedral, opened in 2002 as the Cathedral of Our Lady of the Angels. Saint Vibiana, meanwhile, had been sold in 1999 to a real estate developer with plans to transform the building into a performing arts and educational center. Though substantially changed in function, it remains standing as a key monument to the political and architectural, as well as religious, history of southern California.

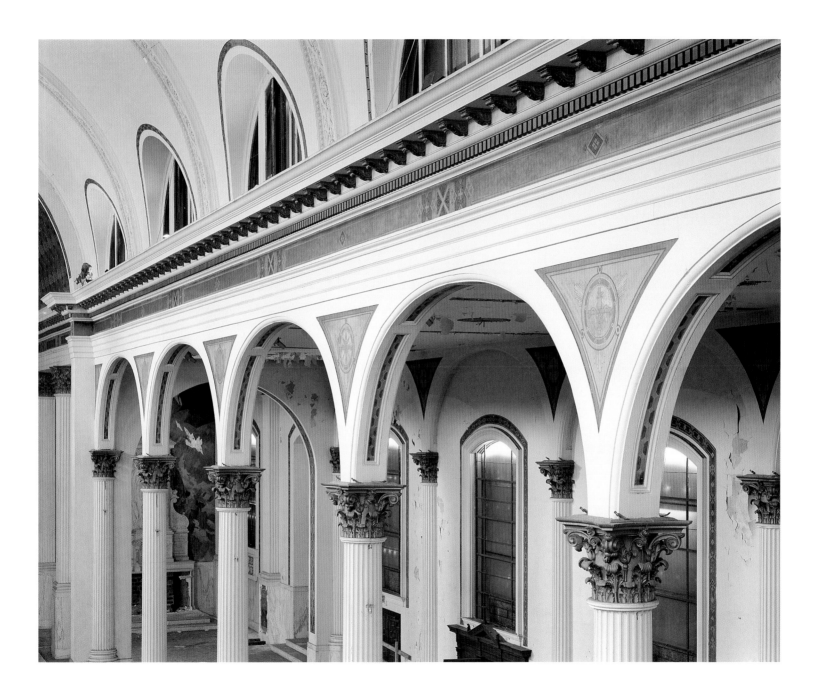

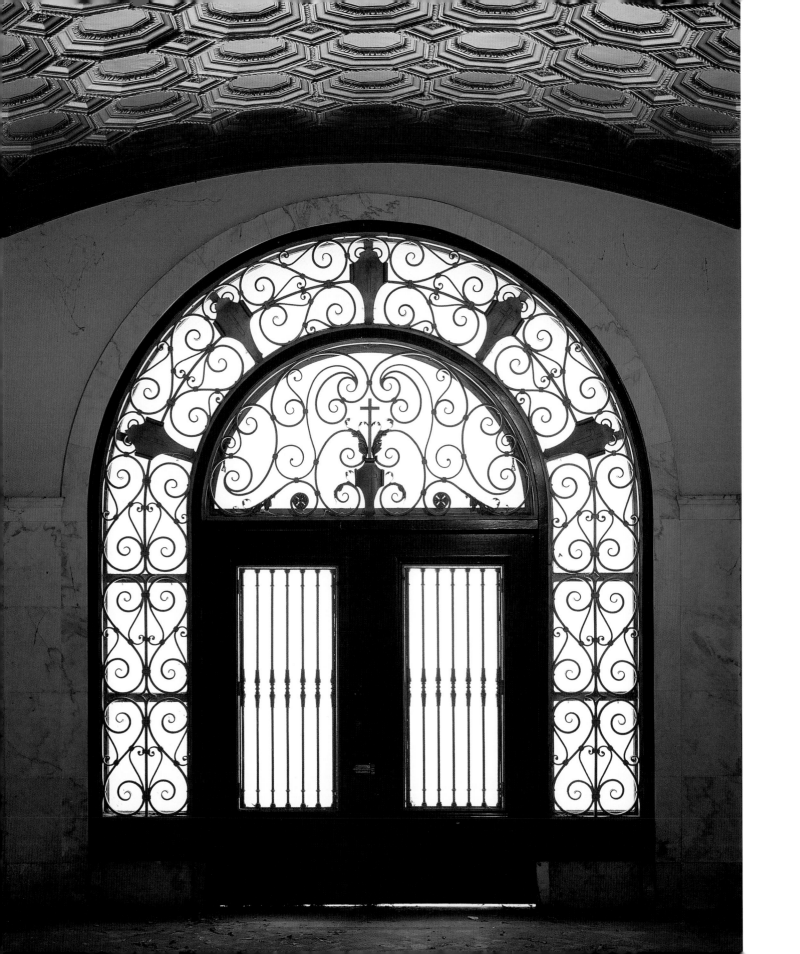

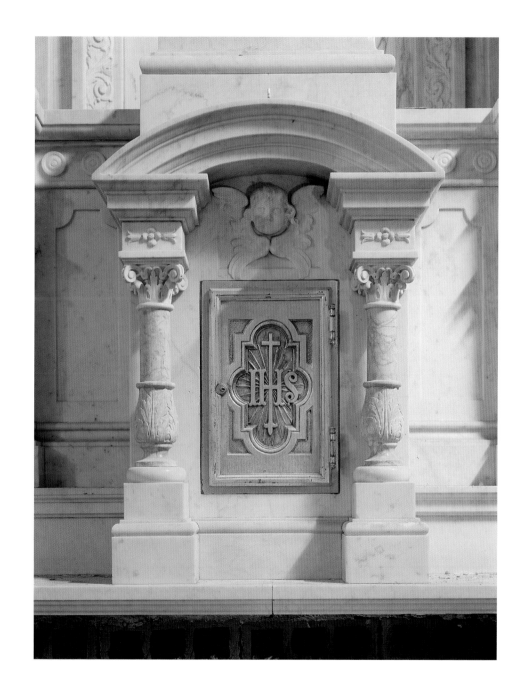

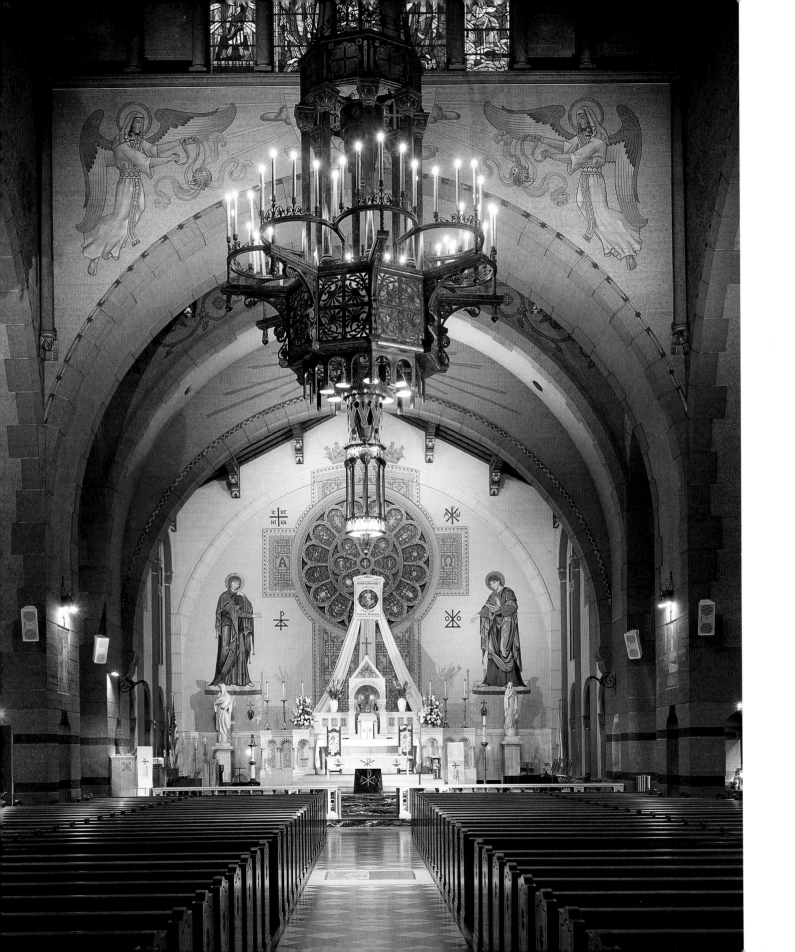

Saint Cecilia

Saint Cecilia Roman Catholic Church is at once one of the most formally inventive and one of the most historically evocative religious buildings in Los Angeles. Its architect, Ross G. Montgomery, is best remembered for his restoration of the Santa Barbara mission church after the 1925 earthquake. He was, however, responsible for numerous other distinguished Catholic churches throughout southern California, including the contemporaneous St. Andrew in Pasadena.

Built in 1927 of reinforced concrete at a cost in excess of $200,000, the church gains an impressive monumentality from the simple geometry of its massing, its careful craftsmanship and its sparse exterior ornamentation. The plan is a Greek cross extended by a short nave to the south. The crossing itself is treated as a cubic mass surmounted by a low octagonal lantern. The overall effect calls to mind the Romanesque architecture of Lombardy, though without imitating any of its particular examples.

Symmetrical when one is approaching the main entrance from 43rd Street, the structure looks more picturesque from Normandie Avenue. The Normandie elevation is asymmetrical, terminated by a campanile at the north end of the chancel. The exterior walls are subtly colored, with some of the horizontal bands cast in the concrete tinted pink and the rest remaining a dull gray.

Inside, the sacred space of the church unfolds in layers opening into each other in all directions. Ornate wrought-iron chandeliers, wrought-iron gates at the entrance to the baptistery and a series of 14 tile wall panels add color to the otherwise austere interior. These tile panels, made in Glendale by the famous firm of Gladding McBean and depicting the Stations of the Cross, materially enhance not only the beauty of Saint Cecilia but also the experience of worship there.

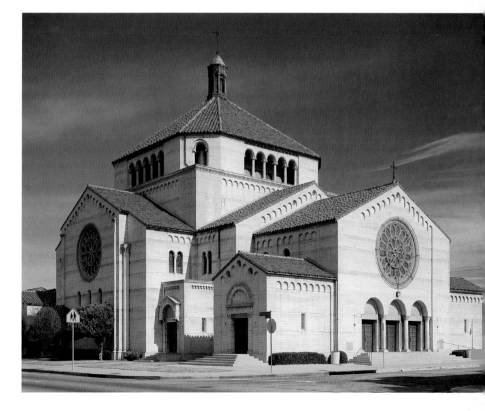

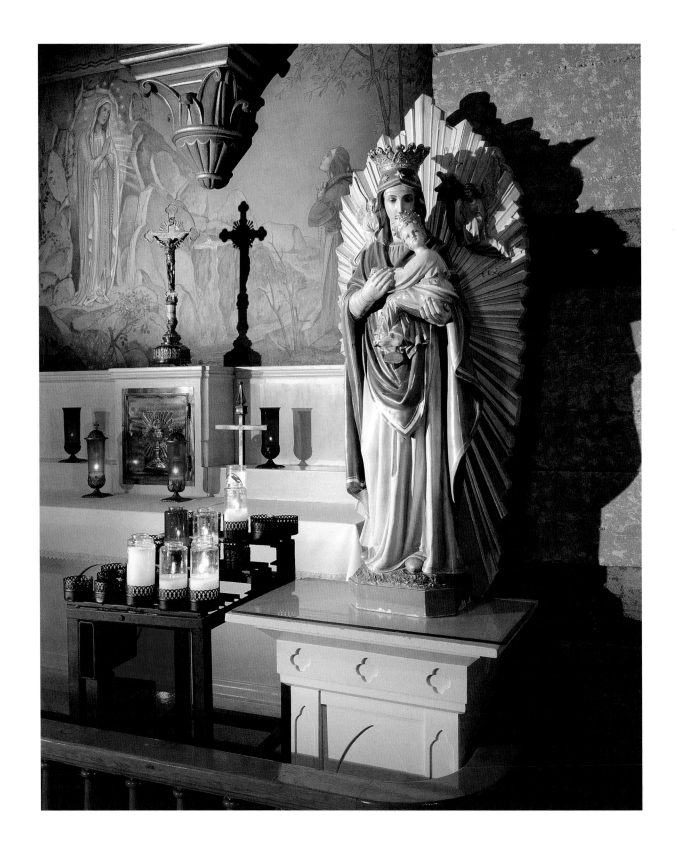

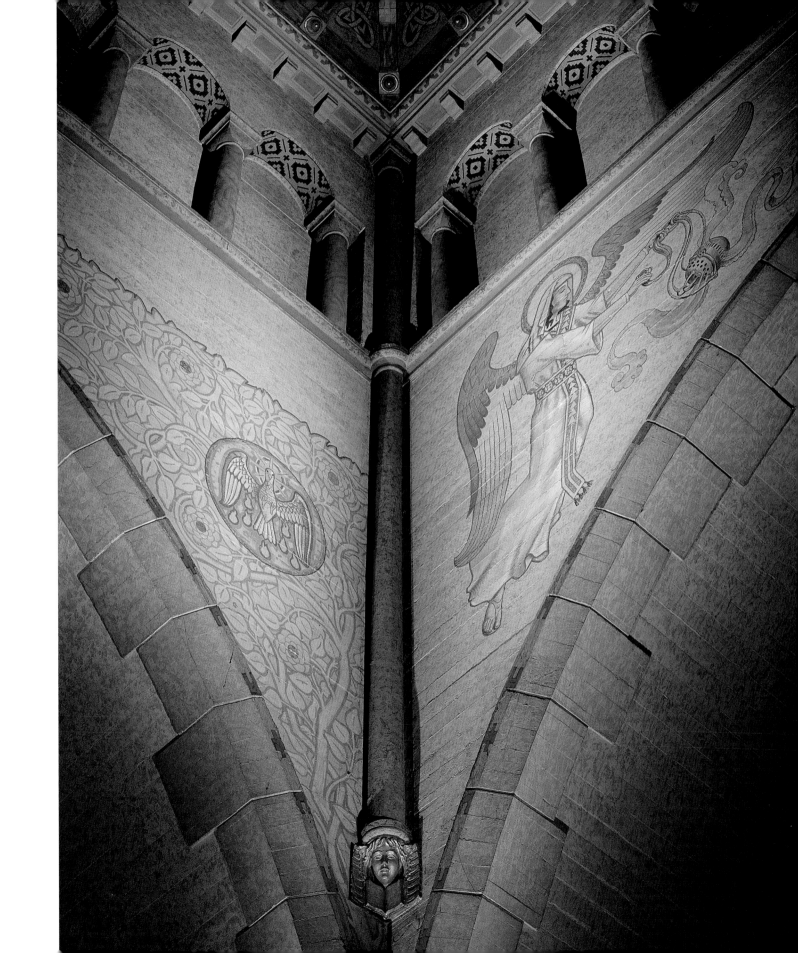

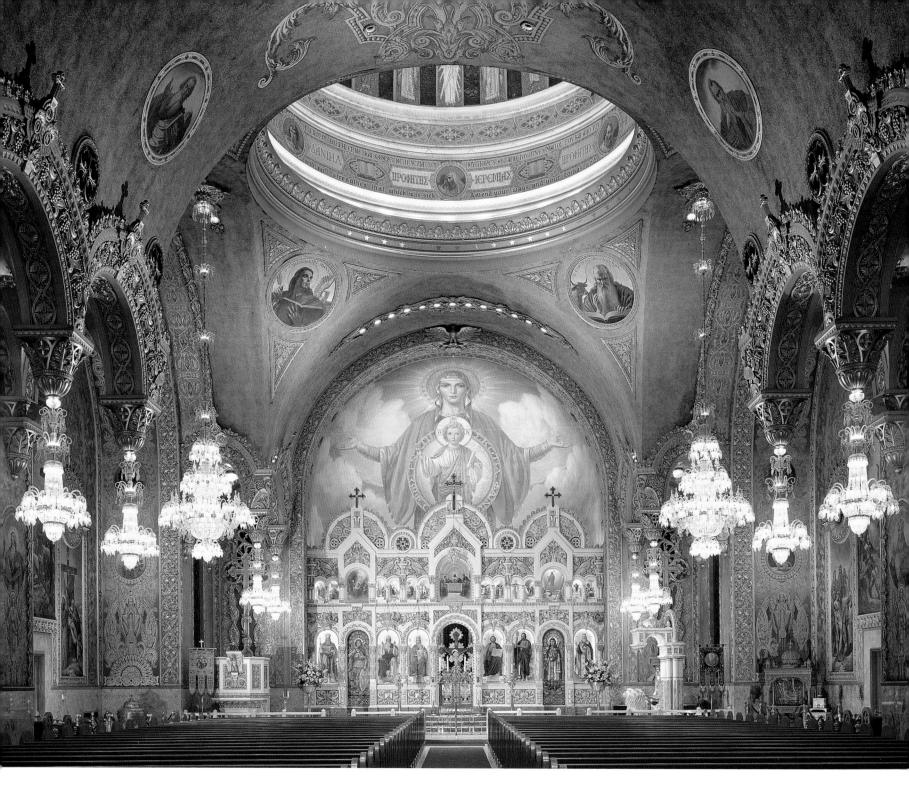

Saint Sophia Greek Orthodox Cathedral

Saint Sophia stands as a proud symbol of Southern California's Greek Orthodox community and a monument to one of that community's most prominent members, Charles Skouras.

Skouras and his brothers, Spyros and George, had entered the theater business in St. Louis in 1914 and amassed an enormous fortune over the two decades following their acquisition of the nationwide National Theaters Amusement Company in 1932. In connection with that takeover, Skouras moved to Los Angeles to manage the integration of the bankrupt chain of 411 Fox West Coast Theaters. A main component of his strategy for revitalizing his struggling theaters was refurbishment and redecoration, sometimes to a radical extent. His personal involvement in numerous remodeling projects deepened his personal interest in architecture. In 1942, he made a remarkable offer to the congregation of the Greek Orthodox Church of the Annunciation in downtown Los Angeles. He proposed to take personal charge of financing and building the new church that the city's Greek Orthodox community had desired for at least a decade — one more splendid, by far, than anyone could have imagined.

The result fulfilled Skouras' personal vision for a church that would rival its namesake, Justinian's great church of Hagia Sophia in Constantinople. Although not the engineering marvel that Justinian's church remains even today, the Los Angeles church is indeed, like that one, filled with a dazzling array of artwork.

Architect Albert R. Walker drew up plans for the steel and reinforced concrete structure in 1949. Over the next three years, they were refined by, and carried out under the supervision of, the firm of Walker, Kalionzes & Klingerman. As Saint Sophia neared completion in 1951, the same architects erected a private mausoleum for Charles Skouras adjacent to the church.

Saint Sophia Greek Orthodox Cathedral was consecrated with appropriately theatrical pomp and traditional sacred ceremony on October 2, 1952 as a Cathedral, the seat of the Greek Orthodox Archdiocese having been transferred from San Francisco to Los Angeles. Valued

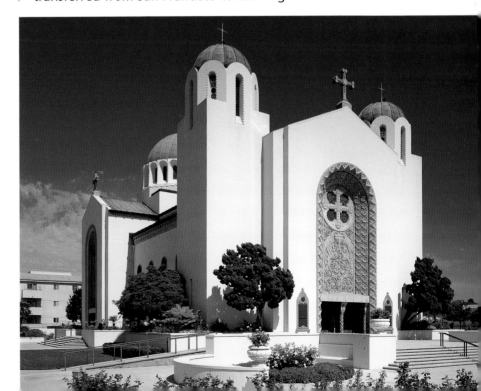

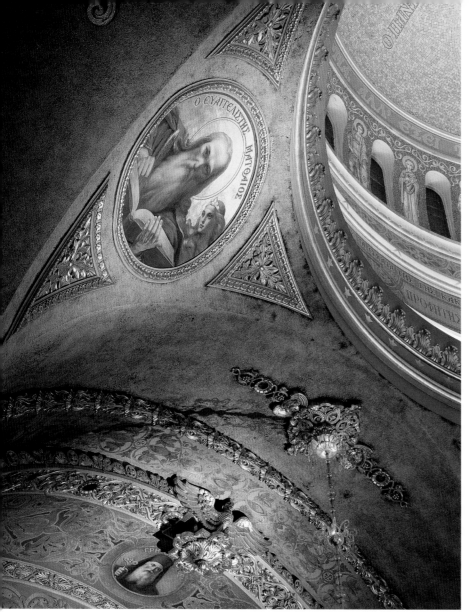

at five to six million dollars, it was publicized as the most expensive church in America. Skouras frankly expressed his pride in the new cathedral that was enhanced by the carefully planned lighting of its interior. To a LIFE magazine reporter sent to cover the consecration, he confided that he had "blended my theatrical experiences into this thing."

A thing of wonder indeed, the Cathedral's relatively simple exterior contrasts sharply with its elaborately decorated interior. Virtually every surface is covered with painted or plastic embellishment, most of which has iconographic significance. Artist William Chavalas was responsible for the design of the whole decorative program. Its focus is a monumental depiction of the Holy Virgin Mary presenting the Christ child, painted on the back wall of the sanctuary behind an elaborate iconostasis. A Christ Pantocrator is painted on the dome, with portraits of the four Evangelists occupying roundels in the pendentives that support it. Suspended from the dome and the pendant arches along the sides of the nave are enormous crystal chandeliers imported from Czechoslovakia. The whole, with its extensive use of marble and gilding, evokes both Byzantine splendor and the glamour of Hollywood, both the traditional heritage of Greek Orthodoxy and the modernity of the American business enterprise whose success could finance it.

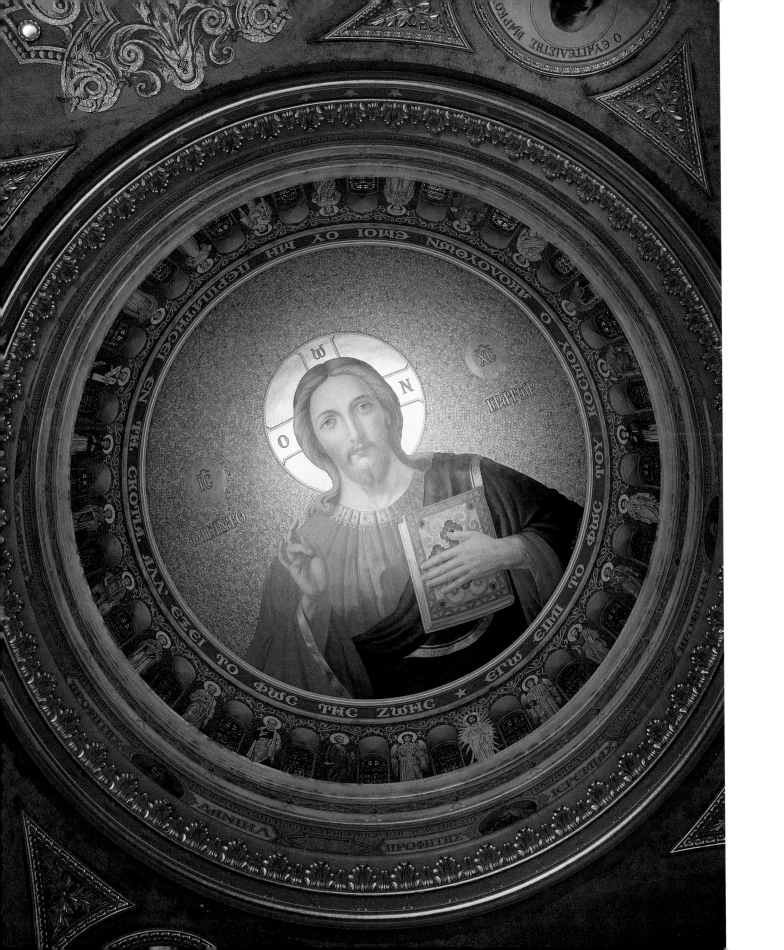

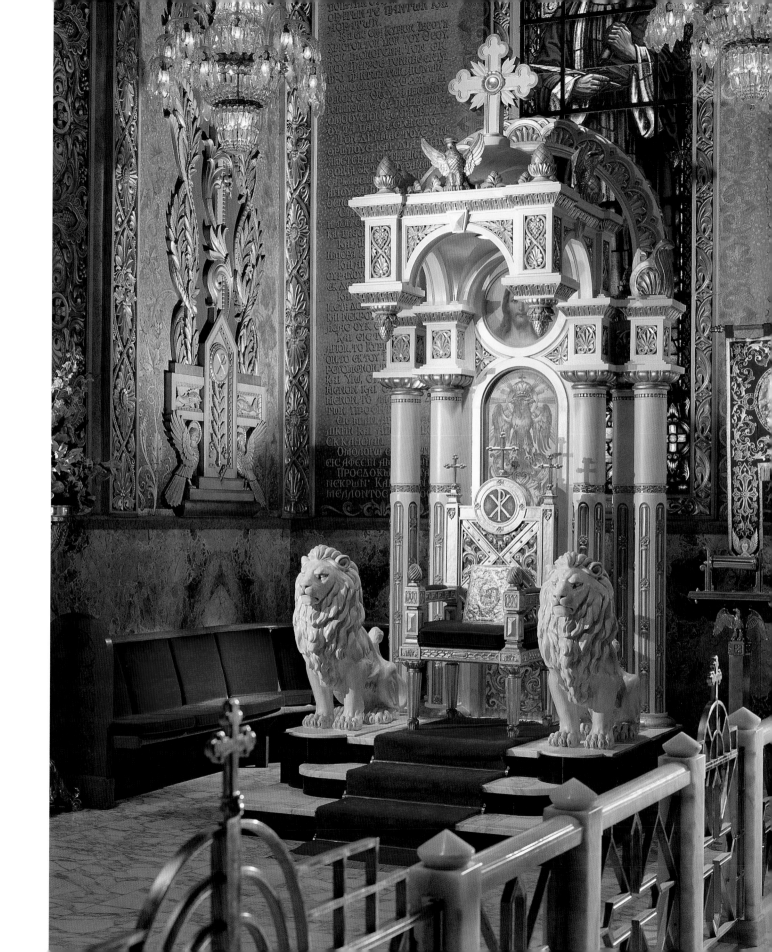

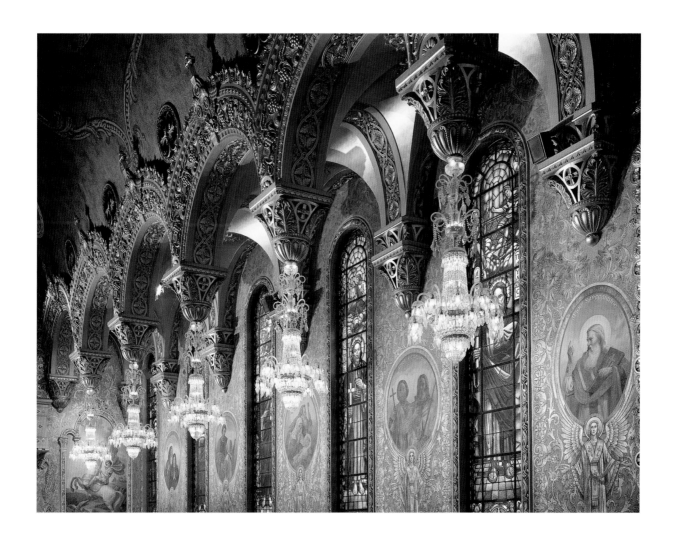

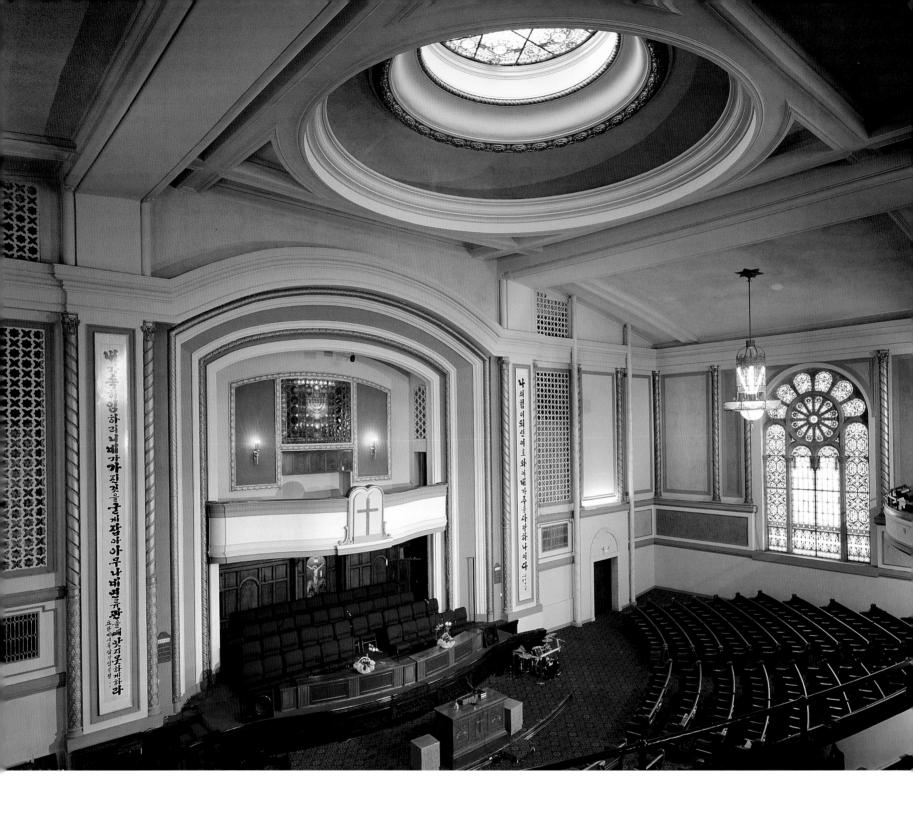

Temple Sinai East
Korean Philadelphia Presbyterian Church

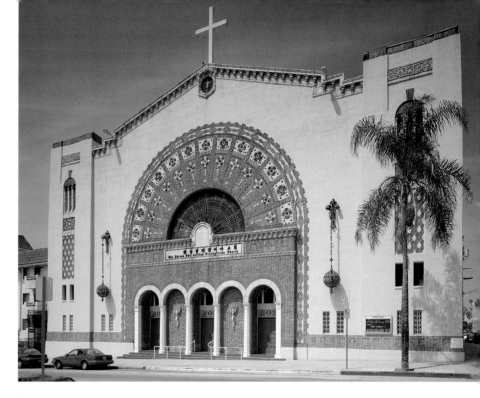

In 1926, barely fifteen years after occupying its synagogue at Twelfth and Valencia Streets, Los Angeles' oldest Conservative Jewish congregation had outgrown those quarters and found itself moving westward — along with much of the city's population — and into a new building at Fourth Street and New Hampshire Avenue. Designed, like the original, by S. Tilden Norton (now in partnership with Frederick Wallis), the new edifice seated more than twice as many people.

The building occupies its entire site, providing space for both worship and education. Its style was intended to suggest Roman architecture, with details recalling the building tradition of ancient Palestine. The entrance on New Hampshire Avenue is flanked by a pair of towers and surmounted by a great arch somewhat reminiscent of the "Golden Door" of Louis Sullivan's Transportation Building at the 1893 World's Columbian Exposition in Chicago. Ornamentation both inside and outside is ornate but carried out in relatively low relief, a strategy that increases the grand effect of the building's simple massing. The interior is flooded with light from a large oculus in its central dome.

As the Jewish population continued to shift westward after World War II, Temple Sinai decided to move once again in 1956. The congregation left this synagogue in 1961 to occupy a new facility in Westwood, giving rise to the nickname "Temple Sinai East" for the original temple. As members continued to feel sentimentally attached to the old building, the sale of the structure was postponed for more than a decade pending the identification of a buyer who would commit to preserving it. After being declared Los Angeles Historic-Cultural Monument Number 91, it was sold in 1973 to the Korean Royal Church and now serves as the Korean Philadelphia Presbyterian Church and is recognized as a monument of Jewish Los Angeles and Korean Los Angeles alike. It provides striking material evidence of the constantly changing cultural demographics of Los Angeles as well as of the possibilities for the adaptive re-use of works of historic architecture.

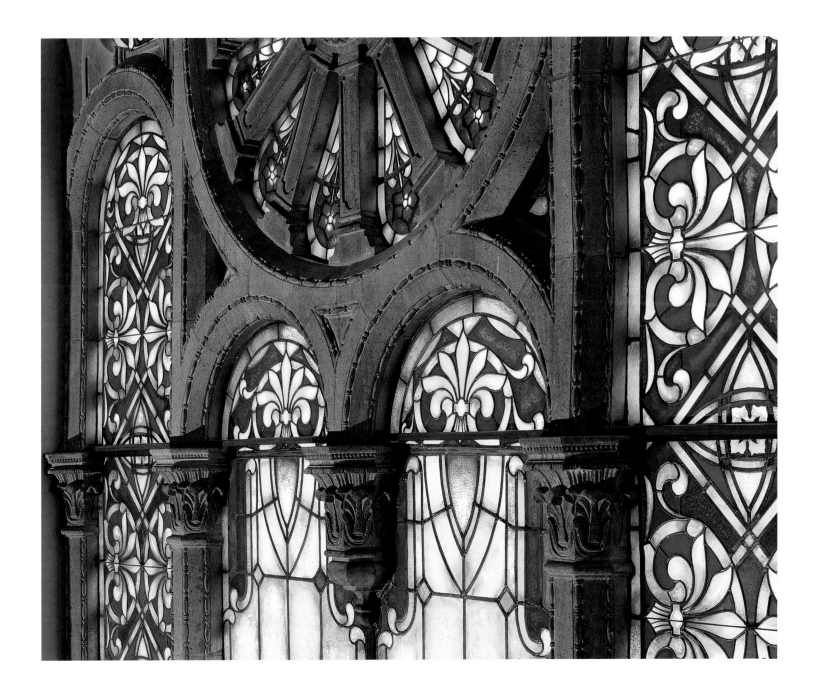

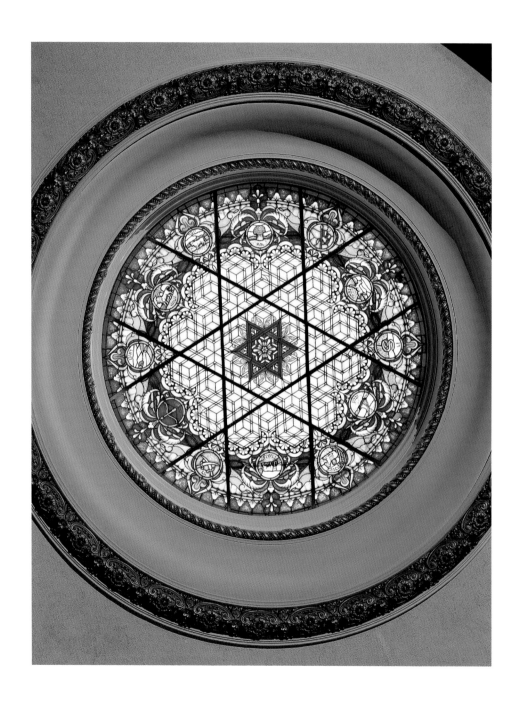

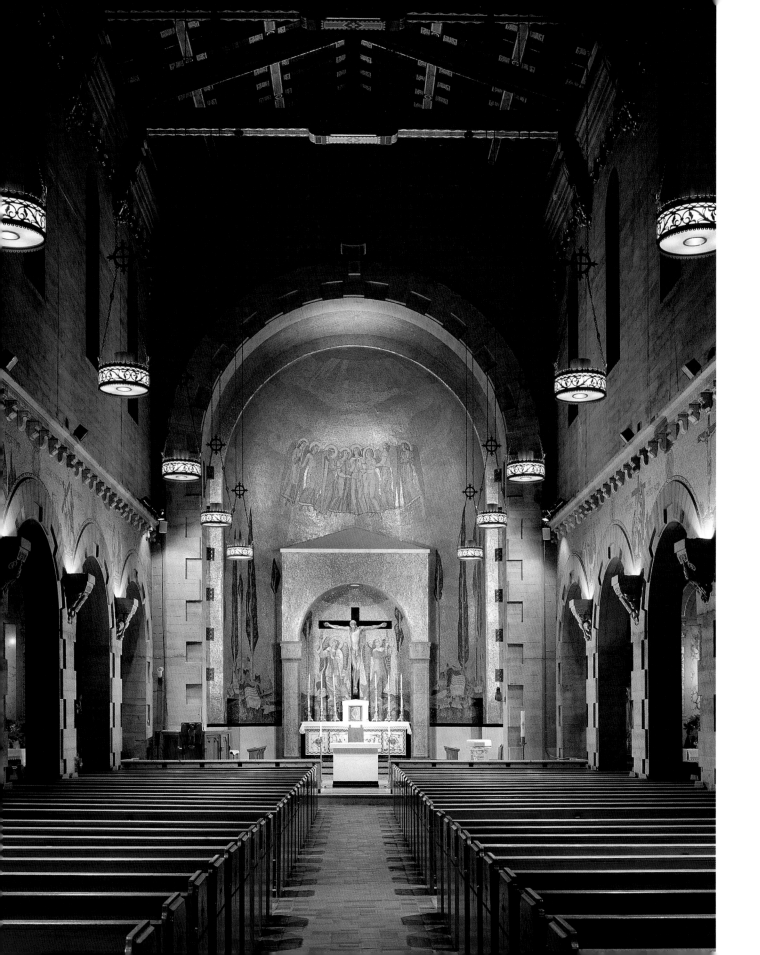

Church of the Precious Blood

Although not really a small building, the Church of the Precious Blood seems like the miniature masterpiece of some medieval craftsman in comparison with its enormous neighbor, First Congregational Church, that towers over it. Its proportions are elegant; its lines are sharp; its details are finely conceived and just as finely executed. It is indeed a masterpiece, though one of a decidedly twentieth-century sort: a work of engineering as much as of architecture, realized in reinforced concrete and cast stone using the most modern building methods of the Wurster Construction Company, roofed with steel trusses and ventilated by mechanically forced air.

Truesdell & Newton designed this church in 1924, but it was completed in 1926 by the firm of Newton & Murray. Cruciform in plan, with its long nave and short transepts, the building seems peculiarly adapted to the shape of its triangular site. Inside, the narrow aisles allow the nave to occupy nearly the full width of the necessarily narrow building. The architecture of this Roman Catholic church recalls the survival of early Christian forms into the period of the Italian Romanesque.

The concrete, used straightforwardly with traces of its formwork left exposed, is itself one of the beauties of this building. It provides a sensuously textured yet neutral background for carefully placed sculptural and other details. Chief among them is the entrance portal, carved in tufa stone by Salvatore Cartiano Scarpitta best known for his work on L.A.'s City Hall. The figure of Christ on the trumeau strongly recalls that of the famous south portal of Chartres Cathedral in France. Mosaics fill the arch above the portal and a niche centered in the blind arcade above it. More mosaics sparkle in the dramatically lit interior. Around 1951, Wallace Neff supervised a remodeling of the nave that was intended mainly to increase the resistance of the structure to seismic forces.

Perhaps the best-known parishioner of the Church of the Precious Blood is former Los Angeles Superior Court Presiding Judge Victor Chavez, who served as an altar boy there while growing up in the neighborhood.

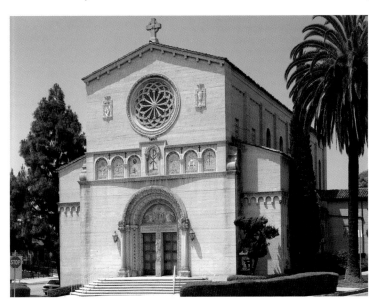

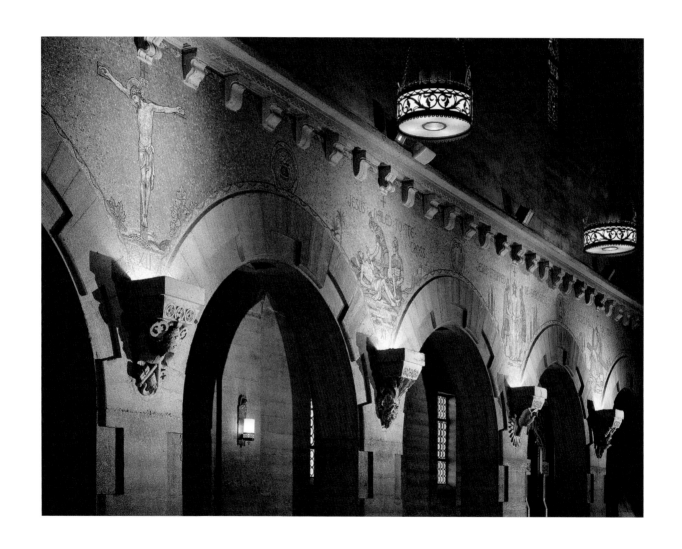

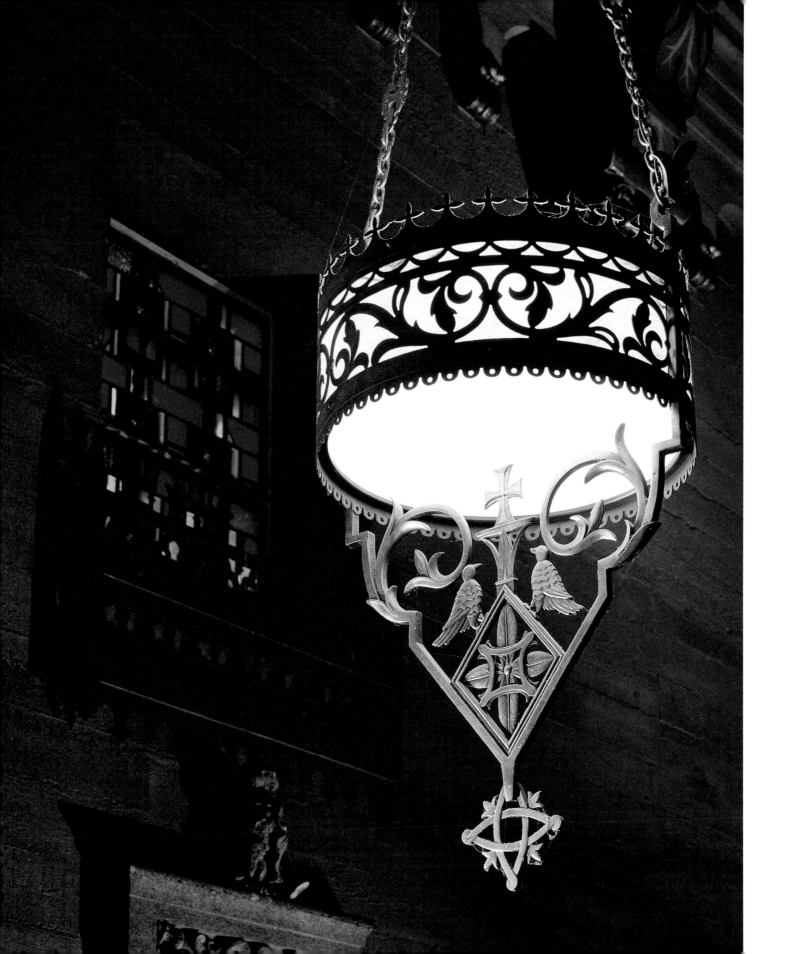

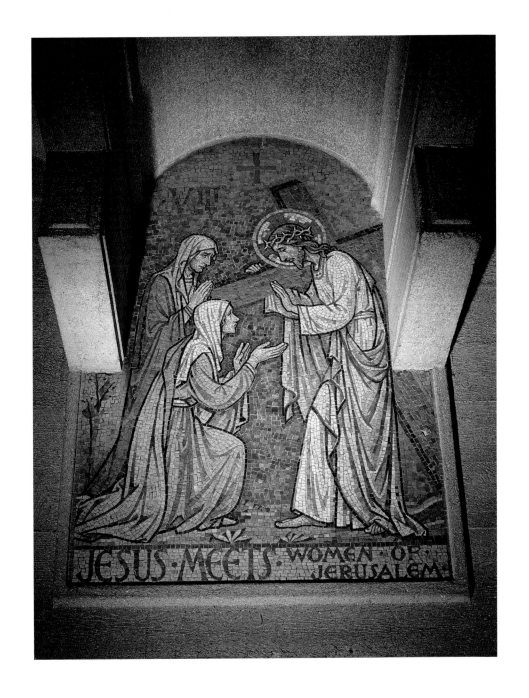

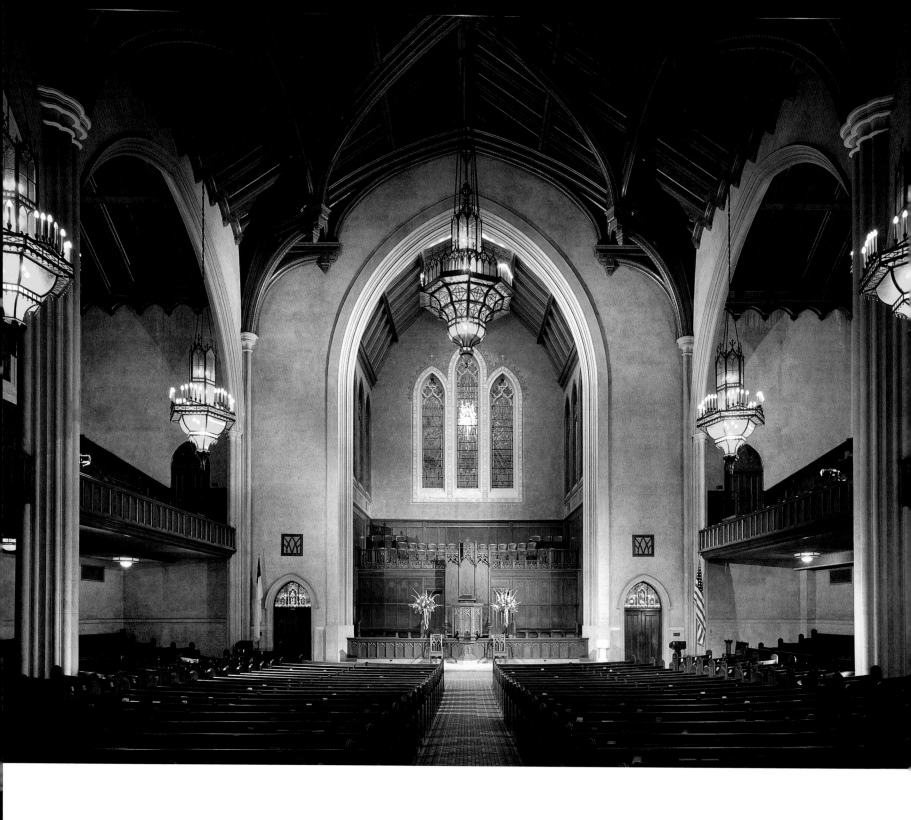

Immanuel Presbyterian Church

Immanuel Presbyterian Church is the masterpiece of its architect, Chauncey Skilling, and the most imposing of the many fine churches that distinguish Wilshire Boulevard.

The congregation was formed in 1888 as an offshoot of the First Presbyterian Church of Los Angeles. Within fifteen years, it had grown into the largest Presbyterian congregation on the West Coast. In 1921, the church commissioned Skilling to design a new building for a site at Tenth and Figueroa Streets to accommodate a sanctuary seating some 2,500 worshippers, one of the largest organs in the country, a multi-story education wing, a parish house and a secondary auditorium seating 500. Skilling's proposed design evoked English Perpendicular Gothic architecture in reinforced concrete but was not carried out.

By the mid-1920s, the congregation had acquired a site in the fast-growing Wilshire district. For this site, Skilling, now in collaboration with Henry M. Patterson, proposed a design inspired by fifteenth-century French Gothic architecture. The new church was completed in 1927.

A tower rises to a height of 205 feet from the corner of Wilshire Boulevard and Berendo Street. A steel skeleton supports the medieval style stone cladding of the entire structure. Thus, despite its exterior appearance, the church is, in fact, a thoroughly modern artifact. Thanks to the steel framework, the interior is strikingly spacious, with high aisles and a broad nave. Extensive woodwork, massive chandeliers, stenciled ceilings and colorful stained-glass windows by the Dixon Studios produce an effect of decided magnificence.

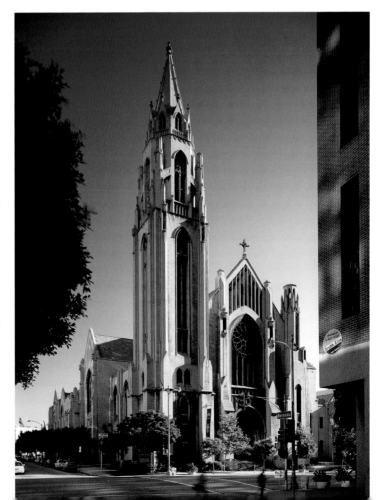

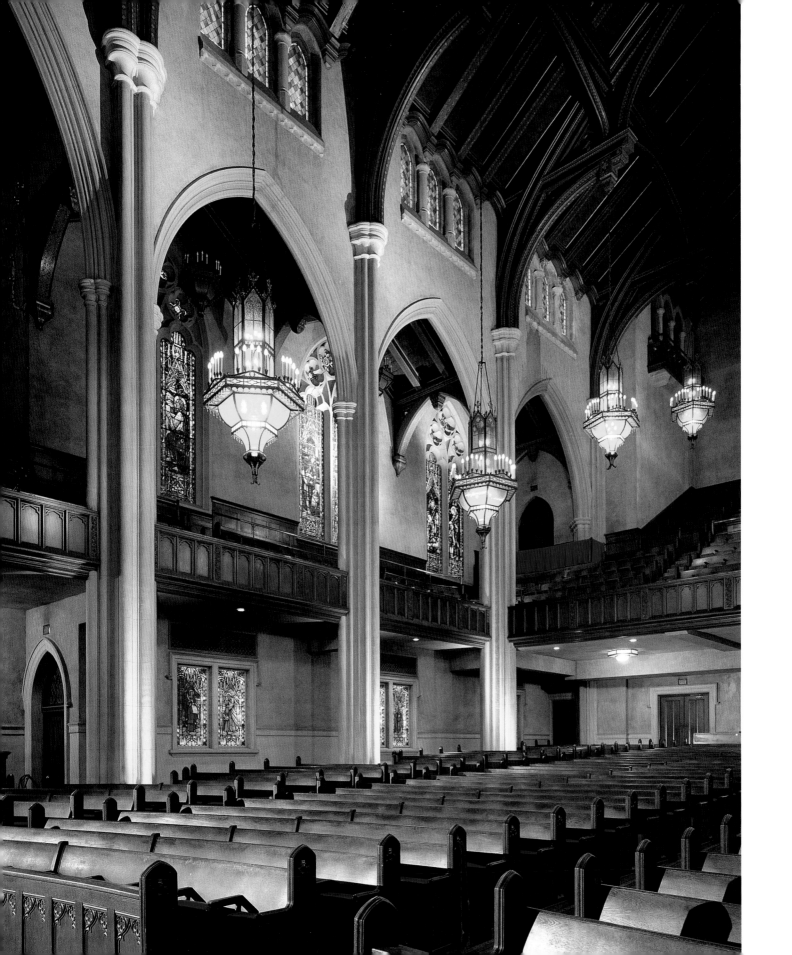

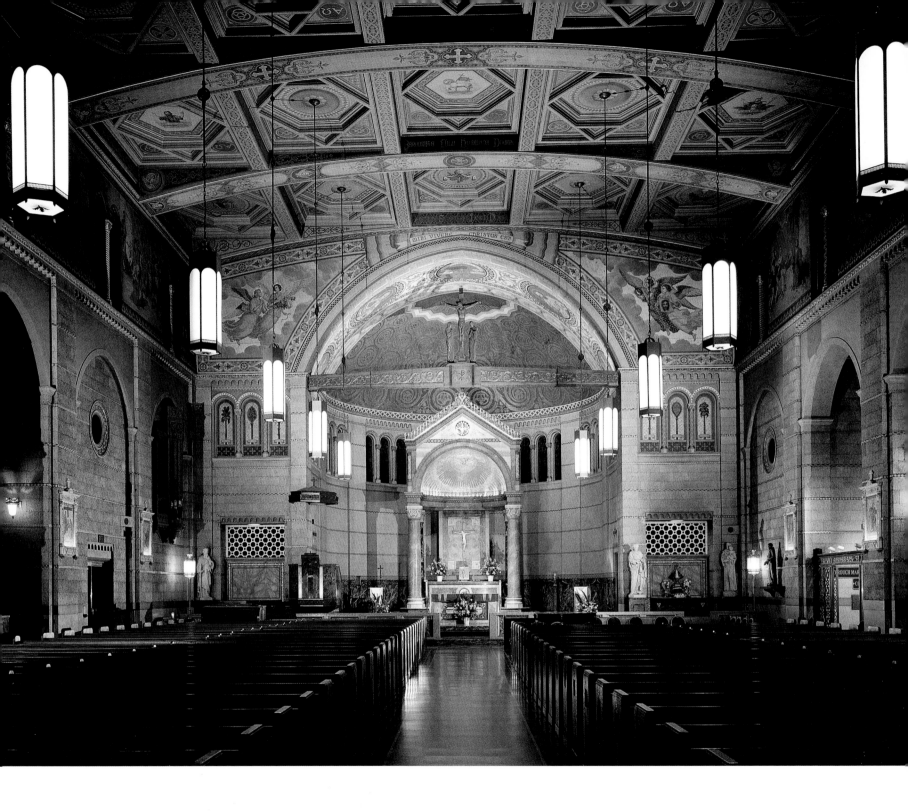

Saint Paul's Roman Catholic Church

In this basilican church, as in his much more famous projects, the Los Angeles City Hall and the Griffith Park Observatory, English-born architect John C. Austin demonstrated his ability to excel in collaboration with other artists and designers. Austin positioned the building on its trapezoidal site in order to take full advantage of its potential for visibility. Approached from the west, the façade of the church rises as a dramatically simple flat plane set off by its position behind a triangular garden forecourt. Approached from the opposite direction, it is marked by a high campanile located near its eastern end and a secondary entrance on Washington Boulevard.

Begun in 1937, this church was substantially completed the following year. Its reinforced concrete exterior recalls the architecture of the Italian Romanesque period. A cloister runs along the north side of the nave, from the narthex to the base of the tower. The interior is treated eclectically, with suggestions of Byzantine, Early Christian, Romanesque, Renaissance and even Baroque architecture blended into unity by the uniformly high quality of the ornamentation executed by numerous distinguished craftsmen. This ornamentation includes stained-glass windows by Charles Connick of Boston and wall paintings conceived by John Smeraldi and completed in 1947 by Innocenzo Daraio. The iconographic program, comprising both the windows and the murals, is one of the most complete in any Los Angeles church; its main themes are the majesty of Christ and the life of Saint Paul, but numerous symbols of Christian theology also appear.

Despite its overwhelmingly traditional character, Saint Paul's has more than a few features sharing affinities with the Modernism that was fast becoming the dominant force in Southern California's architecture during the years of its completion. Functionalism is evident in the planning of the church's basement as a social hall and recreation center. Advanced principles of earthquake engineering were applied to the design of its structure and innovative techniques were employed to save materials in the construction of the tiled roof.

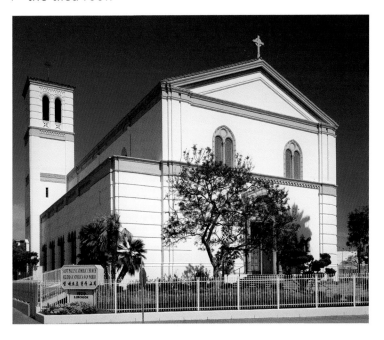

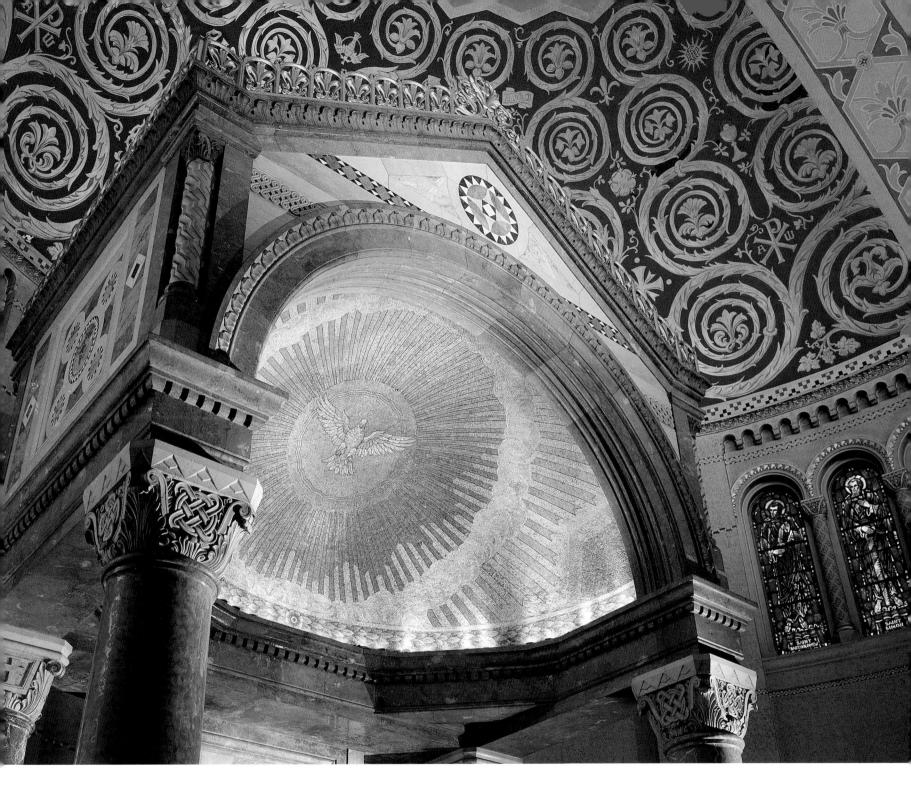

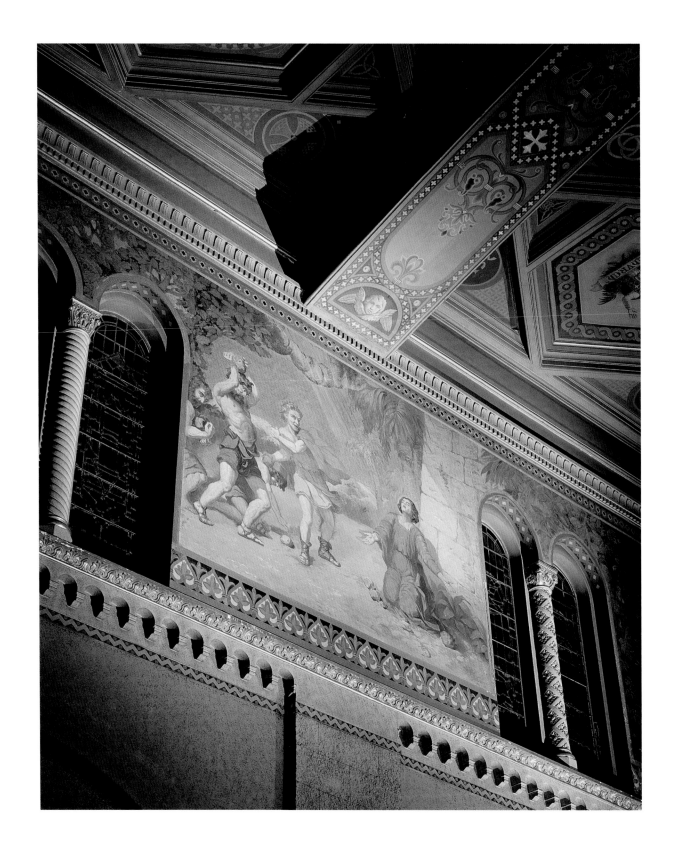

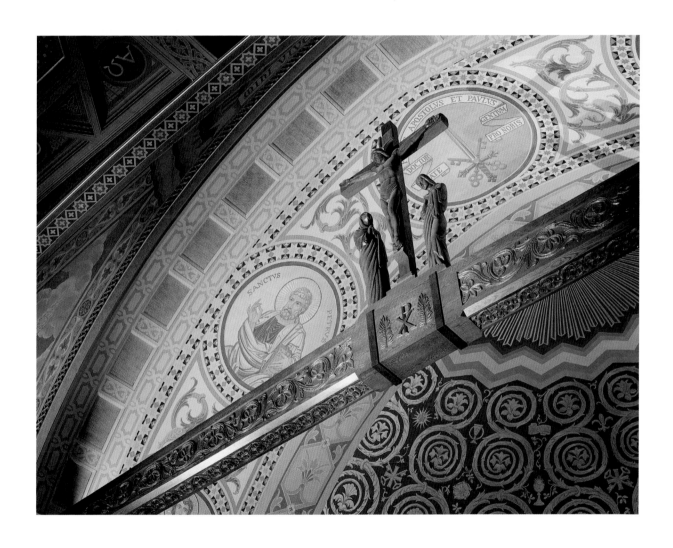

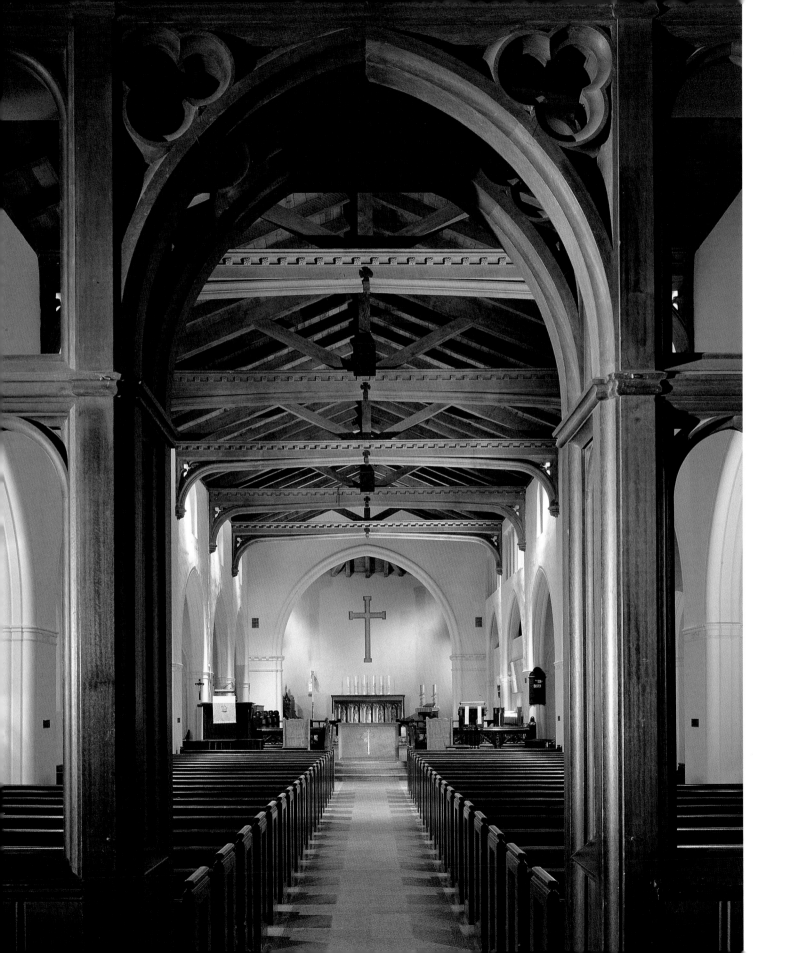

Saint Alban's Episcopal Church

This church, across the street from the UCLA campus, is one of the chief delights of a neighborhood abounding in works of fine architecture. It consists of three neo-gothic structures arranged in a U-shape to form a garden forecourt. They are built of red brick with stone dressings, lightly whitewashed to accentuate their rustic effect.

The first component of the complex to be erected, the chapel, lies along the southern boundary of its site at the corner of Hilgard and Westholme Avenues. Designed by Reginald Johnson, it dates to 1931. The distinctive feature of its exterior is a narthex treated as a porch appended to the west end of the structure. Inside, it was equipped with an Aeolian-Skinner organ. In 1940, the sanctuary was constructed on the north side of the property. Its design, by architect Percy Paul Lewis, is somewhat more formal than that of the chapel and hence less charming. A Sunday School building, fronted by an arcade and linking the chapel and sanctuary, was later added to complete the ensemble.

The church's small windows are filled with stained glass produced by the Judson Studios. Blues and reds predominate, in keeping with the medieval feeling evoked by the architecture.

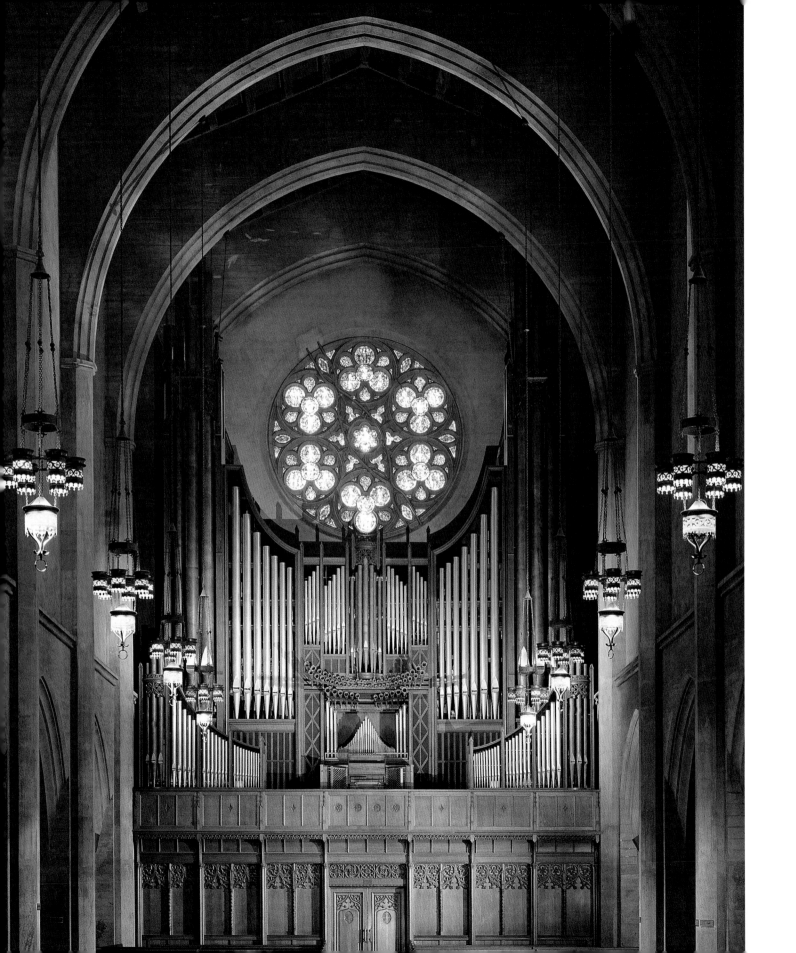

First Congregational Church

One of the most dramatically sited churches in Los Angeles, First Congregational Church ranks among the very best of the dozens of reinforced concrete churches found throughout the Los Angeles area. Viewed from the northwest corner of Lafayette Park, the east end of its sanctuary soars high above the street to dominate the city like the English medieval cathedral it resembles; hence its nickname, "the concrete cathedral." The sanctuary shelters a cloister-like patio to its north. Also grouped around this patio are the Shatto Chapel further to the northwest and an education building (with its own courtyard) filling the northeast corner of the site.

Although Allison & Allison were the architects of record for this church, George B. Allison credited Austin Whittlesey with the actual design. It may well have been inspired by the architecture of the Congregational church designed in 1911 for a Pomona congregation by Robert Orr, Pierpont Davis and L. T. Bishop. The congregation had wanted a rendition of Salisbury Cathedral, but scarce funds during the Depression dictated certain reductions in the scope of their vision and influenced the choice of the materials used. The church was completed in 1933.

The concrete is masterfully handled, with the texture of the eight-inch boards of the formwork left exposed to suggest horizontal courses of masonry. The cast-stone ornamentation is limited mainly to niches, tracery, finials and the enrichment of the entrance at the back of the forecourt facing Commonwealth Avenue. The impressiveness of the unornamented exterior depends mainly on the very size and simplicity of its well-proportioned masses rising heavenward.

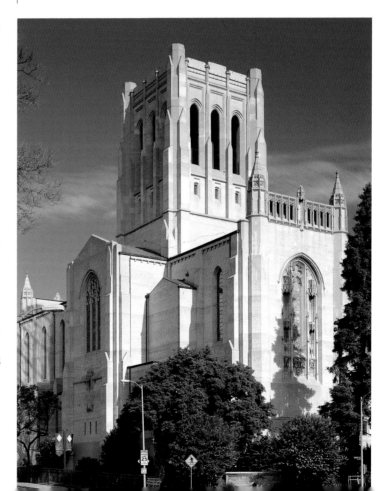

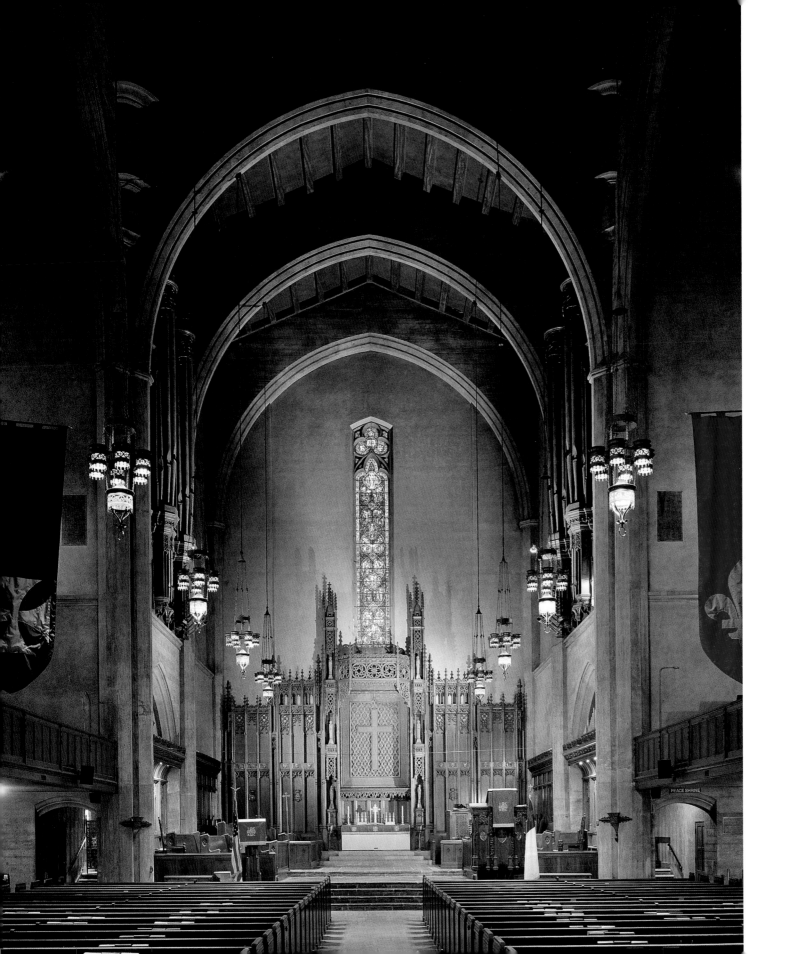

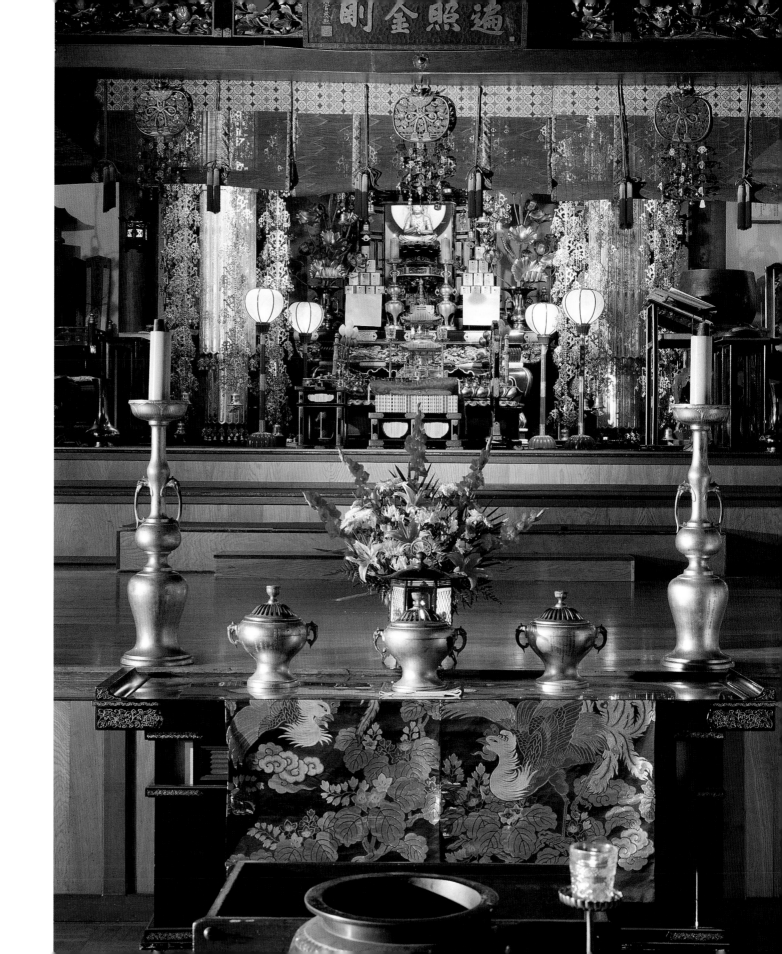

Koyasan Buddhist Temple

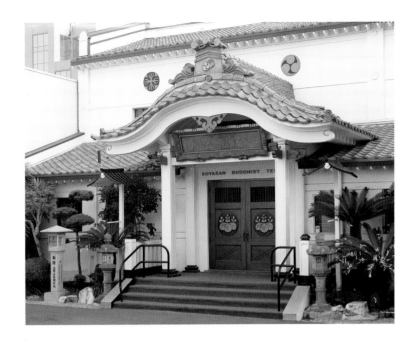

A narrow alley between two unobtrusive little buildings on East First Street opens suddenly into a paved courtyard and reveals one of the most remarkable monuments of Little Tokyo, the Koyasan Buddhist Temple. This temple, with its stucco and wood exterior strongly suggesting traditional Japanese architecture, serves as the main North American headquarters of Shingon Esoteric Buddhist sect. Officially known as "Koyasan Beikoku Betsuin of Los Angeles," the temple was named for the sect's principal temple at Koyasan, Wakayama Prefecture, Japan.

In 1938, the City issued a permit for construction of the one-story temple according to a design prepared by architect Lyle Newton Barcume. The building takes the form of a high hall, along the front of which runs a low tiled-roof porch and shallow garden areas. The exterior color scheme is a subdued one of gray, black and white. The two halls inside are equally sober in their finishes, contrasting with the richly furnished altars. In 1939, the City issued more permits for modifications planned by architect Yoshihiro Hirose. Changes to the trussed roof structure were authorized in 1940.

A group of Japanese-American businessmen, including H. T. Komai, financed the construction of this temple. Komai at the time served as editor of Rafu Shimpo, the venerable Japanese-American newspaper published in Los Angeles since 1903.

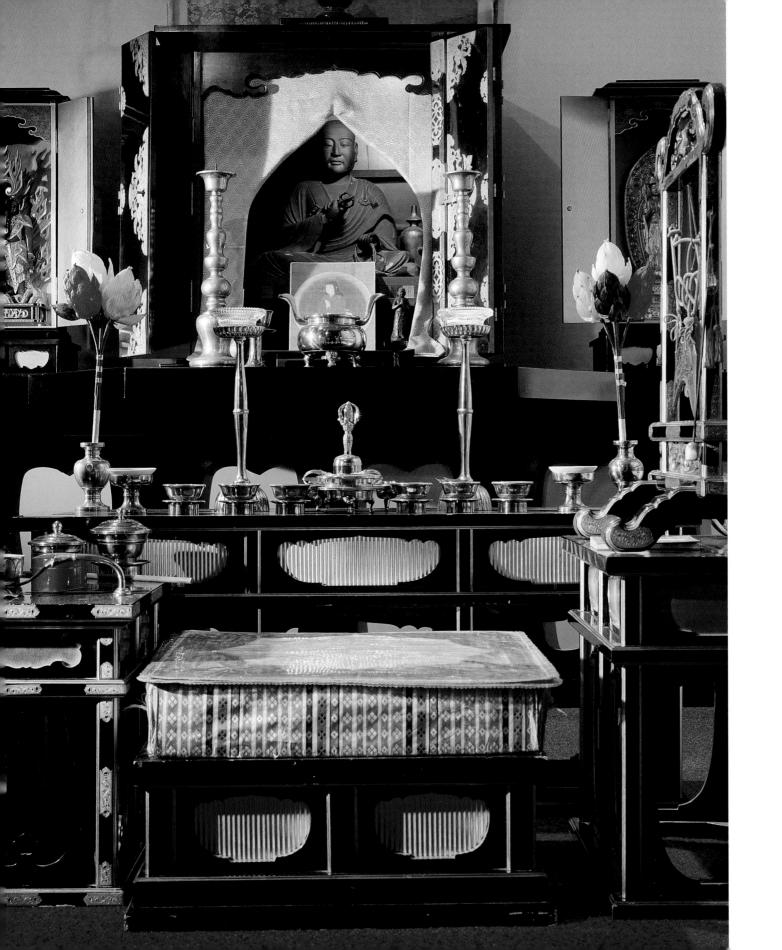

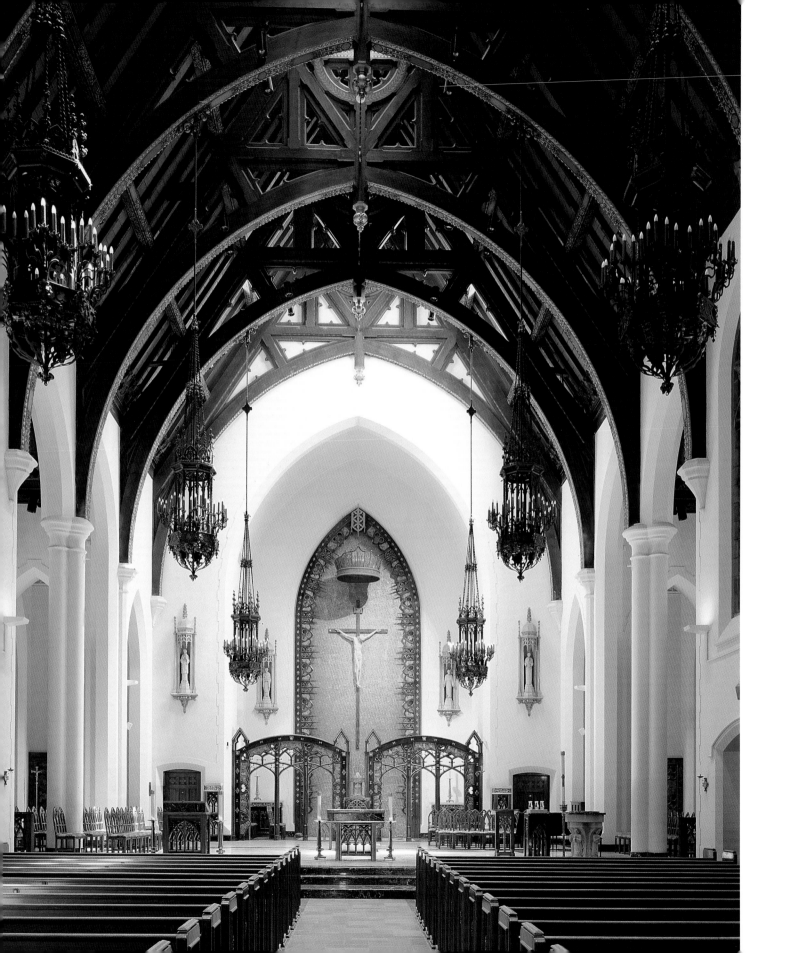

Saint Brendan's Roman Catholic Church

Saint Brendan's in Hancock Park is arguably the best of a number of outstanding churches designed by Emmett Martin, brother of Albert C. Martin, who founded one of Los Angeles' most prolific and respected architectural dynasties. In its style and highly refined proportions, it reflects an eclectic appreciation of Gothic architecture. The fact that its character and details have been variously seen as English Perpendicular and Late French Gothic provides strong evidence of Martin's originality as an architect.

Plans for this splendid church were announced in July, 1924. Construction, however, began in 1926. The edifice, which seats about 650 worshippers, was dedicated in 1928. The exterior is finished in Boise stone with cast stone pinnacles and other ornaments sculpted by J. S. Watkins. Its delicate spire reaches a height of 125 feet.

Martin's design eschews aisles. Nevertheless, the use of a steel frame, including a roof structure of steel trusses covered by redwood veneer, allowed him to achieve a striking lightness of effect in the nave. Serving one of the city's wealthiest parishes, it is therefore not surprising that it boasts not only fine architecture but also a rich set of interior appointments. The oak woodwork found throughout the church is embellished with carving by Belgian sculptor Martin Barbier. The stained-glass windows, imported from Germany, are the work of Heinrich Oidtmann. Intricate wrought-iron grilles, screens, rails, and lighting fixtures were executed from designs by the architect. The interior was finished with murals painted by Chicago artist Arthur Hercz.

St. Brendan's appeared as a location or background in a number of the later Our Gang comedies produced by the Hal Roach Studios, including 1930's *Pups is Pups*. But the church's most famous appearance on the silver screen came in 1953, when it served as the location for the terrifying climactic scene in *War of the Worlds*.

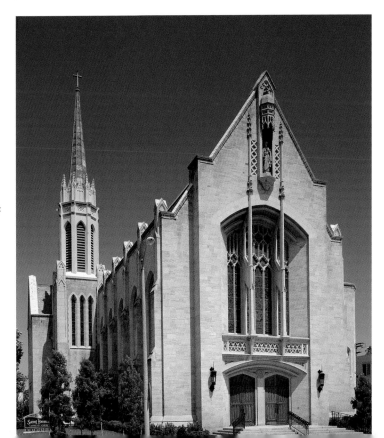

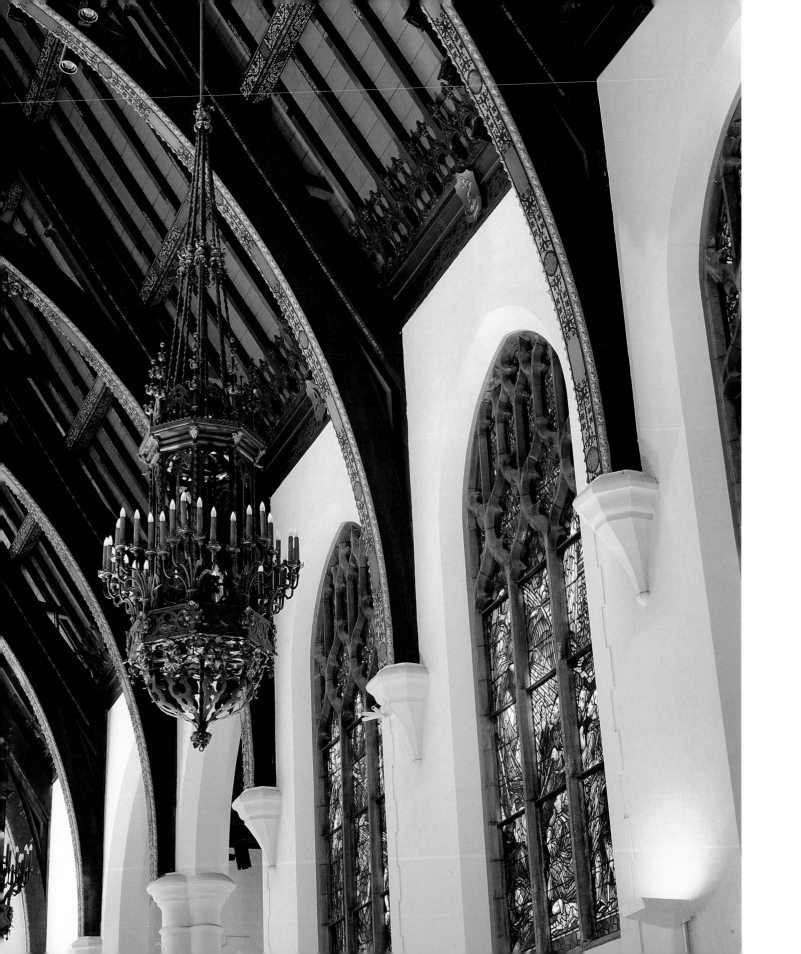

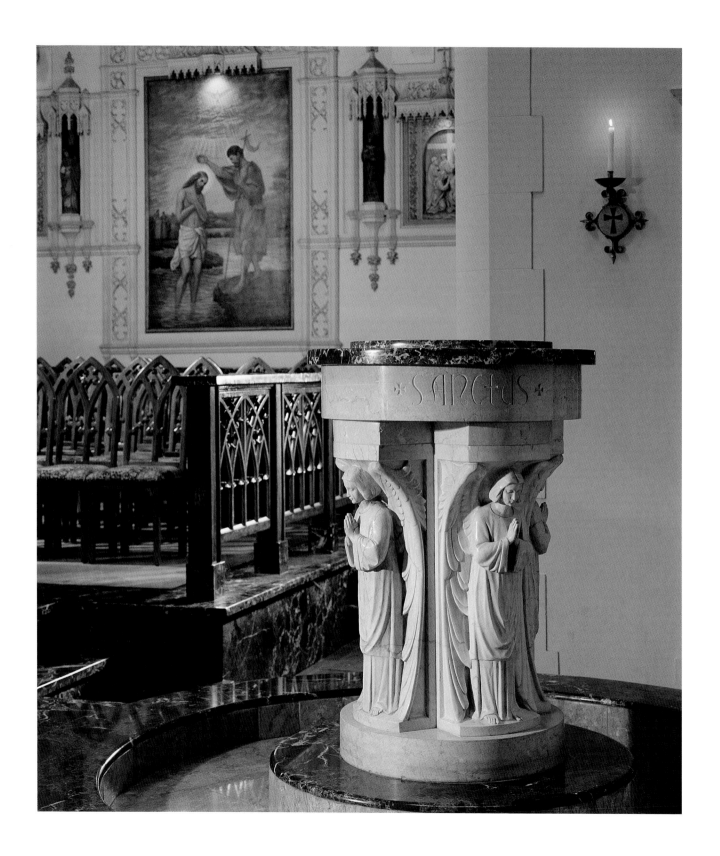

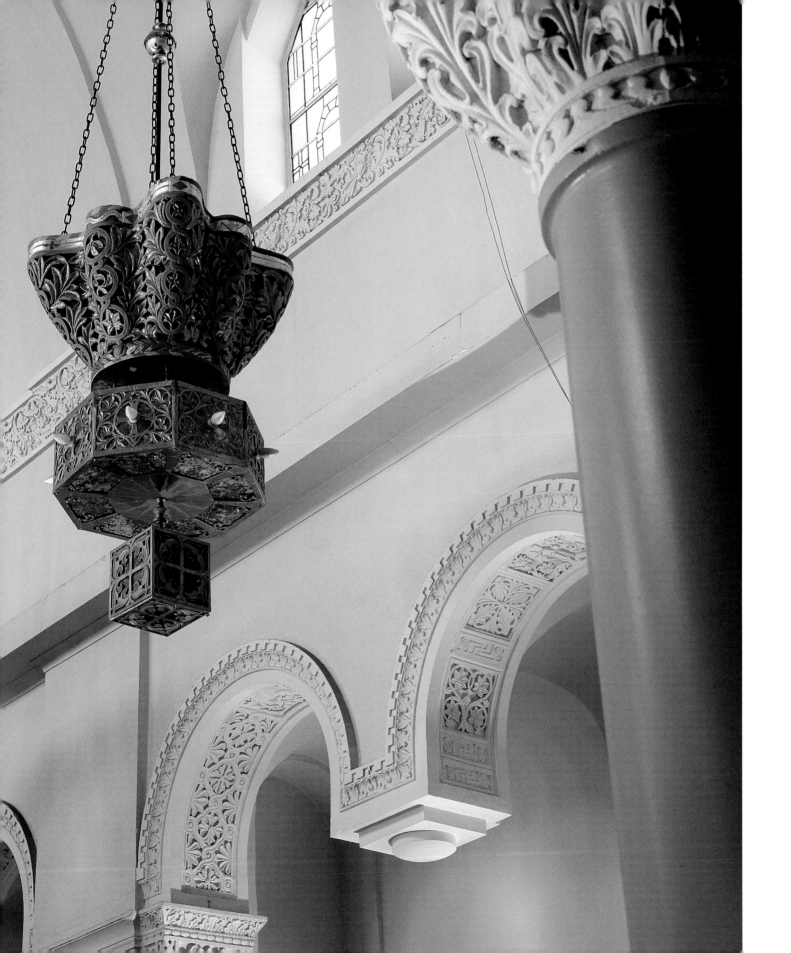

St. Mary's Roman Catholic Church

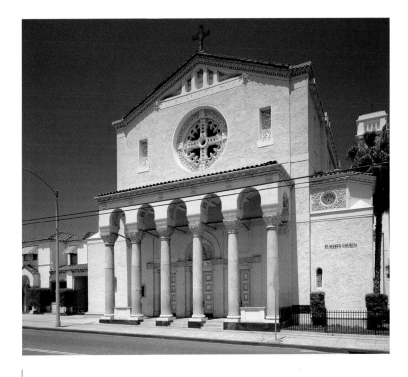

The construction of this church in 1924 is due largely to the dynamism of parish priest Father Thomas O'Regan, noted for his financial wizardry and fund-raising abilities. Designed by Thomas Power, it replaced a red brick church of eclectic design erected in 1897 on the corner of Chicago and Fourth Streets in Boyle Heights. As a souvenir of the old church, its bell was installed in the new one.

Built of brick with marble used to enhance the entrance, St. Mary's projects the image of an early Christian or Byzantine basilica. This effect is due mainly to the treatment of the arcaded porch, with its six Byzantine columns, but also by the thermal windows placed high in the side walls to light the interior. The interior, focused on a barrel-vaulted chancel, was originally painted in colors that suggested ancient Egypt and ornate light fixtures are of distinctly byzantine inspiration.

A restoration of the building followed the 1994 earthquake, during which St. Mary's suffered considerable, though superficial, damage. It was featured as one of the many unusual locations used in the time-bending horror movie, *Soul Keeper*, released on television in October, 2001.

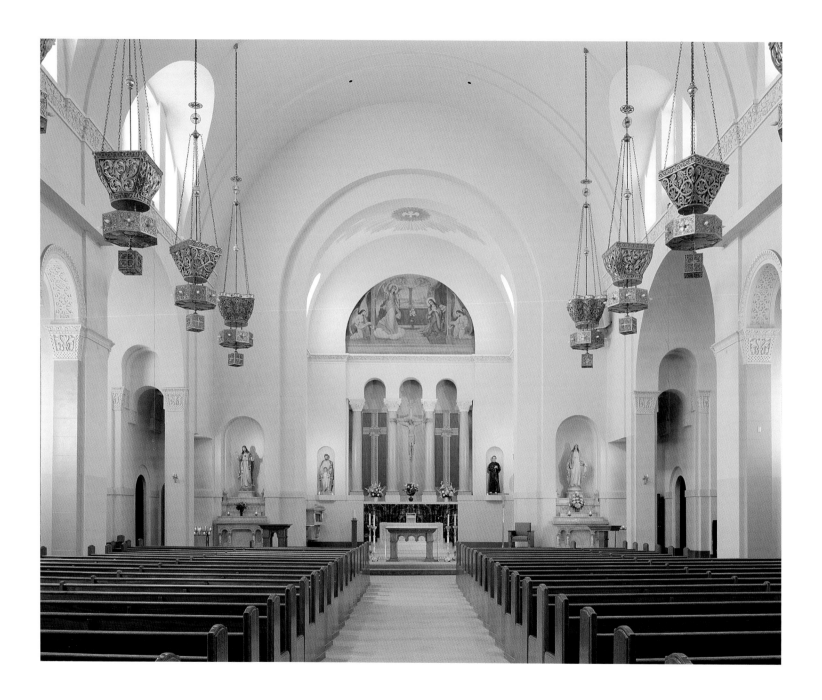

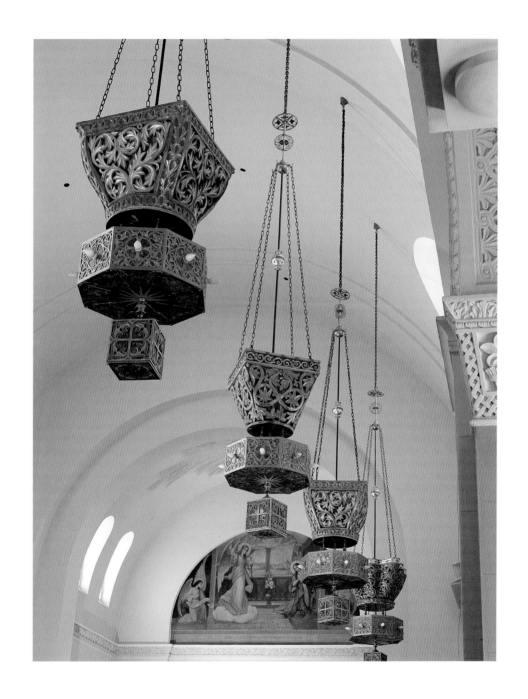

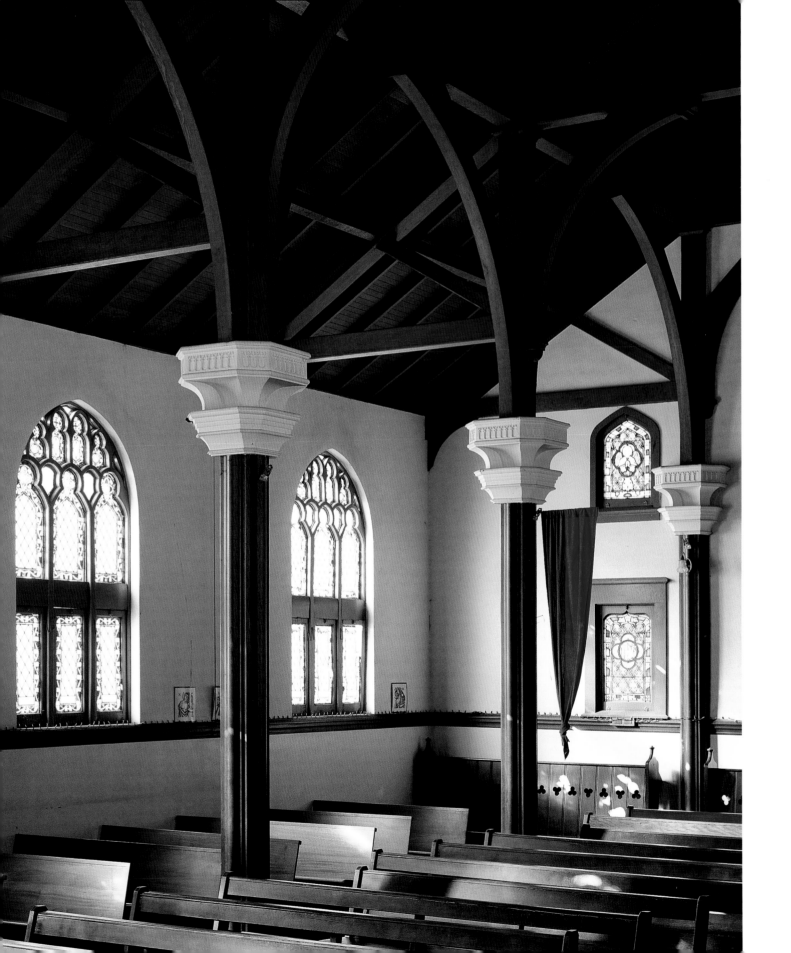

Church of the Epiphany

This church, the oldest Episcopal congregation in Los Angeles, possesses two outstanding works of southern California architecture: a chapel designed by Ernest Coxhead in 1888 and a sanctuary designed by Arthur B. Benton in 1913. The chapel is an Arts and Crafts jewel in a simplified Queen Anne manner. To complement rather than compete with it, Benton gave the neo-gothic sanctuary its low proportions and emphasized simplicity of form and straightforward detailing. On the interior, wooden arches define a central nave within the hall-like space and seem to carry the open trusses of the roof as a light burden. The theme of simplicity is carried through in the paneled chancel. Stained-glass windows are the sanctuary's chief ornament.

The church's real treasure is a historic bell, brought to the West Coast in 1855 and formerly hung in the belfry of St. Athanasius Church downtown. Brought to the Church of the Epiphany in 1886, it was repaired and rededicated in 1948.

Located in what is now a working-class neighborhood, the church is, not surprisingly, historically entwined with the modern labor movement. During the early years of his struggle to organize California's farm workers in the 1960s and 1970s, Cesar Chavez was a frequent visitor. The church's solidarity with Chavez's efforts continues to be reflected in the its ongoing ministries to the disadvantaged.

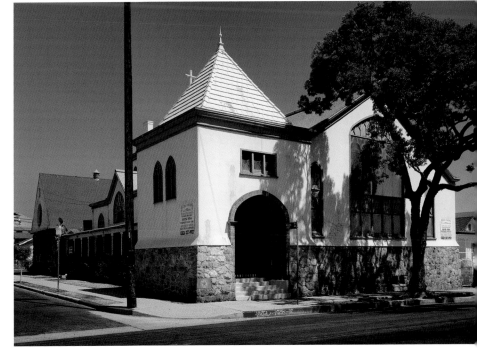

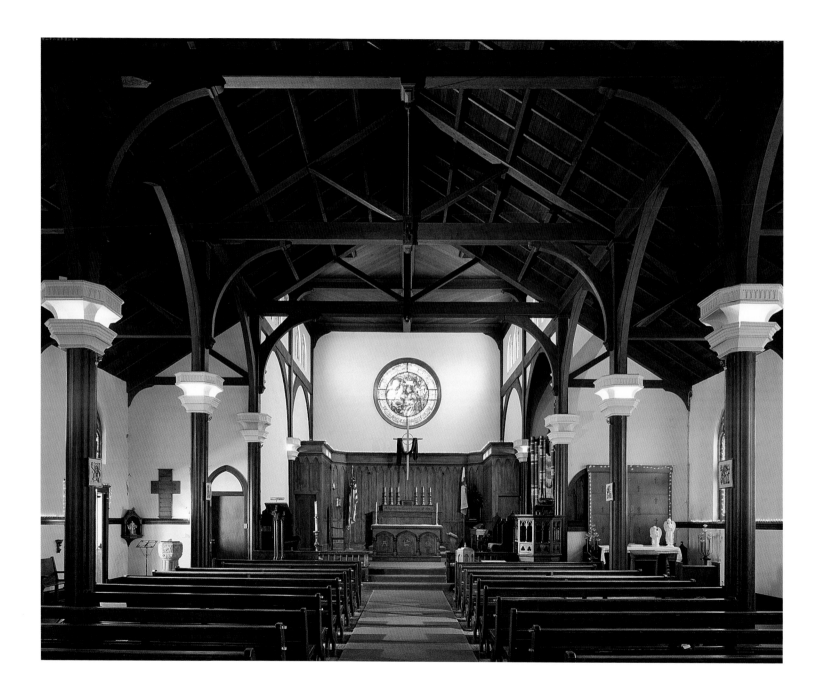

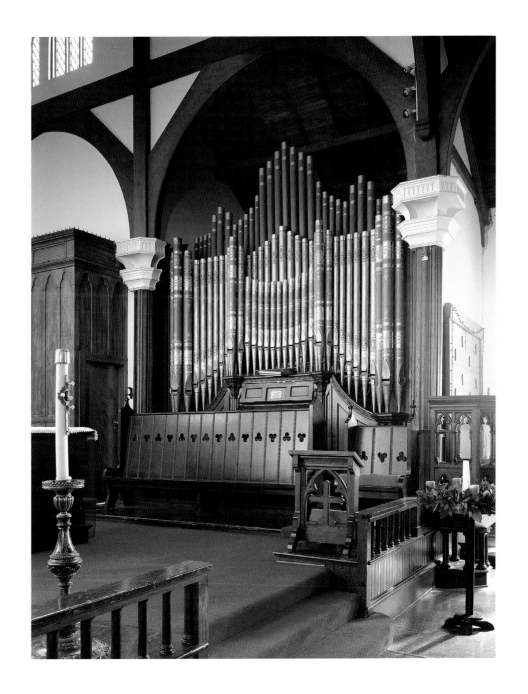

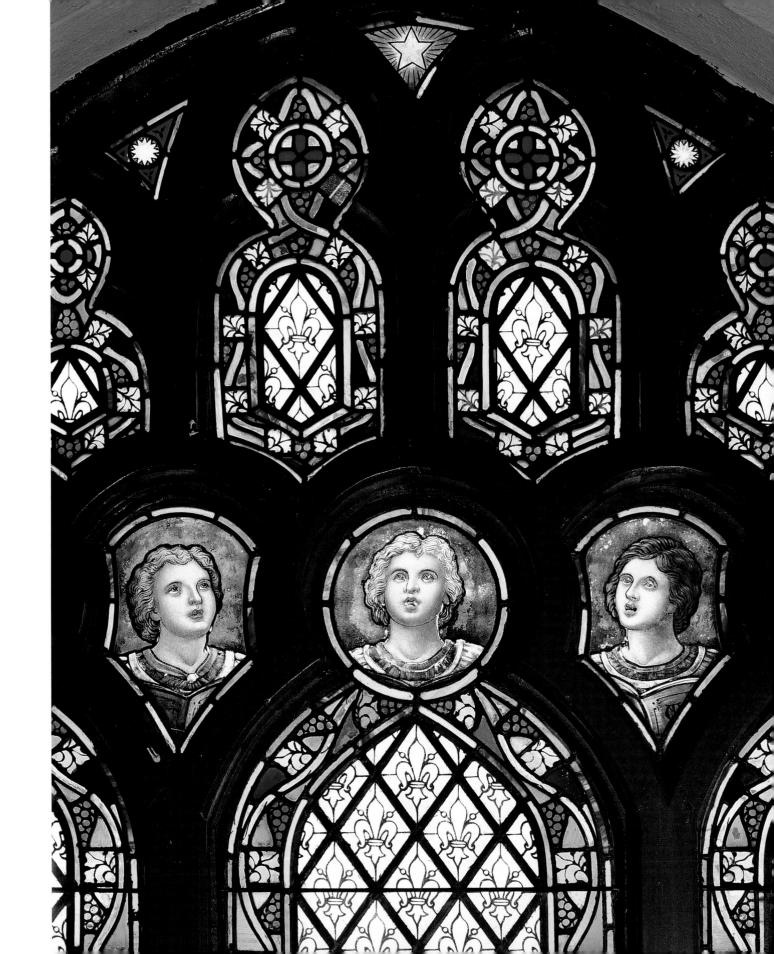

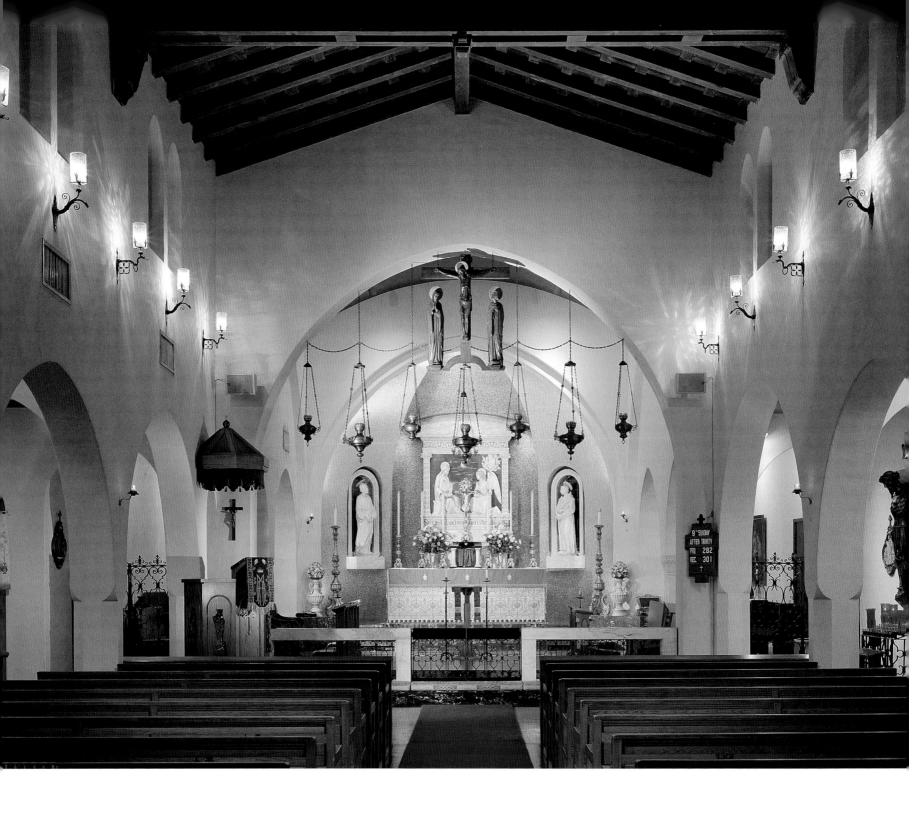

Saint Mary of the Angels

Serving an Anglo-Catholic congregation, Saint Mary of the Angels may very well be Hollywood's most famous church. When built in 1930 as a memorial to the Reverend Samuel Philp by his daughter, Florence Philp Quinn, and opened with what seemed to be all of Hollywood in attendance, it fulfilled a dream nurtured for at least a decade by its founding rector, Neal Dodd.

Dodd himself was a prominent figure in Hollywood's film world. He played a clergyman in numerous films, and eventually earned credit in 385 movies. As rector of Saint Mary of the Angels, he officiated at the weddings of some 300 motion-picture workers and stars, most memorably at that of Mary Pickford and Douglas Fairbanks (held in his office).

It was Dodd's special vocation to minister to the motion-picture community of Hollywood, and to that end, in 1918, he conceived the erection of a church to be funded by contributions from its members. Preliminary plans for such a building were made in 1920, but the realization of Dodd's dream had to wait another decade. The design as built, created by Carlton M. Winslow, Sr., was inspired by California's early mission architecture.

Hollywood's "Little Church Around the Corner" is built on an intimate, almost miniature scale. Its narrow nave, flanked by low aisles, lies beyond the narthex and is reached via a small, raised forecourt. The interior radiates a primitive English Gothic feeling, but while it is just as austere as the exterior, which is of contrasting stylistic expression, the two aspects of the building still harmonize. The apse of the chancel, lying beyond a wrought-iron screen, was originally furnished with a mural painted by Lucile Lloyd depicting the Madonna in a mandorla. In 1971, this altarpiece was replaced with the reproduction of a della Robbia terracotta – an Anunciation flanked by Saints John and Francis – that had formerly stood in the forecourt.

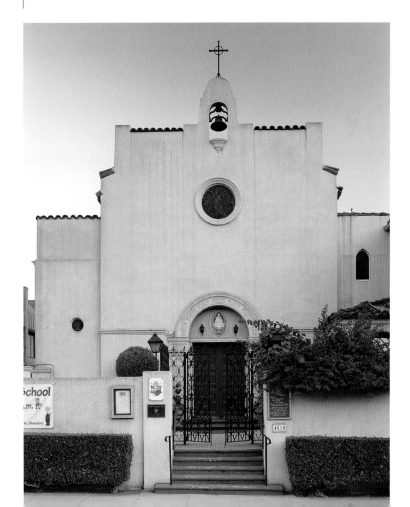

The building's stained-glass windows reflect in their iconography the dedication of the church and the English heritage of Catholicism. The clerestory windows depict English saints, while the rose window over the organ loft portrays the Coronation of the Blessed Virgin.

Beautifully conceived, carefully crafted, and filled with works of sacred art, Saint Mary of the Angels is a place of sacred mystery and devotion undiminished by the glamour of the cinema, whose history in southern California has been so closely bound up with its own.

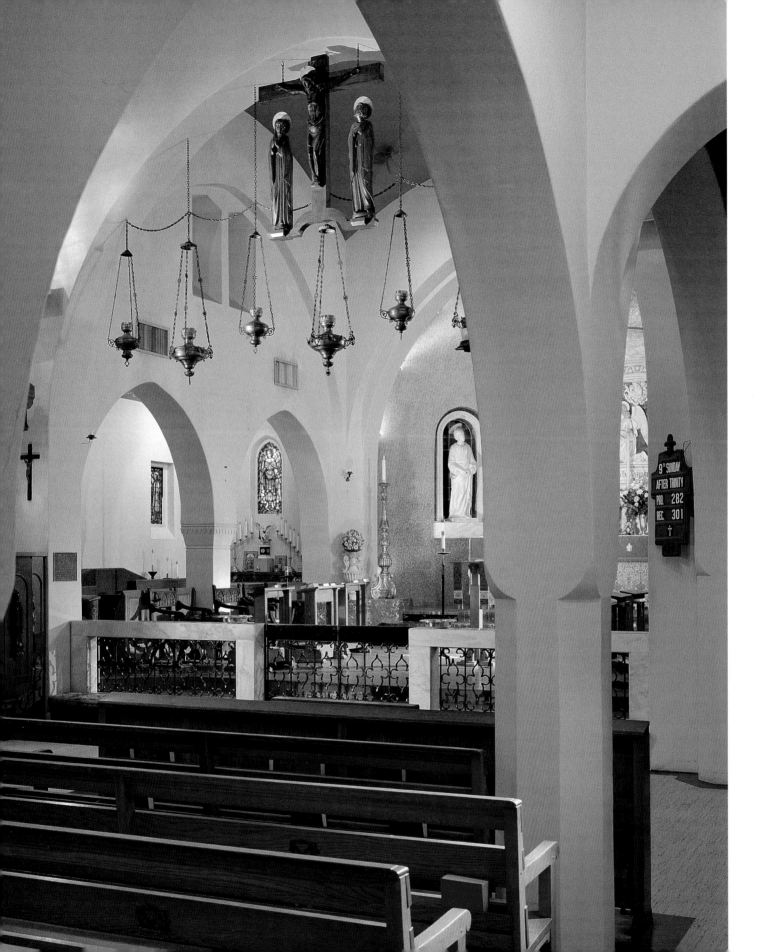

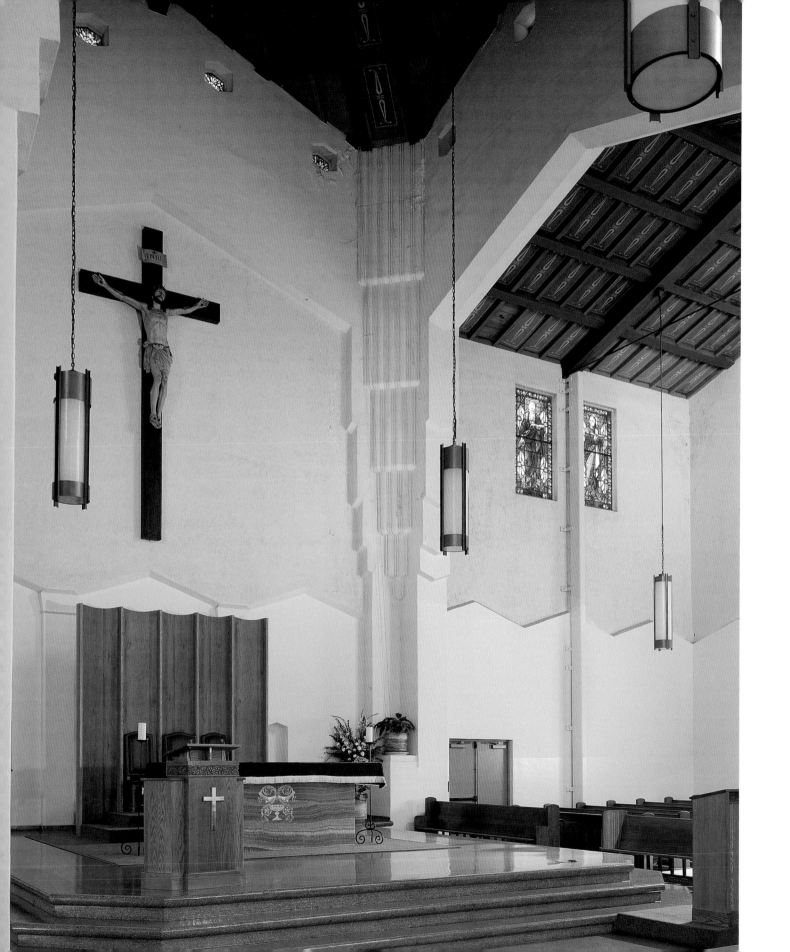

Our Lady of Lourdes

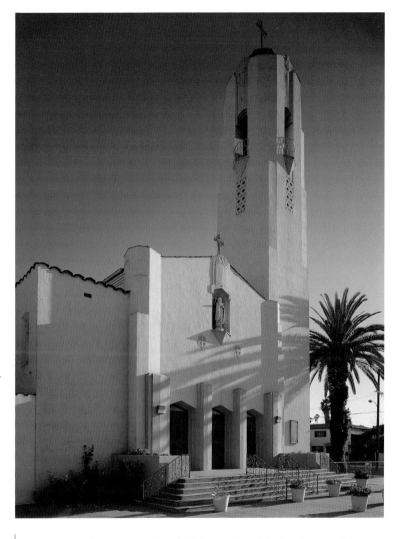

A rare example of Art Deco religious architecture in Los Angeles, Our Lady of Lourdes was built to serve a Roman Catholic parish established in 1904 primarily to serve Basque and French immigrants. Its architect, Leslie G. Scherer, is mainly remembered for his designs for exhibitions and homes. Here, however, in 1930, he designed what was one of the country's first Catholic churches of a distinctly Modern character. Completed in 1931, this reinforced concrete structure features angular ornamentation around the entrance and toward the top of the tower. The ornamental vocabulary derives ultimately from the German Expressionist architecture of the 1920s. The mass of the tower is lightened by its corners, which are cut back and chamfered as the tower rises to its full height of over one hundred feet. The church's plan follows the traditional cruciform shape, though with sacristies replacing the chancel. This innovation brings the altar out into the crossing and thus into an unusually intimate relation with the seating provided for worshippers in the nave and transepts. Over the altar, a dramatic scagliola baldachin marks the focal point of the sanctuary. Although, as a result of the plan, the entire church hints strongly of the Mission Revival, the coherent program of geometric decoration carried through on both exterior and interior relate it unmistakably to the rich heritage of the modernistic architecture of downtown Los Angeles and Wilshire Boulevard. Coverage of this church in *Architectural Forum* in 1932 indicates both how striking it appeared when completed and the national scope of the admiration it received.

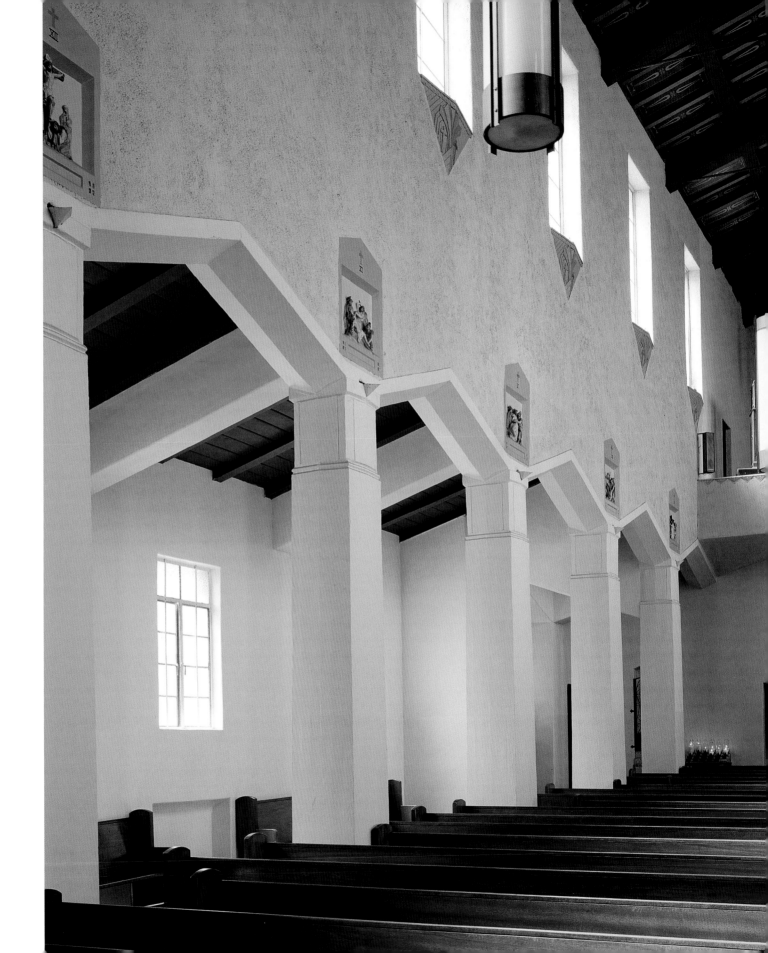

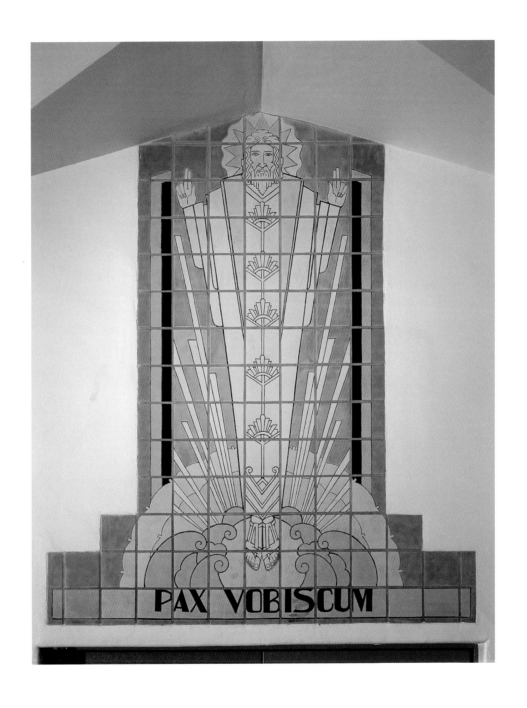

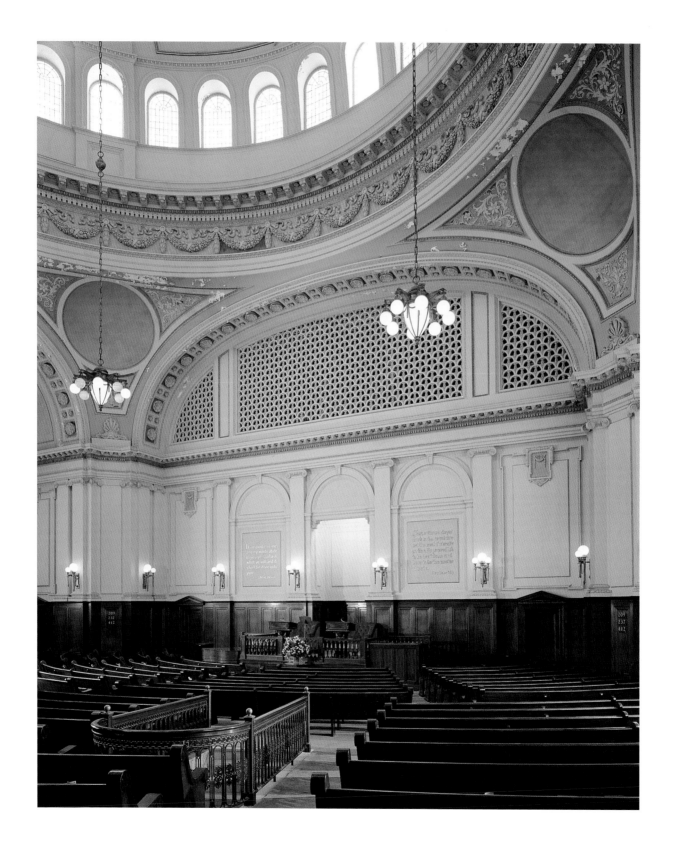

Second Church of Christ, Scientist

One of several important churches still bearing witness to the wealth and prestige of the West Adams district around the turn of the twentieth century, this church edifice is the masterpiece of architect Alfred Rosenheim. After successfully practicing architecture in his native St. Louis, Rosenheim relocated to Los Angeles in 1903 and there embarked on a second and equally distinguished career.

Arguably Los Angeles' finest example of Beaux Arts classicism, the Second Church's building was designed in 1908 and completed in 1910 in the same style used by Charles Brigham in Boston's Christian Science Mother Church Extension of 1904 - 1909. The Second Los Angeles congregation no doubt preferred that style precisely because it recalled that Boston edifice. It was frequently employed across the United States in the early 1900s for Christian Science structures.

The plan is based on a short-armed Greek cross, with the south and north arms slightly extended to accommodate readers' rooms and a hexastyle Corinthian portico, respectively. Entrance is gained through a spacious foyer on the ground floor. The sanctuary, reached by several sets of stairs, possesses an austere elegance. It features seating arranged on a slightly sloping floor in the manner of a stadium. This arrangement resulted in improved sight lines and enhanced the acoustic performance of the sanctuary space, but invited criticism from architects such as Elmer Grey because it suggested a purpose more theatrical than sacred. Below the sanctuary lies a capacious Sunday School room.

As remarkable as it is for its beautiful appearance, this building is perhaps even more notable as a work of engineering. Built of reinforced concrete, it is surmounted by a copper-clad ribbed dome roughly 70 feet in diameter. At the time it was constructed this structure was said to be the largest concrete dome in the United States and possibly the world; it still remains an impressive feature of the south Los Angeles skyline. Not only was the dome itself a feat of engineering, but so were the massive concrete girders that supported it across clear spans of some 68 feet. Albert C. Martin served as associate architect, in the capacity of structural engineer, for the design of the dome.

The classical grandeur of this church edifice made it a logical choice as the location standing in for Washington, D.C.'s Senate Office Building in the 1998 film *Bulworth*.

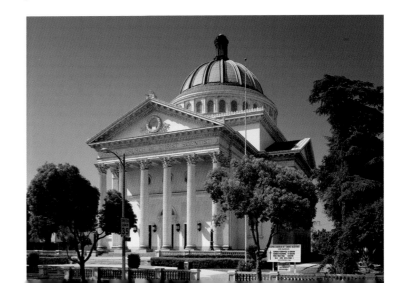

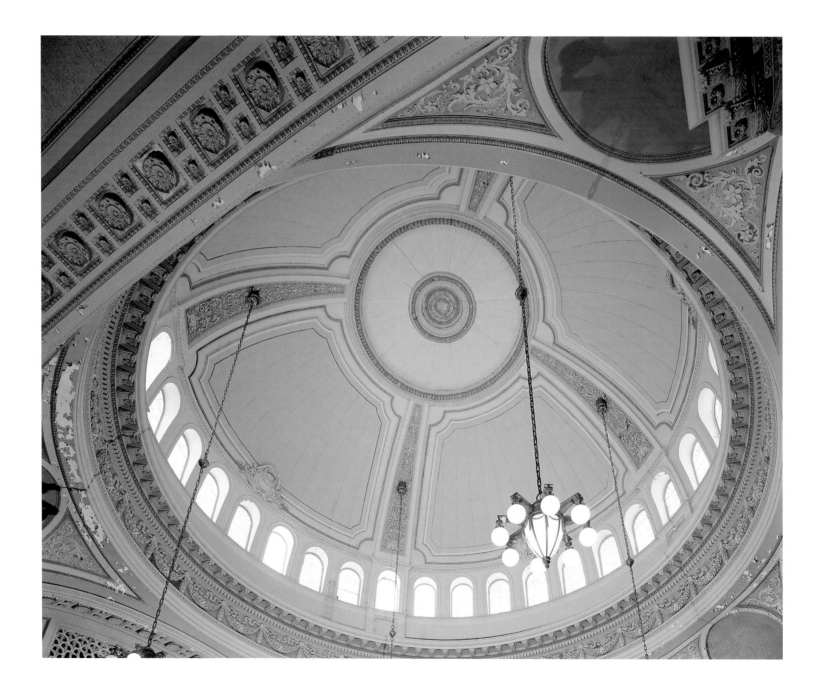

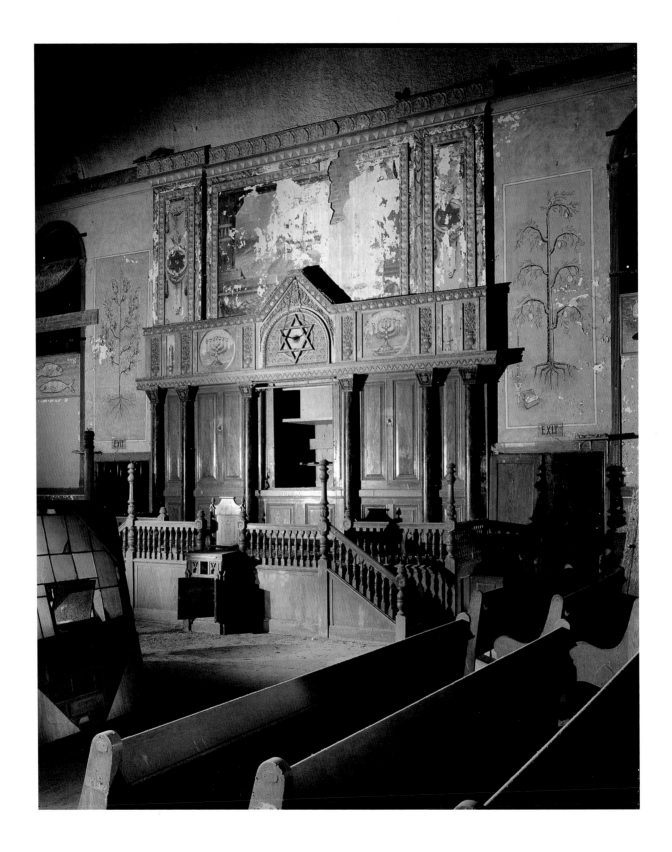

Breed Street Shul
Congregation Talmud Torah

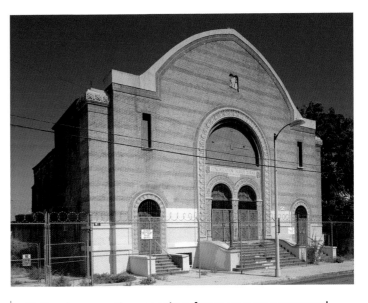

In the early twentieth century, the Breed Street Shul was one of dozens of centers of worship and cultural development serving some 75,000 mainly Eastern European Jews living in Boyle Heights and City Terrace. As that population emigrated over the years into other parts of the city, its synagogues and Hebrew schools gradually closed and disappeared, leaving the Breed Street Shul standing as the sole survivor of their kind.

The Breed Street Shul consisted of a complex of structures built over a period of fifteen years. In 1914, a school building was constructed in accordance with a design by O. M. Werner. Four years later, in 1918, the Pacific Portable Construction Company erected another, larger schoolhouse. Construction of the largest building on the site, a synagogue for the Orthodox Congregation Talmud Torah, began in the summer of 1920. Planned by the firm of Edelman & Barnett, its exterior strongly resembled that of New York City's B'nai Jeshurun synagogue completed in 1918 according to a design by W. S. Schneider and H. B. Herts. A frame addition added to the structure in 1930 by architect Max Maltzman completed the ensemble.

The synagogue proper was built of brick and, like its New York model, styled in an eclectic manner using motifs from Moorish, Romanesque, and Gothic architecture. Inside, in accordance with traditional

Orthodox practice, seating for men was arranged on the main level and that for women in a gallery. Originally intended to be finished in stone, it ended up painted in trompe-l'oeil.

Used only intermittently after suffering considerable damage in the 1987 Whittier Narrows earthquake, the Breed Street Shul was closed definitively in the mid-1990s. Exposed to the ravages of nature and vandalism, it deteriorated rapidly. Light streaming through a hole in the roof reveals peeling paint, graffiti-covered walls, a desolate bema and an empty ark. Undaunted by the challenge of reversing such a situation, the Jewish Historical Society and activists from the now predominantly Latino neighborhood have since the 1980s worked together to devise a plan for the synagogue's preservation and adaptive re-use as a community center. Supported by the J. Paul Getty Trust, these plans now seem likely to succeed.

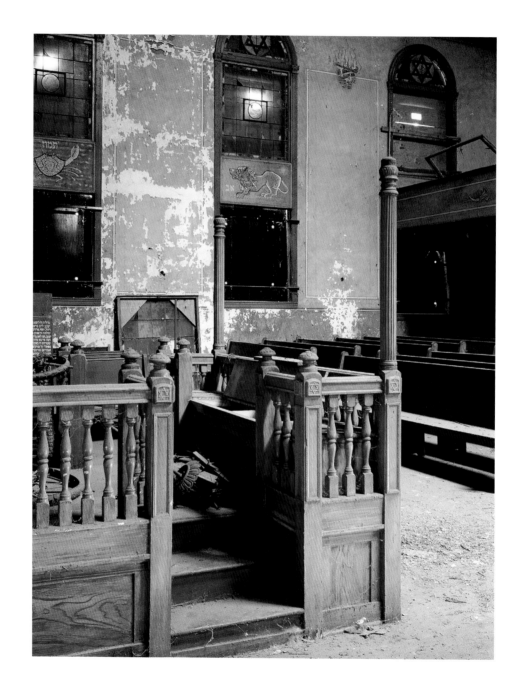

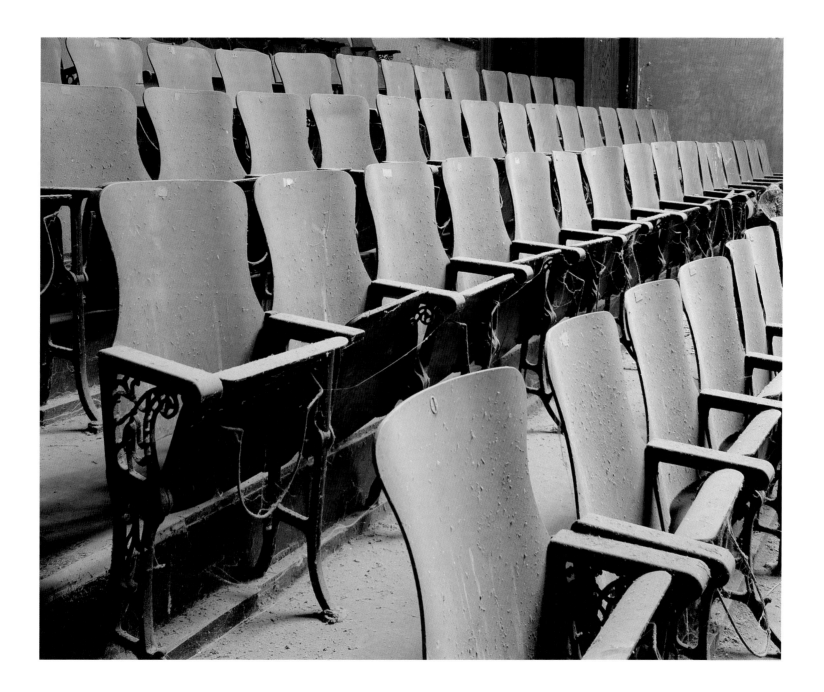

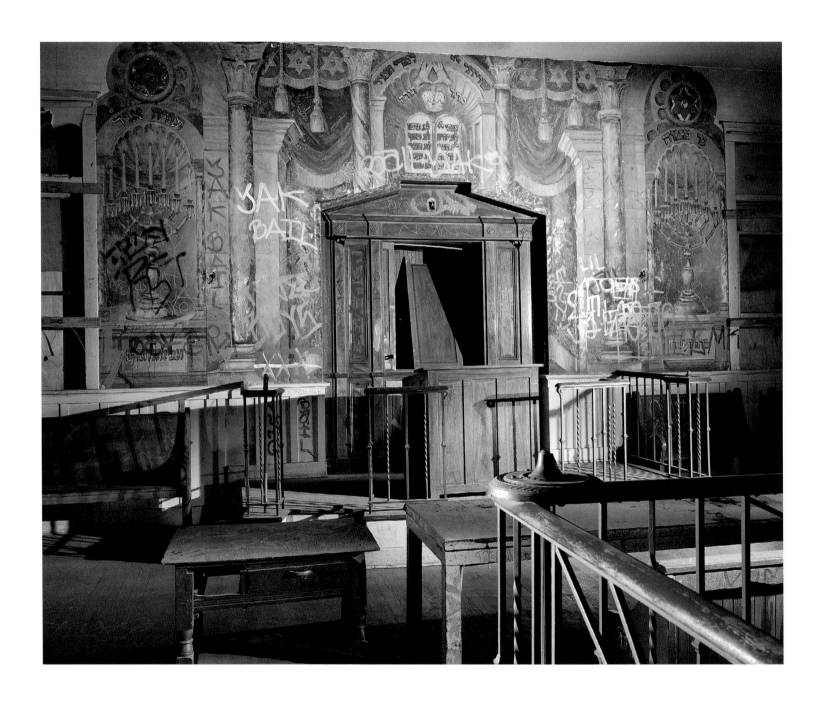

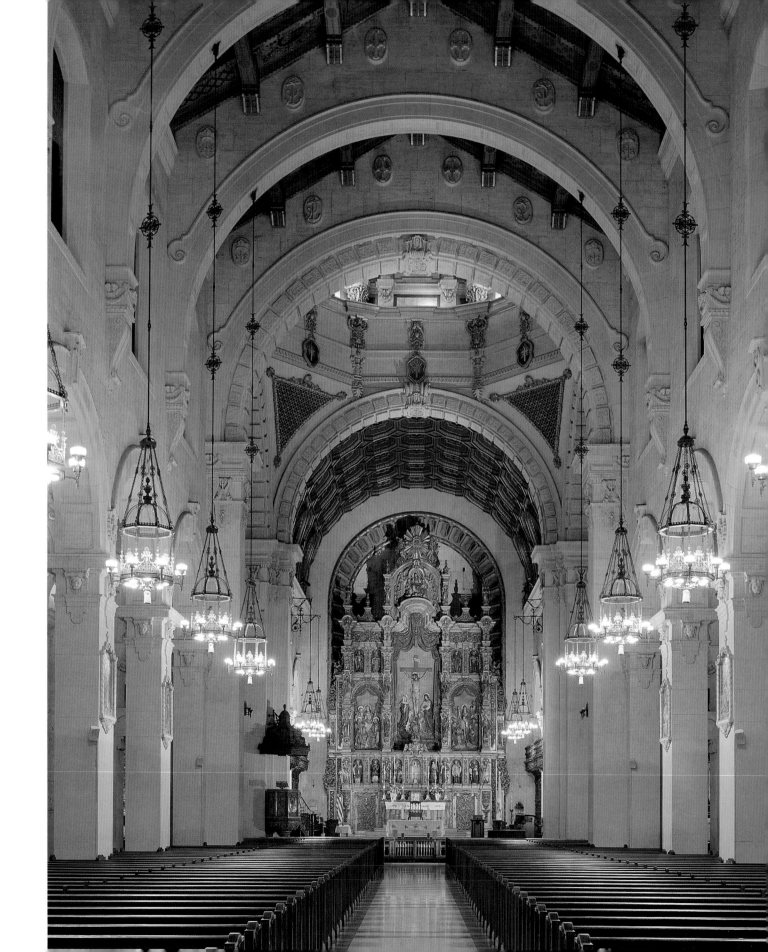

Saint Vincent de Paul

In a city replete with Spanish Colonial Revival structures of all sizes and functions, the Roman Catholic parish church of Saint Vincent de Paul perhaps ranks as the most outstanding exemplar of that style. It has been called the most beautiful parochial church and pointed out as one of the most notable Spanish Colonial Revival structures in California. Its splendor is due not only to the talents of its designers, but also (and in no small measure) to the lavish budget available for its construction and decoration. This budget was funded out of the deep pockets of oil magnate Edward L. Doheny, who resided with his devout wife, Estelle, at 8 Chester Place, just behind the church's site on the corner of South Figueroa Street and West Adams Boulevard.

The Saint Vincent's parish was founded in 1886. The first plans for a new church on the present site were announced in early 1914. Architect John T. Combes of Pittsburgh authored the proposed design. It called for a high nave flanked by low aisles, serving as a foil for a free-standing tower some 225 high. The exterior was treated in an eclectic manner suggesting Spanish architecture but combining Romanesque, Gothic, and Renaissance features.

In 1922, Albert C. Martin prepared an alternative design, one subsequently adopted in 1923. Its Spanish Colonial styling has been said to pay homage to the Dohenys' special appreciation for the 18th-century cathedral at Taxco, Mexico. In point of fact, however, its most direct predecessor was Martin's own 1921 design for the church of Our Lady of Victory in Fresno. Martin's design for Saint Vincent de Paul, as built, places the tower on the west side of the nave, almost flush with the entrance façade. The lower parts of the reinforced-concrete building are left almost unadorned, to accentuate the exhuberant ornamentation of the façade, the upper stories of the tower, and the colorfully tiled dome over the crossing.

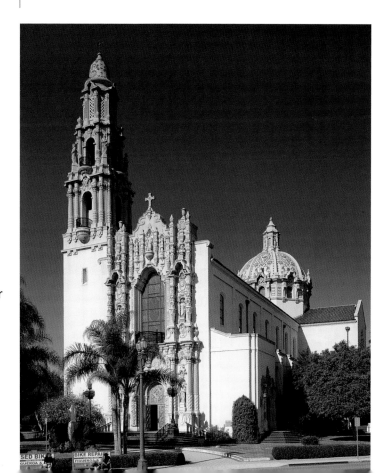

The light-filled interior features an exceptionally long and relatively wide nave flanked by narrow aisles. Over the crossing, an inspiring dome rises high on pendentives. At the far end of the spacious chancel, a monumental altar with its reredos reaching almost to the ceiling was given by the Doheny's in 1930, the year of the church's consecration, as a memorial to their son, Edward L. Doheny, Jr. ("Ned" Doheny, had been murdered the year before at Greystone, his recently completed Beverly Hills mansion.) At the same time, the Dohenys funded an entire program of interior embellishment designed by America's leading church architects, the Boston-based firm of Cram & Ferguson. Local supervision of this decorative work was by architect Samuel E. Lunden. The variously colored marbles, fine woods, bronze, gold leaf, polychromatic painting, and stained glass — all crafted to the highest standards — combined to produce an effect of richness and iconographic cohesion all but unparalleled in southern California's religious architecture. St. Vincent de Paul church has stained glass windows done by Bertram Goodhue's nephew, Harry Wright Goodhue. The face of the figure of Saint Edward the Confessor in the reredos of the main altar reproduces the likeness of Edward Doheny. This detail marks this building as a monument to his own temporal power in the worlds of finance and politics even as it glorifies a less temporal and divine one.

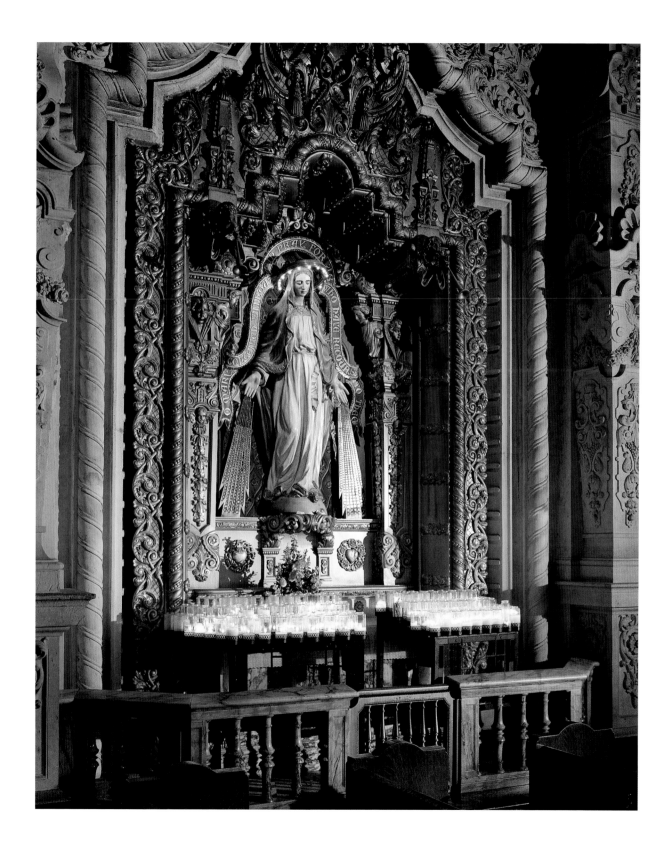

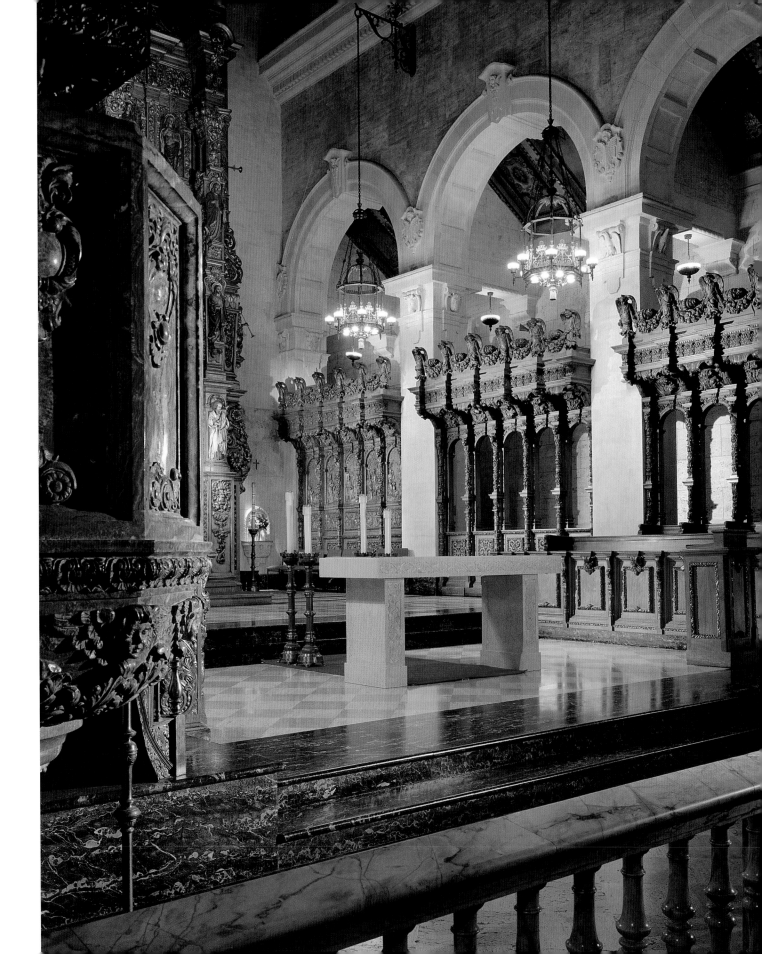

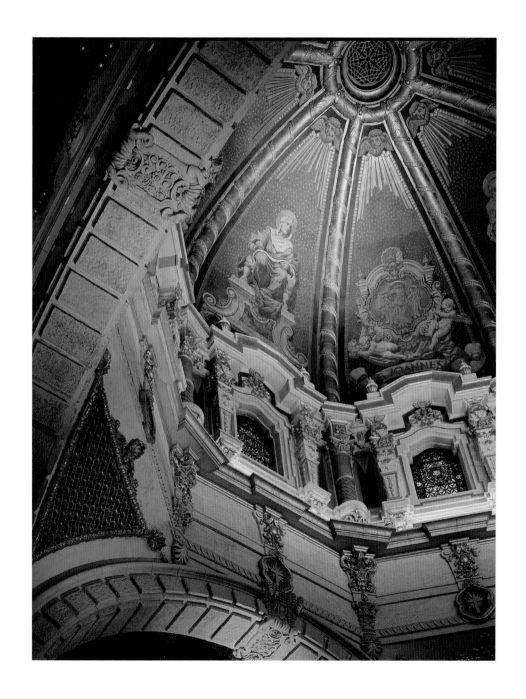

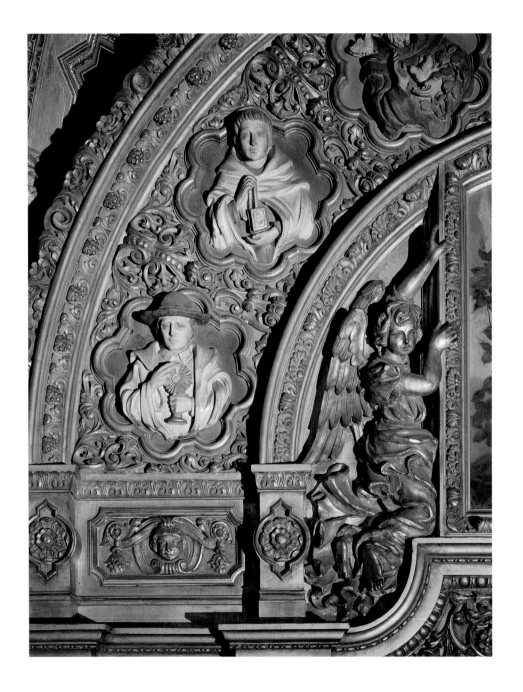

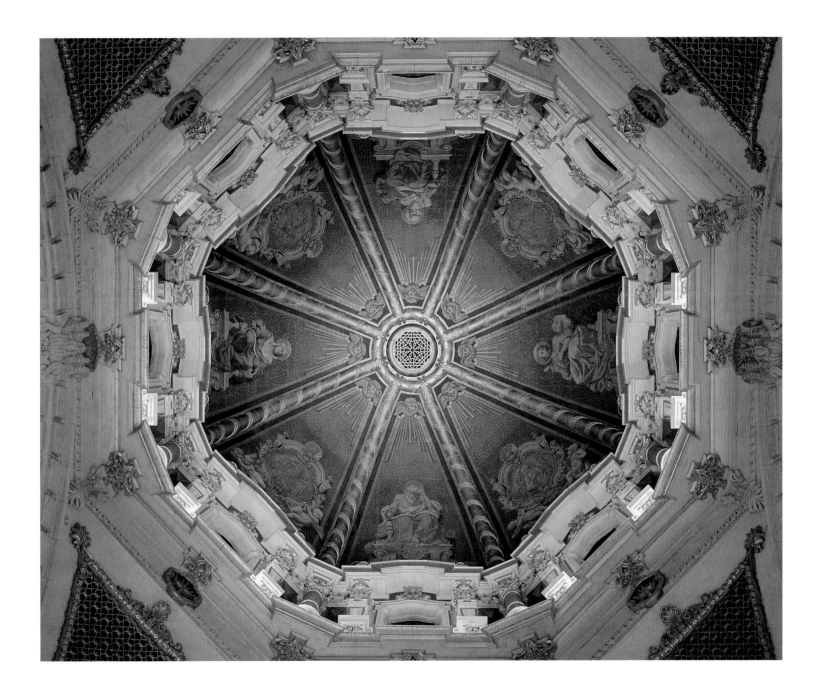

Good Shepherd Catholic Church

Just as construction on this basilican church was about to begin in late 1924, its architect was killed in an automobile accident. It thus may be considered a kind of memorial to J.J. Donnellan and his brief activity in southern California after practicing earlier in Chicago and San Francisco. It was dedicated upon completion in 1925.

With its twin towers rising in stages to culminate in open belfries with domes above, the church of the Good Shepherd is one of the most monumental of the many Mission-style churches in Los Angeles. Despite the qualities of its architecture, however, this church has never been famous primarily as a work of design. Instead, it has become best know for its associations with the movie world.

Hollywood celebrities have counted prominently among the parishioners at Good Shepherd since the very establishment of the parish in 1923. The long list of them runs from Rudolph Valentino to Gary Cooper and Bing Crosby. When the first services were held in the church on Christmas Day 1924, those in attendance found themselves sitting on pews given by silent-screen actor Ben Turpin, listening to music played on an organ given by actress May McAvoy, and worshipping before one of three altars donated by Jack Coogan.

The church has been the scene of numerous Hollywood funerals, including those of Gary Cooper, Rita Hayworth, Danny Thomas, Eva Gabor, and Frank Sinatra. It was the location used filming the tragic funeral scene in the 1954 version of *A Star Is Born*, with Judy Garland

Celebrities married here have included Loretta Young and Rod Stewart. But the 1950 wedding of Elizabeth Taylor to Nicky Hilton eclipsed any other event ever held at Good Shepherd in both glamour and controversy. The event itself was orchestrated by Taylor's studio, MGM, no doubt motivated by its possibilities for promoting their star's upcoming release, *Father of the Bride*. With the church packed with invited guests from the Hollywood elite, thousands of fans stood outside to witness the ceremony. At the close of the ceremony, the newlyweds indulged in a long kiss before the altar rail, then embraced a second time, with at least equal passion, at the door of the church as they left for a dazzling reception at the Bel Air County Club.

Saint James Episcopal Church

This church, completed in 1925, is one numerous structures that bear witness to the rapid growth of the Diocese of Los Angeles during the 1920s and the accompanying building boom. Its design, a rare example of Flemish Gothic Revival in American architecture, is usually credited to San Francisco architect Benjamin McDougall. However, a drawing of its interior published in a 1925 fundraising brochure bears the signatures of both McDougall and Edward A. Eames as associate.

The design of Saint James was probably inspired by that of the Beezer Brothers' Church of Saint Dominic in San Francisco, built between 1923 and 1928. The churches differ significantly in their detailing, which is simplified in the Los Angeles edifice. In both cases, the tower recalls that of the cathedral in Antwerp, Belgium. Saint James is built of reinforced concrete, a structural system in which McDougall had special expertise. Although many of Los Angeles' reinforced concrete churches of the 1920s frankly expressed the nature of that material by revealing the traces of the formwork used in constructing them, here the outer surface of the concrete has been covered with a smooth layer of stucco.

The interior features low aisles and high clerestory windows filled with richly colored glass by Judson Studios. As the windows of Saint James were installed over a long period from 1928 through the 1990s, they provide a remarkably compact overview of the history of Judson's production over most of the twentieth century. The verticality of the nave walls is accentuated by a lofty hammer-beam roof structure of redwood members.

The nave of Saint James provided a glorious yet intimate setting for the funeral of Nat King Cole, held there in 1965. The televised event was crowded with celebrities, including Frank Sinatra, Cab Calloway, Duke Ellington, George Burns and Senator Robert Kennedy.

Thirteenth Church of Christ, Scientist

This large reinforced concrete church edifice, completed in 1930 by Allison & Allison, seats 1,200 people. It is approached via a series of stepped terraces in a beautifully landscaped garden forecourt. Like the slightly later First Unitarian Church by the same architects, this one was designed in an austere, classical manner with motifs derived from the early Italian Renaissance. As does that church, this one features a tall, narrow tower crowned with four obelisks above an open belfry. Terminating in an octagonal spire, the tower uncannily resembles a minaret and so gives the church something of a Moorish air when seen from a distance in silhouette against the Hollywood hills.

The arcade of a graceful loggia, supported on slender Ionic columns, runs across the front of the building. Inside, because of the shallow depth of the lot, both the foyer and the auditorium are set with their long axes parallel with Edgemont Street. Theater-style seating in the auditorium, arranged beneath a coffered ceiling, has an intimate feeling despite its size as a result of the unusual orientation. Decoration is limited by practicality to the ceiling and the carved oak screen of the organ chamber, positioned as a backdrop to the speakers' platform.

The building is now the home of the Full Gospel Los Angeles Church, a Korean-American congregation. It is Los Angeles Historic-Cultural Monument Number 559.

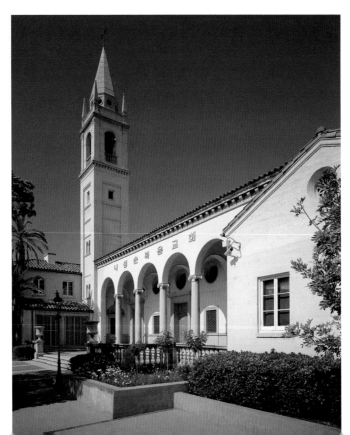

Vedanta Temple

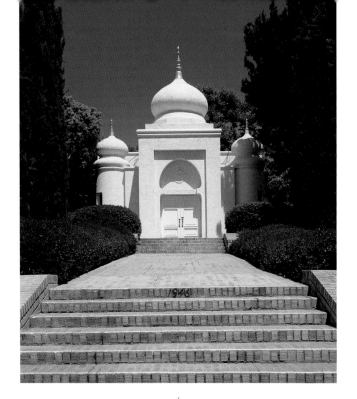

A universalizing religious philosophy grounded in the basic principles of Hinduism, Vedanta was brought to America by Swami Vivekananda, one of the best-remembered speakers at the World Parliament of Religions in Chicago in 1893. Vivekananda brought Vedanta to southern California during a six-week stay with the Mead sisters in South Pasadena in 1900.

In 1930, a small but growing number of Vedantists in Los Angeles began meeting in the home of Carrie Mead Wyckoff. This property, at 1946 Ivar Avenue, later became known as Vedanta Place. In 1933, a shrine room was added to Mrs. Wyckoff's residence (renamed Vivekananda House), and in 1934, the Vedanta Society was incorporated. A growing membership in the mid-1930s made it possible to erect a temple a few years later.

The foundation stone of this temple was laid on January 22, 1938, the birthday of Swami Vivekananda.

Private dedication services on July 7 and public ceremonies on July 10 marked the opening of the temple in the summer of that year. Reflecting Vedanta's origins in Indian culture, the temple's exterior was designed to recall Mughal architecture.

With three bulbous domes, the white stucco temple can give the impression of being a miniature Taj Mahal, but its actual inspiration was the Golden Temple of Benares. The interior includes an auditorium for lectures and a shrine room reserved for meditation and ritual worship.

Gerald Heard, Christopher Isherwood and Aldous Huxley began attending lectures of the Vedanta Society in the late 1930s. The involvement of still other writers, such as John van Druten, assured a permanent association of the white-domed temple overlooking Hollywood with the city's mid-twentieth century literary achievements.

Krotona Inn

Now used as apartments, the Krotona Inn was completed by the San Diego partnership of Mead & Requa in the spring of 1913. It originally housed students of the Krotona Institute of Theosophy, and as such stood as the principal building of one of California's three important early twentieth-century Theosophical colonies in California. Its denizens included Marie Russak (Theosophical lecturer and the future astrologer of John Barrymore) and Judge Carlos Hardy (later impeached after his involvement in the trial of Aimee Semple McPherson in 1927). In a series of buildings scattered among citrus groves on the slopes of the Hollywood Hills above Franklin Avenue, Krotona flourished from 1912 to 1926 before moving to Ojai as the increasing suburban development of its environs compromised the original tranquility of the place.

The Krotona Inn included a number of bedrooms for guests, a lecture hall, a vegetarian restaurant and an apartment for the Krotona colony's founder, Alfred P. Warrington. The bedrooms all opened onto a courtyard, in which the quiet, communal atmosphere of the contemplative life at Krotona can still be sensed. Overlooking this courtyard and its central pool, a sort of kiosk — the Esoteric Room — was entered from the Inn's flat roof. Designed in a Moorish style, the domed Esoteric Room contained little besides a shrine-like cabinet and served the Krotonians as a place of group meditation.

Both Mead and Requa had been associated with Irving Gill prior to their partnership. Not surprisingly, therefore, the severely plain architecture and simple geometry of the Krotona Inn suggests affinities with the proto-modern architecture for which Gill became famous. It is also explained, however, by Mead's personal familiarity with the traditional architecture of North Africa, which he may have in fact been responsible for introducing to Gill. The choice of Moorish elements for the embellishment of the Esoteric Room may have been intended to echo the blending of eastern and western ideas in the belief system of modern Theosophy.

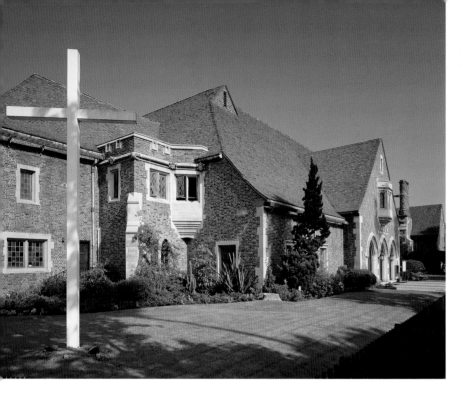

Ninth Church of Christ, Scientist

Built to replace the congregation's former facility a few blocks away on New Hampshire Street, this Tudor revival building offers a rare example of a Christian Science church edifice in that style. Christian Science congregations typically prefer neoclassical architecture. Here, the design-build firm, Meyer & Holler, which was soon to create the fanciful Grauman's Chinese Theatre on Hollywood Boulevard, created an equally fanciful, equally theatrical evocation of such English monuments as Hampton Court Palace or Compton Wynyates, albeit for a decidedly less secular purpose.

The designers spent an unusually long time — more than six months in 1923 and 1924 — studying the design and ornamentation of what would eventually look more like a country house than a church building, as well as the acoustics of its main interior spaces. The picturesque massing and meticulous craftsmanship of the brick and stone structure somewhat disguise its actual bulk, which is sufficient to include an auditorium seating 1,250 people and a Sunday School room accommodating 800 more. Intending it to be one of the most distinctive religious buildings in the United States, its builders doubtless achieved their goal.

A year before moving into new quarters in the Equitable Building on Wilshire Boulevard in 1997, the Ninth Church of Christ, Scientist sold its building to the Korean-American Great Vision Church.

Our Lady Queen of Angels

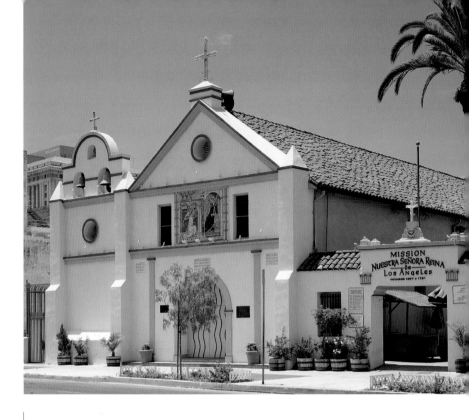

Erected as a chapel of the San Gabriel Mission, this church, whose Spanish name is homonymous with that of the city it was established to serve, stands as both an integral part of Los Angeles and its most enduring symbol. It represents the Hispanic heritage of Los Angeles while serving an increasingly diverse population and bearing witness to the durability of memory over long periods of great historical change.

This "Plaza Church" is the oldest extant religious edifice in central Los Angeles, but it is not the first church built in the settlement, nor does it retain its original form. The first church on the plaza, a presumably adobe structure, was begun about 1784-86 and completed about three years later. Following a flood in 1815, the plaza was relocated and, between 1818 and 1822, a new church, also adobe, was built to face it. On its entrance facade, a modestly curved pediment surmounted by a small belfry lent a modicum of ornamental distinction to what was an otherwise severely plain building. The edifice became a parish church in 1826 and a pro-cathedral in 1859 when Thaddeus Amat, Bishop of Monterey, transferred his residence to Los Angeles. The relics of Saint Vibiana reposed here from 1868 until their translation in the mid-1870s to the new cathedral erected under her patronage.

The increasing prestige of the Plaza Church in the mid-nineteenth century led to a series of major modifications to its fabric. The year 1861 saw the erection of a new facade with a triangular pediment replacing the scrolled gable, this time in red brick. The next addition, about 1869-71, was a bell tower consisting of a squat base surmounted by a delicate openwork belfry in wood.

In 1912, the church was greatly enlarged. In an apparent effort to enhance the Spanish look of the church, the customs of whose parishioners remained strongly rooted in Hispanic traditions, the Victorian belfry was eliminated in favor of a masonry structure in the Mission Revival style. A further westward expansion of the nave was undertaken in 1931 and finished in 1933.

Structural problems apparent by the mid-1950s required a thorough restoration of the Plaza Church in order to assure its survival. Its historical importance, together with the fact that so little actually remained by then of its earliest substance or even appearance, made the plans inevitably controversial. As completed in 1965, the restoration retained the early-twentieth-century form of the church's exterior while dividing the nave into two back-to-back halls with the reconstruction of the original west wall. What was the original nave is now known as the Chapel of Perpetual Adoration of the Blessed Sacrament. Accommodating a devotional practice begun in 1939, it has a tiled floor and painted wooden ceiling. Pilasters divide its sidewalls into regular bays pierced by tiny high windows and its shallow apse contains an altar and gilded reredos in the Spanish Renaissance style. The room's proportions and decoration have been calculated to produce the effect of the sort of small church of the late Spanish Colonial period in California of which the Plaza church was an excellent example.

In 1981, a mosaic depicting the Annunciation was placed over the entrance from Main Street to commemorate the bicentennial of the founding of Los Angeles. For more than two centuries now, Our Lady Queen of the Angels has provided the backdrop for notable events (such as the elaborate funeral service in 1938 of Los Angeles pioneer and state senator Reginaldo Francisco del Valle). It has meanwhile provided a popular focal point for Catholic worship in Los Angeles. The church is especially attractive to Latinos, who have dubbed it "La Placita" and who throng to it today as in yesteryear not only for services but for private prayer as well.

Wilshire Boulevard Christian Church

Wilshire Boulevard Christian Church was the first church to be located on Wilshire Boulevard. After outgrowing its unusual 1911 building designed by W. C. Harris (that combined the effects of both bungalow and castle architecture), the congregation in 1925 undertook construction of its new facility. The first design prepared by architect Robert Orr called for an English Gothic Revival structure. This proposal was rejected in favor of an alternative inspired by the forms of Early Christian and Byzantine architecture.

The building's unusual siting, with its main entrance facing a side street rather than Wilshire Boulevard, permitted a traditional orientation of the chancel toward the east but also the placement of its tower in a position of maximum visibility from downtown Los Angeles. Rising as an almost sheer shaft from a square base to support an octagonal belfry, the tower would have played an increasingly important advertising function for the church as the population of Los Angeles shifted westward in the 1920s and Wilshire Boulevard developed into a major traffic artery. The picturesque massing of the long facade on Wilshire Boulevard is another device designed to make the church stand out from its urban background when viewed from a passing automobile.

Although the exterior suggests a basilican plan, the interior is almost square. Its theater-style seating in concentric rows extends outward to fill apses that extend to the south and north on a secondary axis perpendicular to that running from the narthex to the pulpit. A large balcony, also furnished with curving pews, surrounds the sanctuary on three sides. The medieval atmosphere cast by the colored light streaming in through windows by the Judson Studio somewhat mitigates the modern effect of these seating arrangements. The east end of the sanctuary, with a tabernacle-like baptistery as its focal point behind the dais and choir loft, is filled with a dramatic arrangement of organ pipes.

Now serving the congregation known as the Wilshire Christian Church, the building is Los Angeles Historic-Cultural Monument Number 209.

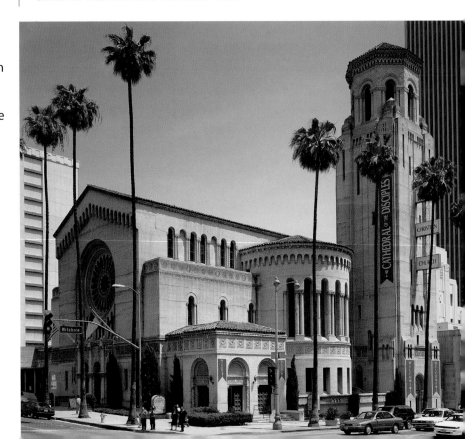

Emanuel Danish
Evangelical Lutheran Church
Victory Christian Center

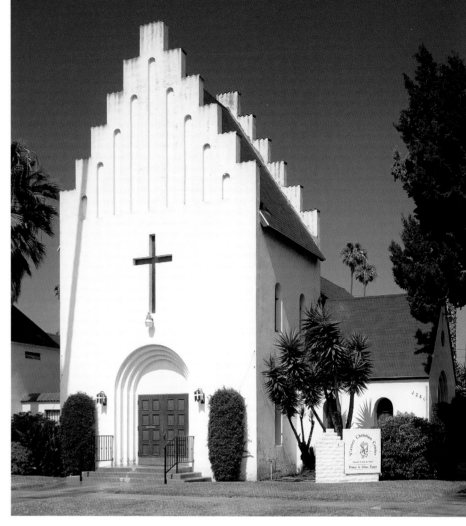

Danish-born Edith Northman, one of the few women architects practicing in Los Angeles before World War II, designed this unusual church in 1937 in the spirit of the traditional village churches of Denmark. Northman received the commission for this project after a 1936 Mission design by Rainer Nielson had been rejected by the congregation on the grounds of its stylistic irrelevance to the Danish immigrant experience. Members of the congregation participated directly in its construction in 1941. It functioned not only as a place of worship but effectively also as a Danish-American cultural center.

The distinctive feature of the church's stuccoed frame structure is a low tower at the front, topped with a crow-stepped gable. The interior, intended to seat only 170 worshippers and originally containing chancel furniture designed by Northman, is austere.

As the epicenter of southern California's Danish-American population shifted toward the southeast, the location of this church became increasingly inconvenient. Its design is echoed in the new Danish Church in Yorba Linda, completed in 1995 to plans by architect Ebbe Videriksen. No longer the property of a Danish Lutheran congregation, the building designed by Northman is now occupied by the Victory Christian Center. It is Los Angeles Historic-Cultural Monument 578.

Nishi Hongwanji Buddhist Temple

Now an integral part of the Japanese American National Museum, this former temple ranks as the premier historical monument of Little Tokyo. It was erected to serve the needs of three Japanese Buddhist congregations that merged in 1917. Its designation as a Nishi (or Hongpa) Hongwanji temple indicates that it serves one of ten sub-denominations of the Jodo Shinsu school of Buddhism.

After occupying leased quarters in the Yamoto Hall and at other temporary locations for several years, the temple's congregation began construction of its new building in February 1925. Edgar H. Kline provided the architectural design, which called for a row of several rental stores on the First Street side of a triangular site. Treated in a straightforward commercial manner, this elevation gives no hint of the religious function of the structure. That function is evident only from the entrance side facing Central Avenue (now the museum's plaza). This slightly asymmetrical, tripartite elevation is subtly polychromatic, with terracotta details in ochre, turquoise, red and sky blue playing off against the background of buff brick. There is little fenestration, betraying the importance of the building's interior space and the relative insignificance of its external form. The Central Avenue elevation is nonetheless monumental, with its massive Japanese-style entrance and

a row of pilasters, surrounded by lotus capitals, carrying a molded cavetto cornice.

Inside, the temple proper was designed to be an austerely simple space focused on the altar and graced by eight mural paintings depicting the life of the Buddha. As a concession to Western customs, pews were included in the room's planned appointments. Other interior spaces included offices and dwellings for the resident monks.

In 1926, soon after completion, the temple held funeral services for the Japanese emperor Taisho. In 1931, it was elevated to the status of Betsuin (literally a "branch temple" and in Japan one headed by a Lord Abbot), indicating honorifically its large size and its ability to assist with the foundation or support of smaller temples nearby. The Nishi Hongwanji Temple had the melancholy function during World War II of warehousing the possessions of Japanese-Americans held in internment camps. Threatened by urban renewal in the 1960s, the temple erected a new structure further to the east and abandoned its venerable headquarters on Central Avenue. Efforts to save the building succeeded in the late 1980s with its incorporation into the present museum complex. Renovation was supervised by a team of four Japanese-American architects (David Kikuchi, Yosh Nishimoto, Frank Sada and Robert Uyeda) and presentation consultant James T. McElwain.

First Baptist

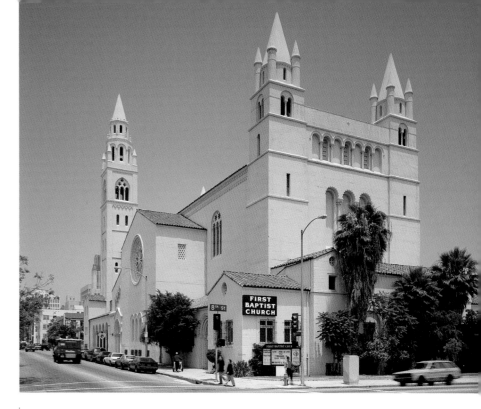

Allison & Allison designed this sprawling complex of reinforced concrete buildings that includes a sanctuary that accommodates nearly 2,000 worshippers in theater-style seats, a chapel seating 300 and a social hall seating 500, as well as vast facilities for Sunday School and administration. The eclectic styling mixes motifs of late Gothic and early Italian Renaissance architecture, while suggesting those of some other periods as well. Numerous towers and turrets punctuate the church's picturesque skyline; the highest of the towers, on the northwest corner, rises to a height of 153 feet.

The bulkiness and rather schematic quality of the exterior make this church somewhat reminiscent of the Mission Inn in Riverside. The tower of the nearby Bullocks Wilshire department store provides a foil for its spires, suggesting contrasts of modernity with tradition, as well as of secular materialism with Christian spirituality.

The interior of the sanctuary features a coffered ceiling said to imitate one in Mantua's ducal palace. The long vista down the center aisle focuses on the pulpit and, behind it, a choir loft rising in concentric rings of stalls to a baptistery designed for the total immersion required in Baptist practice. The baptistery is treated as a pedimented aedicule recalling the Italian Romanesque in its forms. An arcaded screen forms the western end of the sanctuary and screens the chamber holding the pipes of its 88-rank organ, which number over 5,000.

Prominent Los Angeles contractor Weymouth Crowell served as the church's treasurer and a member of its board of trustees. The Weymouth Crowell Company built the edifice, which, alongside the Los Angeles Central Public Library and the Ambassador Hotel, was among its most notable projects.

First Church of Christ, Scientist
Central Spanish Seventh-Day Adventist

This gray brick structure, completed in 1912, embodies the design principles advocated by one of the great theoreticians of Christian Science architecture, Elmer Grey. A Pasadena architect, Grey was as concerned with the functional performance of Christian Science churches as with their stylistic expression.

Grey's plan maximizes the use of an oval-shaped site placing the entrance at the site's most prominent corner. The mass of the building is rectangular in plan, extended by apses on its long sides and by a polygonal annex at the end opposite the entrance. A semicircular porch provides an outdoor extension of the generous entrance foyer just inside. The arrangement of seating on the auditorium's raked floor to optimizes sight lines. Fine acoustics in the auditorium were assured by Grey's consultation of Harvard's Professor Wallace Sabine, the founder of the science of architectural acoustics.

Grey's choice of the Italian Romanesque style called attention to the similarity of the Italian climate to that of Southern California and gave it an arguably appropriate local character.

This building later became the People's Temple Christian Church, and today is The Central Spanish Seventh-Day Adventist Church. It is Los Angeles Historic-Cultural Monument Number 89.

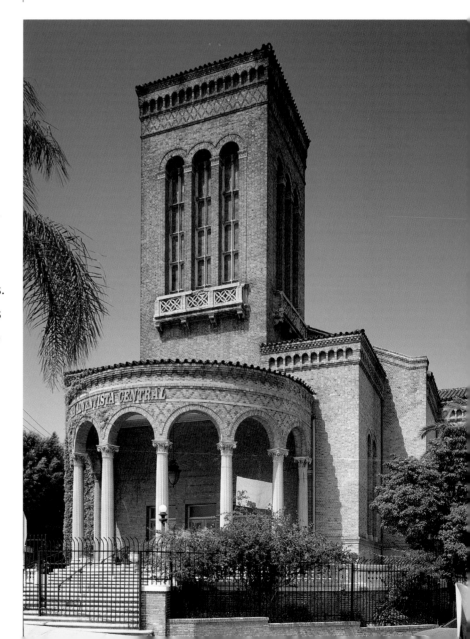

Holy Cross Catholic Church

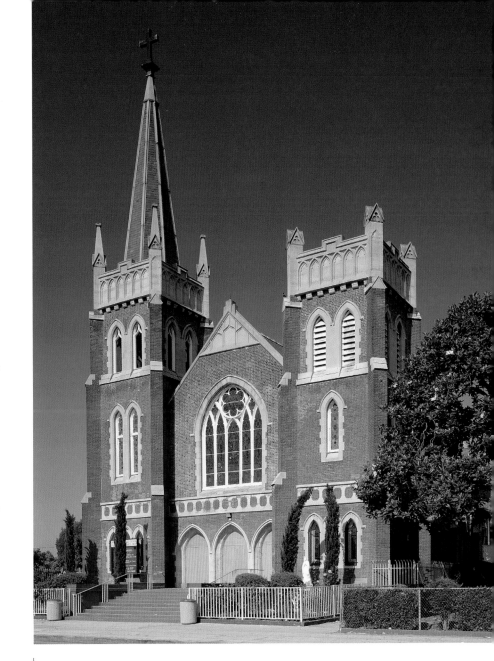

A temporary church building was erected in 1907 to serve a parish established the year before. In 1912, a permanent building, still in use today, was erected according to a design by Albert C. Martin. It was dedicated on Thanksgiving Day 1913.

The neo-Gothic sanctuary, built of red brick over a cruciform ground plan, features asymmetrical towers flanking its triple entrance. The taller tower, on the southeast corner of the building, carries a spire. Stained-glass windows light the interior, which is dominated by a monumental painted altarpiece reproducing the painting Crucifixion, by nineteenth-century Hungarian artist Mihaly Munkácsy.

Pilgrim Congregational Church

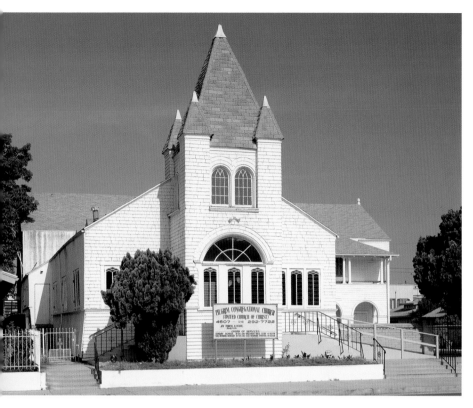

This modest frame building is a good example of an early-twentieth-century suburban church. When completed in 1910 according to a design by Lester S. Moore, it served a congregation of 87 members. Its Arts and Crafts styling would have blended well with the look of the many of the thousands of bungalows then springing up all over greater Los Angeles. When he undertook this project, Moore had already designed the Congregational church in Avalon in 1905 and the Plymouth Congregational Church in Los Angeles in 1907. He would go on in 1913 to design the city's Park Congregational Church.

In 1921, architect Carlton S. Winslow, Sr., announced that he was preparing plans for a 400-seat sanctuary for the Pilgrim Congregational Church. It seems likely that these plans were not carried out, and that additions and modifications to the existing building were carried out instead.

The distinctive feature of this church is its short tower, crowned by a step-pyramidal roof. The front entrance, originally placed in the front of the tower, was changed in 1923 when architect Hilliard Kerr also added a two-story annex to the rear of the sanctuary beyond an earlier Sunday school room already added to the sanctuary's rear by T. E. Harrison in 1912.

Angelica Lutheran Church

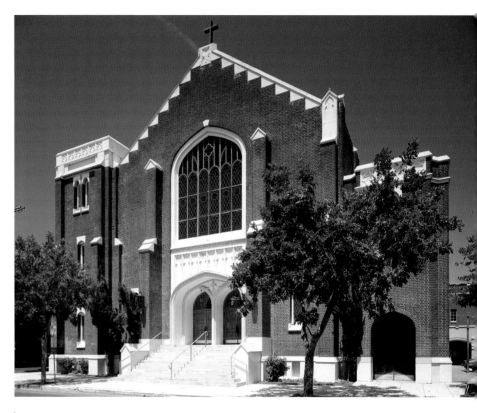

This Gothic revival building was erected to serve a Swedish congregation organized in 1888. The architect G. S. Larson, was a member of the congregation, as was C. G. Hokanson, who was responsible for the interior decoration. The contractor was the Pozzo Construction Company, which had undertaken construction of the Thirteenth Church of Christ, Scientist, by the time Angelica Lutheran Church was nearing completion after only about eight months of work.

The Gothic styling used here belies a thoroughly modern steel structure faced with red brick and equally modern cast stone. A three-story tower punctuates the corner of 14th Street and South Burlingame Avenue and marks the church as a significant landmark in its neighborhood. A generously proportioned ogival arch, filled with stained glass above and a cast-stone porch below, lends drama to the avenue façade.

Second Baptist Church

One of the leading African-American churches of Los Angeles, the Second Baptist Church was founded in 1885. In 1924, the congregation broke ground for a building designed by Norman F. Marsh in association with a young architect, Paul R. Williams, who was destined to leave an indelible mark on his profession as the first African-American member of the American Institute of Architects. The Second Baptist Church was among his first public projects during an early career dominated by residential commissions.

For Second Baptist Church, Marsh and Williams produced an Italianate design of ochre brick. Many of its details seem to have been inspired by the Romanesque architecture of Lombardy. With tall arched windows between well-proportioned intersecting pilasters, the church's interior is more classical and monumental in effect than the exterior.

Pastor Lee Griffith, Sr., who spearheaded the project, insisted on the participation of black-owned businesses and craftsmen in its construction as well as its design. Completed over the course of 1925, partially with labor contributed by members of the congregation such as highly respected carpenter John Session, the edifice was dedicated in January, 1926.

The Second Baptist Church played a significant role in supporting the NAACP and advancing the civil rights movement. Its members are remembered for having funded the printing of the legal briefs used in connection with the case of Brown v. Board of Education of Topeka. The church had several direct associations with Dr. and Mrs. Martin Luther King, Jr.. King addressed an NAACP rally against job discrimination held at Second Baptist in 1958. Ten years later, in 1968, he delivered his last public address in Los Angeles from the church's pulpit. A few years after his death, Coretta Scott King gave a solo voice concert at the church. She also appeared as a featured speaker at the church in 1979.

Meanwhile, in 1978, Second Baptist Church was declared Los Angeles Historic-Cultural Monument Number 200.

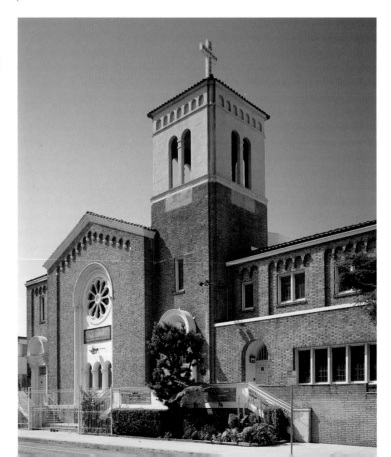

First Unitarian Church

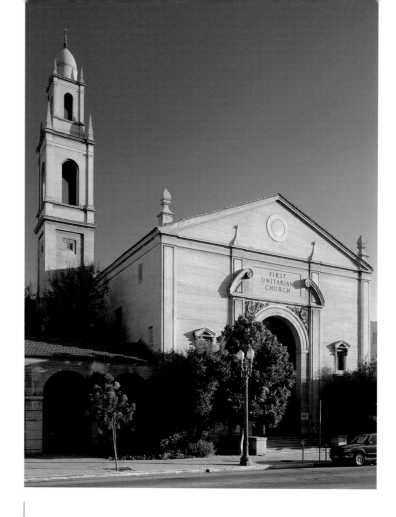

B Begun in 1926, this reinforced concrete edifice was completed in 1927, the fiftieth anniversary of its congregation's founding. The design is austere, the main source of its inspiration being the Italian Renaissance. Both inside and out, the ornamentation of the walls is handled in very low relief. On most of the height of the exterior walls, the trace of the wooden formwork remains visible in a subtle pattern of horizontal bands. On the lower parts of the walls, however, the concrete was cast in imitation of ashlar. Inside, the lower portions of the walls are paneled and the upper parts left perfectly plain.

Following a configuration popular in Los Angeles churches, the site plan organizes the sanctuary and a smaller meeting space on either side of a patio, screened from the street by an arcade. In a corner of the court-yard rises a tower, open at its upper levels and so slender that it almost suggests a minaret.

In accordance with the liberal outlook of Unitarianism in general, the First Unitarian church has a long record of supporting progressive causes. During the 1950s, its well-educated congregation supported Paul Robeson and other victims of Hollywood blacklisting and the McCarthy hearings. It later lent support to the civil rights movement and organized opposition to the Vietnam War. In 1983, it became the first church in Los Angeles to announce the dedication of its facilities to the sheltering of Central American refugees. Over the years, speakers at the church have included Robeson, W. E. B. Du Bois, Benjamin Spock, Daniel Berrigan and Gore Vidal. The church's heated commitment to political activism contrasts with the cool, classical architecture of its building, earning it the nickname of "The Little Red Church on the Hill" a half-century ago.

Japanese Union Church

Largely through the efforts over three years of the Japanese-American minister Magojiro Furuya, the Japanese Presbyterian Church, the Bethlehem Congregational Church and Furuya's own Japanese Mission of the First Congregationalist Church agreed to a merger in 1918 that created the Japanese Union Church.

Since the size of the merged congregation exceeded the capacity of any of the buildings formerly used by its constituent organizations, an immediate priority for the new congregation was acquiring a suitable building for its services. Nevertheless, it was only in 1922 that the church could commission plans from architect Henry M. Patterson and in March, 1923 that it could occupy the structure completed in accordance with those plans. A freestanding structure of orange brick, it featured art-glass windows and a tetrastyle Ionic portico. Unmistakably marking the Christian function of this building in the heart of Little Tokyo, a large cross was mounted on the gable behind the portico's pediment.

Over the 1920s and 1930s, the Japanese Union Church offered a larger and larger range of educational services (such as English-language classes) and recreational opportunities for children. As the proportion of English-speaking, American-born Japanese (Nisei) grew over these years, the church took on an increasingly American character. In 1930, in a bid to remain relevant to the younger members of its congregation, the church began offering services in English as well as Japanese. In 1942, like many other cultural and religious facilities in Little Tokyo, its building became an assembly center for the

Japanese population destined to wait out the duration of World War II in detention camps. Until 1949, the church served as an African-American cultural center. It then reverted to its original use.

Its home threatened with demolition by urban renewal plans developed in the mid-1960s, the Union Church erected a new building in 1976 and sold its historic property to the City of Los Angeles. Growing public support for historic preservation in general, and a growing awareness of the importance of the Japanese contribution to the cultural heritage of Southern California in particular, eventually coalesced to form a successful effort to save the building and adapt it to a new use. In 1986, it was declared Los Angeles Historic-Cultural Monument Number 312.

Its exterior restored and its interior remodeled in 1998 by Glenn Togawa of Togawa & Smith, the Japanese Union Church is now officially known as the David Henry Hwang Theater, Union Center for the Arts. As such, it is the home of one of America's leading theater groups, the East West Players. Now associated with the theater, it also gained a connection during its years of vacancy with the movies; it served as the key location used in making John Carpenter's 1987 horror film *Prince of Darkness*.

Theosophy Hall

Robert Crosbie, after leaving San Diego's famous Theosophical colony at Point Loma in 1904, came to Los Angeles and there founded the United Lodge of Theosophists in 1909. The objective of Crosbie and his like-minded collaborators was to disseminate the principles of Theosophy as they had been originally set forth in the nineteenth-century writings and teachings of Helena Petrovna Blavatsky and William Q. Judge. As it carried out its program mainly by presenting lectures and organizing study series, its main requirements in a public building were for an auditorium and meeting spaces.

These requirements were filled by Theosophy Hall, designed by Abram M. Edelman and Archie C. Zimmerman for a site near from the campus of the University of Southern California. The owner of record, listed on the building permit dated August 1, 1927, was the Theosophy Company (the United Lodge of Theosophists' publishing arm). The structure possesses simple aspects and, with details evoking both Spanish and Italian architecture, projects a vaguely Mediterranean image.

In 1930, a neon sign was added to the roof. The sign advanced the mission of the United Lodge of Theosophists by advertising the presence of its head-quarters in a city that was, by then, well known for its diversity of religious cultures. It was one of dozens of such signs once lit nightly atop theaters, hotels and apartment houses throughout Los Angeles and hence it was baldly associated with commerce and competition. Its presence also intimated the engagement of Theosophy in an increasingly crowded marketplace of spiritual ideas.

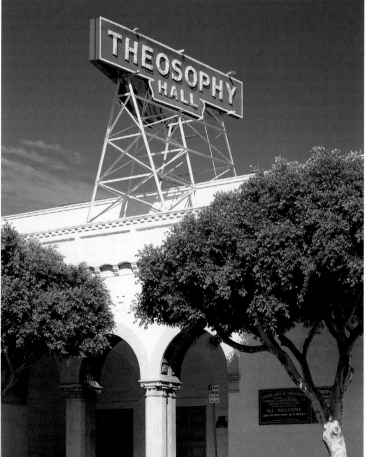

Angelus Temple

Famous more because of the notoriety of its founding pastor, the Canadian-born evangelist Aimée Semple McPherson, than for its architecture, this much-remodeled reinforced concrete sanctuary ranks among the best-known monuments of Los Angeles.

McPherson toured America as a tent revivalist beginning in 1912. In 1918, she settled in Los Angeles and resolved to build a permanent home for her Four-square Gospel Church. She funded this project with money raised in another preaching tour from 1918 to 1923.

Her preaching style evolved over the course of the 1920s into one that could be accurately (if unsympathetically) described as a vaudeville act. For her performances as an evangelist, McPherson conceived and later perfected her church as a theater of conversion. Like many actual theaters of its time, it had atmospheric decorations such as a ceiling painted with heavenly clouds and a giant mural by Emil Jean Kosa, Jr., of the Second Coming of Jesus Christ. It boasted its own orchestra, in which Anthony Quinn played saxophone before he achieved fame as a screen star.

This church, overlooking Echo Park and visible from vantage points stretching many blocks in all directions, has been attributed to various designers, no doubt due to the many changes made to it during McPherson's lifetime and continuing after her death in 1944. In late July 1921, the Winter Construction Company was reportedly preparing to start work on the foundations for what was then called McPherson's "Echo Park Avenue Tabernacle" in accordance with plans provided by architect William Wheeler of San Diego. Construction apparently proceeded over the course of 1922, adding the choir loft and font designed by Wheeler. The building was completed in time for its dedication on January 1, 1923. Photographs reproduced in the Los Angeles Times later that year show that it was a neo-gothic structure, roughly fan-shaped in plan, with large ogival windows and seats arranged theater-style.

The resemblance of the Angelus Temple to the Mormon Tabernacle in Salt Lake City (1863-75) has been plausibly noted. Its design may also be related to that of Chicago's 1925 Moody Memorial Church, a structure of similar size, shape and function.

Almost immediately, McPherson began to modify and expand the new facility. In 1923, she added radio towers and a radio room. In 1924, she expanded the church's radio studio as she increased the intensity of her pioneering use of radio broadcasts for evangelization. At some time before 1930 — possibly as late as 1929, when she radically transformed the pulpit into a stage, complete with proscenium arch and theatrical machinery — she expanded the structure by adding two floors of offices and other rooms above a foyer and changed the exterior expression from neo-gothic to neo-classical. The roof structure was changed to a concrete dome, one of the largest and highest in America. Published attributions of the building to Brook Hawkins and A. F. Leicht are perhaps based on their actual involvement in planning some of those modifications. Together, they transformed McPherson's tabernacle into a veritable temple, indeed a microcosm of the New Jerusalem as the evangelist had sketched it in a diagram of the "Plan of Salvation" published in 1919. Impressive by the standards of a booming Los Angeles in the 1920s, when architectural panache became almost commonplace, the Millennial look of the Angelus Temple doubtless struck many with an even greater impressiveness as the Depression of the 1930s wore on.

The Angelus Temple was renovated in 1972. Recent and controversial modifications to its interior, intended to improve its acoustics and facilitate the integration of audiovisual presentations into worship services, have enhanced the building's already pronounced theatrical qualities. Following a merger in 2001 of the Assemblies of God and the International Church of the Foursquare Gospel, the Angelus Temple became known as the "Angelus Temple, Home of the Dream Center." The new name reflects the commitment of its current pastor, Matthew Barnett, to improving the lives of disadvantaged constituencies in the inner city. The church was rededicated in a spectacular service held on July 14, 2002.

Bethlehem Baptist Church

Built for an African-American congregation of modest means, the Bethlehem Baptist Church ranks, by far, as the finest Modern church in Los Angeles. The fact that it stands in one of the most blighted sections of Los Angeles only enhances the poignant drama of its design, at once highly abstract and distinctly symbolic. It is the only church R.M. Schindler ever designed.

Although it was designed in 1944, construction of the church only began in early 1945 after an existing building was moved back on the lot to accommodate the location of the L-shaped sanctuary on the corner. The older building is linked to the sanctuary by a loggia in order to form a patio open to 49th Street. The exterior is treated as a series of horizontal stucco bands, resembling giant overlapping planks of wood. Fenestration is minimal. The entrance to the church is from the patio, beneath a tower set in the corner of the sanctuary. The tower's superstructure, cruciform in plan, also forms in elevation two crosses interlocked at right angles. A skylight in the tower floods the foyer with light.

Pews are set in two banks, at right angles to each other and facing the dais in the corner opposite the entrance. One of several unorthodox features of this church that yet resonate with traditional forms, this arrangement recalls the diagonal seating arrangements found in many so-called Akron-plan churches of the late nineteenth century

The church's composition of interlocking spaces, as has been often noted, is closely related to that of Schindler's 1925 house for Eads Howe in Silverlake. The L-shaped massing of the church, with its tower in the corner, also recalls that of George J. Adams's 1934 Maronite Church of Our Lady of Lebanon. It is another of the rare International Style churches of greater Los Angeles, and also features a tower in the re-entrant corner, crowned by a cross.

First Presbyterian Church, Hollywood

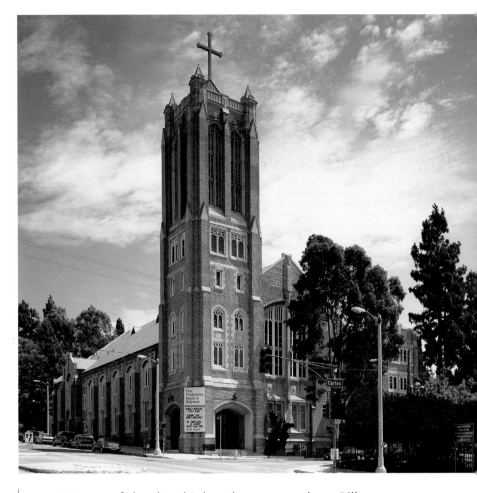

One of the largest Presbyterian churches in America, both the size of its congregation and the great bulk of its facility serve as reminders of the Christian culture prevailing in early Hollywood. The church was founded in 1903, and as a result of its location soon counted many motion-picture people among its members.

The neo-gothic sanctuary, begun in 1923 to a design by Henry M. Patterson, has a heavy and rather dour appearance. Built of red brick and cast stone, it features a corner entrance surmounted by a tower that rises in setback stages to a height sufficient for it to dominate Hollywood Boulevard one block to the south. The structure was completed and dedicated, debt-free, in November 1924. Windows created by the Judson Studios grace the vast interior.

In July, 1949 the church dedicated a new chapel, designed in 1945 by Allison & Rible and funded through a gift of petroleum magnate Herbert G. Wylie. The neo-gothic styling of the chapel harmonizes with that of the church. Reflecting perhaps the taste for simplicity evident in Modern architecture of the mid-twentieth century, the chapel's facade is treated as an expansive brick surface pierced only by the ogee of the entrance and a circular window above it. A small belfry extends above the peak of its gable.

In 1951, one of the church's best-known members, Bill Bright, founded the Campus Crusade for Christ. Debbie Boone, daughter of Christian singer Pat Boone, married Gabriel Ferrer in the sanctuary of this church in 1979.

Saint Monica's Roman Catholic Church

Serving a parish established in 1886, the present Saint Monica's church was completed in 1926 according to a design by Albert C. Martin. Plans for a building to replace the parish's late-nineteenth-century frame church had been in the works for some time. In 1921, a site had been purchased at the corner of 3rd Street and Arizona Avenue in Santa Monica. Definitive plans for a building on another few blocks east, at 8th and Arizona, were announced in April, 1923. However, the death on August 23, 1923 of the parish's first pastor, Father Patrick Hawe, forced a slight postponement of construction. Built in 1924 by the Wurster Construction Company, it was dedicated in 1925. The site had once again shifted, this time two blocks to the northwest, across Wilshire Boulevard and facing Lincoln Park. A rectory was added in 1926.

The architecture reflects that of the Italian Romanesque period. Sheathed in stone, the exterior features sculpture carved by Joseph Conradi, who is well remembered for his work for a number of Los Angeles-

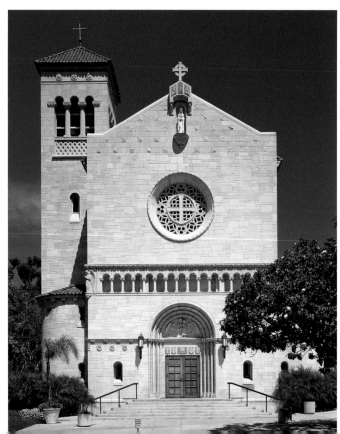

area churches. Inside, a barrel vault surmounts the cathedral-like nave. An enduring association of Saint Monica's with Hollywood stems from the success of *Going My Way*, the winner of an Oscar for best picture in 1944. In the film, the role played by Barry Fitzgerald was based on the real-life character of Saint Monica's parish priest from 1923 to 1949, Father Nicholas Conneally. Among the parishioners at Saint Monica's have been many well-known figures from the film industry and other distinguished walks of life in Los Angeles. They have reportedly included Martin Sheen, Kelsey Grammer and former Los Angeles mayor Richard Riordan. The church was the location of memorial services for comedians Lucille Ball in 1989 and Chris Farley in 1998. New Zealand-born television star Lucy Lawless married producer Robert Tapert in a traditional ceremony held at Saint Monica's in 1998.

First AME Zion
West Adams Presbyterian

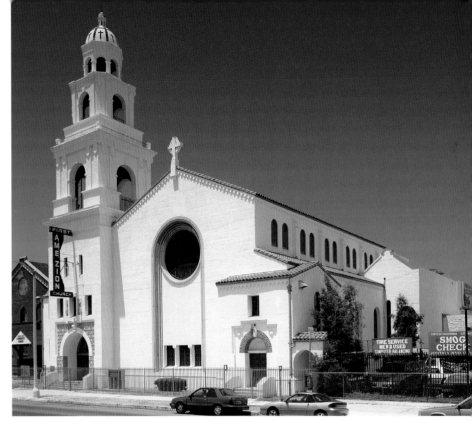

Although sometimes attributed to architects Henry M. Patterson and George W. Kelham, the building permit for this church, dated June 20, 1928, attributes the design to Patterson and Roscoe L. Warren. It replaced a 1904 building for the same congregation, also designed by Patterson, who was then just embarking on what was destined to be a prolific career as a church architect.

This reinforced concrete structure is one of numerous churches built throughout Southern California in a manner suggesting the architecture of the Spanish colonial missions. The tower, especially, rising in several stages, recalls those of Mission San Buenaventura or Mission San Luis Rey de Francia. But the church's composition in general is unmistakably modern. The Spanish Renaissance ornament, concentrated on the tower's upper levels and around the entrance in its base, has been somewhat simplified to adapt it to the requirements of concrete construction. The sanctuary's more Romanesque-looking façade, with its central motif a tall arch framing a bull's-eye window, adapts the parti used by Johnson, Kaufmann & Coates for the front of their now demolished Saint Paul's Episcopal Cathedral on Figueroa Street (1921-24).

When the First African Methodist Episcopal Zion Church purchased the building in 1968, it became home to one of the oldest African-American congregations in Los Angeles.

Shortly after it was renovated in 1997, the church was severely damaged by arson. Within a day, the Walt Disney Company volunteered to assist in a restoration. The newly restored church, featuring 33 windows by the Sunshine Glass Studios and a Rodgers pipe organ, was rededicated in June, 1999.

As one of the focal institutions of the African-American community of Los Angeles, this church has provided a dignified setting for the funerals of numerous civic and cultural leaders. They have included the services held in memory of Mayor Tom Bradley in 1996; publisher Kenneth R. Thomas in 1997; businessman and civil rights activist Samuel Block in 2000; and choreographer Paul Kennedy in 2002. The church edifice is Los Angeles Historic-Cultural Monument Number 341.

Church of the Blessed Sacrament

The hybrid style of this flamboyant church, mixing Art Deco and Spanish Baroque motifs to produce an effect that might fairly be called surrealist, betrays a long building period and the involvement of more than one architect. This Roman Catholic Church stands on the site of the first Christian service held on land that would later become Hollywood: a mass said in 1769 by Father Junipero Serra. The site was purchased in February 1921 for its present purposes. In late 1925, architect Thomas Franklin Power designed a church in Italian Renaissance style, closely based on the famous Jesuit Church in Rome by Vignola. However, in December 1926, the San Francisco firm Beezer Brothers was commissioned to create an alternative design in Spanish style. Power was still retained to handle detailing and engineering as well as to supervise construction; he is also remembered as the architect of record. Ground was broken in March 1927 as fund-raising continued. Among the donors was screen star Dolores del Rio, who started the organ fund.

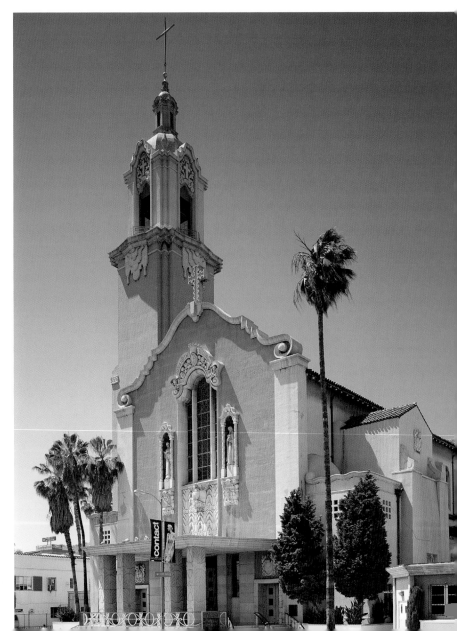

The definitive design called for a Churrigueresque treatment of a structure in reinforced concrete with a roof of steel trusses. A tall tower, elaborately ornamented in its upper parts to contrast with a relatively plain base, was proposed for the west side of the building. A nave 254 feet long was to terminate in a semicircular sanctuary 56 feet wide. Construction started in 1928 and resulted in the completion of the concrete shell. It was halted after 1929, however, by the Depression. Though unfinished, it was occupied and used until construction resumed in 1952.

As finally completed in 1954 under the supervision of architect J. Earl Trudeau, the Church of the Blessed Sacrament was entered through an Art Deco porch. The nave was given a generally Spanish renaissance look, though with some modern features such as the angular columns carrying the arches beneath the clerestory windows. Like the porch, the chancel, richly appointed in marble, was essentially Art Deco in feeling. The facade on Sunset Boulevard, as well as the tower, was stuccoed and ornamented with sparingly placed, though highly plastic, over-scaled motifs inspired by the Churrigueresque precedents originally envisioned by Power. The result is doubly anachronistic, since by the early 1950s both historicizing architecture and Art Deco design had been overtaken by the High Modernism for which Los Angeles was soon to become famous as a principal incubator. Nevertheless, standing tall on Sunset Boulevard next door to Crossroads of the World, it has the stage presence of a great star.

The Blessed Sacrament Roman Catholic Church parish is the oldest in Hollywood, and has gathered numerous stars, such as Loretta Young, into its fold. Bing Crosby was married in the uncompleted church in 1930 to his first wife, Dixie Lee. The funeral of multitalented entertainer Russ Columbo took place there in 1934.

McCarty Memorial Church

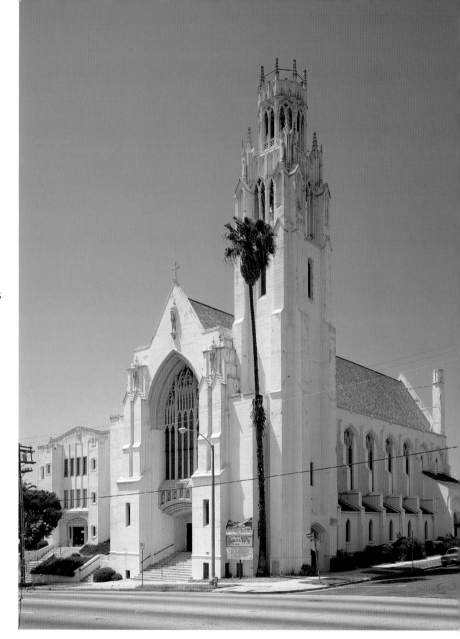

Isaac McCarty, a wealthy physician, was the sole donor of the $200,000 it cost to construct this reinforced concrete church for a congregation of the Disciples of Christ in 1931. Its design by Thomas F. Barber reveals his inspiration by English Gothic architecture. Like Barber's design for Hollywood's First United Methodist Church a few years earlier, the design for this building features a tall tower and a large traceried window over the main entrance. The entrance is dramatically treated as a monumental staircase spilling down to the sidewalk from a deep porch between two massive buttresses. The treatment of the porch, and the minimal fenestration of the lower parts of the church on both the main and side facades, gives the exterior of this church a fortress-like appearance.

The cathedral-like interior is brightly lit by six chandeliers of Czechoslovakian crystal and soaring stained-glass windows above the low side aisles. Each of those windows features Biblical iconography and carries a dedication to a different member of the McCarty family. Overhead, a false hammer-beam roof enhances the lofty effect of the nave. Accommodation for the choir, rising in steep tiers up to a baptismal pool, fills the chancel. About a thousand people can be seated on the main floor and in the balcony above the narthex.

First Methodist, Hollywood

With a tower built as high as the building code in 1926 would allow, this steel-framed reinforced concrete church was designed in what its architect, Thomas Barber called "Modernized, perpendicular English Gothic." It terminates a long vista up Highland Avenue and thus vigorously asserts the presence of Methodism in Hollywood. It forms part of a vast complex of educational and administrative spaces arranged around a cloistered courtyard. The first structure in the complex was built in 1926; the cornerstone of the sanctuary was laid in 1929. The church was dedicated in the following year.

According to Barber's associate, Paul Kingsbury, the style of the building was intended to recall the English origins of Methodism. The solidity of its concrete construction left it unscathed by the March 1933 earthquake.

The loftiness of the exterior, emphasized by the tower and the enormous traceried window above a low entrance, carries through into the interior. The steel roof trusses, encased in plaster finished to resemble wood, imitates that of Westminster Hall in London's Houses of Parliament. The 32 windows contain stained glass produced by the famed Judson Studios; those in the clerestory were meant to be temporary, but the Depression prevented following through with the creation of their intended replacements.

Various parts of the First Methodist Church complex have served as a location for numerous television shows and movies. The sanctuary was still new when a marriage scene was filmed for the 1932 release *What Price Hollywood?* Later releases filmed there have included *One Foot in Heaven, Back to the Future, That Thing You Do* and — perhaps most memorably — Whoopi Goldberg's *Sister Act.*

In the early 1990s, as the AIDS crisis deepened, the First Methodist Church hung a 20-foot model of a red ribbon on the south face of its tower. It testifies to the solidarity of the congregation with those persons living with AIDS and those seeking a cure for the disease that has decimated Hollywood's population. The church thus became a symbol of Christian compassion in the 1990s while remaining a monument to the Christian ideals of Hollywood's founders many decades earlier.

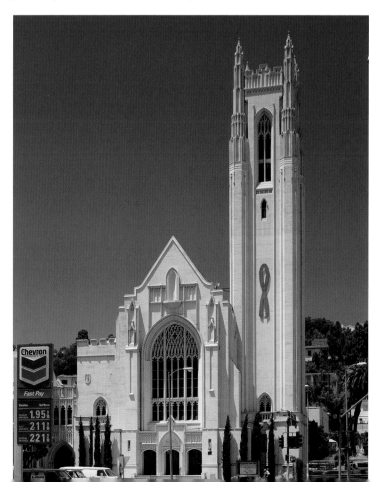

Temple Tifereth Israel
Greater New Vision Church

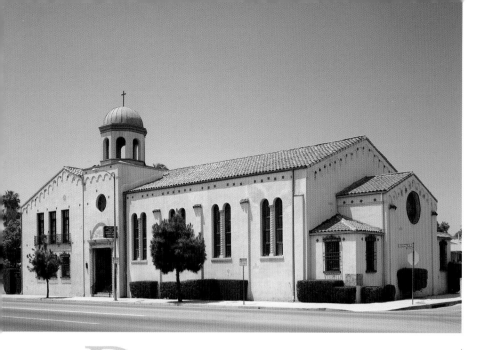

Dating from 1931, this Sephardic synagogue is one of the last works designed by Rudolf Falkenrath, whose career was cut short by death in 1932 at the age of 45. The building's Spanish styling recalls the Iberian origins of the Sephardic community. The exterior is stuccoed. The entrance is marked by a domed cupola over a pavilion rising just slightly above the cornice level.

Sephardim began settling in Los Angeles in 1853. Congregation Tifereth Israel, organized in the early twentieth century largely through the efforts of Rabbi Abraham Caraco, eventually grew into what was probably the largest Sephardic congregation in America. Shortly before his death in 1924, Caraco expressed a final wish that a synagogue be erected to serve the entire Sephardic community of Los Angeles. In 1929, the site on the corner of Santa Barbara and La Salle Avenues was purchased; ground was broken the following year. The new building was dedicated on February 21, 1932.

The interior has been described as classically Sephardic in arrangement. Its chief ornament is a stained-glass window incorporating a Star of David in its tracery.

Congregation Tifereth Israel moved into a new synagogue in western Los Angeles in 1981. Its former synagogue is now the home of the Greater New Vision Church.

Temple Israel of Hollywood

A Reform congregation, Temple Israel was founded in 1926. A majority of its founding members were connected with the Hollywood film industry, as have been many members ever since. Plans prepared in 1927 by S. Tilden Norton for an imposing synagogue to seat 1,600 people, with a dome 108 feet in diameter, dramatically announced the congregation's early optimism and ambitions. Fundraising for a permanent home began making real progress only in 1929, when a successful benefit variety show was organized at the Pantages Theatre. By then, the site envisioned for the new synagogue had changed from the corner of Franklin and Argyle to the corner of De Longpré and June. The Depression of the 1930s, and then World War II, may be blamed for further delays in starting construction.

When in 1946 the congregation was at last ready to build, the site for the synagogue had been changed once again to a corner on Hollywood Boulevard west of La Brea. The design called for a reinforced concrete building in a simplified Mission style, certainly a surprising choice for a synagogue. Its purpose was, however, made unmistakable by the placement of a large window in the shape of a Star of David over the main entrance. The arbitrary — indeed, ironic — relation of the of the building's Jewish function to its stylistic expression, as well as the arrangement of the seating inside in concentric arcs, relate the design of Temple Israel to the architecture of theaters (the specialty of associated architect S. Charles Lee).

Constructed over the course of 1947 and dedicated in September 1948, the worship space in this synagogue was named for Ruth Nussbaum. Rabbi Nussbaum, a noted Zionist, led the congregation from 1942 to 1974. He was responsible for the ultimate success of the fundraising that permitted the construction of the sanctuary and, in the 1950s and 1960s, the rest of the buildings that form a complex grouped around a patio in accordance with the original plans.

The exterior here impresses visitors mainly by the monumentality of its simple geometry and heavy masses. Inside, a silver and marble ark, together with other furnishings, overlays the architecture with an iconography redolent of Jewish heritage. Stars of David feature prominently, appearing in the carpet, pew ends and chandeliers. Number symbolism, referencing Jewish history and the Jewish calendar, is also abundantly in evidence.

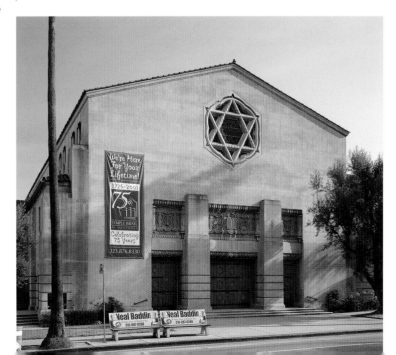

Self-Realization Fellowship Temple

With a note of exoticism, a brilliant white gateway surmounted by a golden lotus bud marks the Sunset Boulevard entrance to the Self-Realization Fellowship's property in Hollywood.

Indian-born Swami Parmhansa Yogananda founded the Self-Realization Fellowship in 1920 while in the United States on a speaking engagement. In 1925, he established its headquarters in the former Mount Washington Hotel in Los Angeles. Yogananda's teaching, based in Hinduism and the principles of yoga, emphasize the unity of all world religions and the universality of spiritual experience.

The Hollywood center is one of several facilities maintained by the Self-Realization Fellowship in the greater Los Angeles area. It has been developed progressively since 1942, when it was established as a sort of replacement for the Golden Lotus Temple of All Religions in Encinitas, lost that year in a landslide. The principal structure on the site, the Church of All Religions, was built in 1942. Designed (like the 1937 Golden Lotus Temple) by Yogananda himself, it incorporates Gothic, Italianate and Mughal motifs in its stained-glass windows, thus suggesting the syncretic character of the Swami's "sacred science." Its interior has been described as originally resembling a small theater, with a blue carpet and blue curtains. The tower-gate leading into the garden before the church dates from 1950. A near double of this gate is found at the Lake Shrine established the same year by the Self-Realization Fellowship in Pacific Palisades. Atop both gates is the figure of a lotus, whose petals as they open symbolize the unfolding of the enlightened soul.

Temple Sinai
Welsh Presbyterian Church

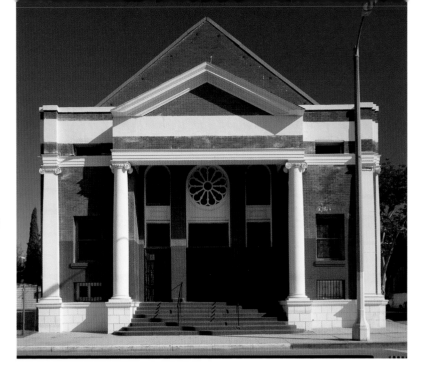

Although now a church, this building's original function as a synagogue is suggested by the double dates (1909 and 5669) recorded in its cornerstone and confirmed by the Star of David motif prominently visible in the tracery of its twelve memorial windows and preserved on the ceiling of its auditorium.

Designed by Jewish architect S. Tilden Norton, it was completed in 1909 for the oldest congregation of Conservative Jews in Los Angeles. It is reputedly the oldest Conservative synagogue built west of Chicago. Its plan is said to have been adapted from that of New York City's much larger Temple Ansche Chesed of 1849. Its style, unlike that of its neo-gothic model, is neo-classical. The red brick and cast-stone structure is entered through a broad, shallow porch flanked by Ionic columns supporting a pediment. Its side facade on Valencia Street, which also features a pediment, is organized into bays of various widths by irregularly spaced pilasters. Seating capacity was originally just over 600, including 200 in the balcony. In 1925, the growing congregation moved into a new and much larger synagogue at Fourth and New Hampshire. In 1926, the building became the home of the Welsh Presbyterian Church, whose property it remains today.

Seismic retrofitting carried out in the late 1980s assured that the church suffered little damage in the 1994 Northridge earthquake. The Welsh congregation has been famed for its choir, which sang at the 1935 San Diego World's Fair and, in the guise of Welsh coal miners, provided choral music for John Ford's 1941 movie masterpiece, *How Green Was My Valley*.

The building itself had entered cinema history somewhat earlier when its interior served as a location for the filming of *The Jazz Singer*, the story of a cantor's son who becomes a star on Broadway, released in 1927 as the first "talkie."

Saint Alban's Liberal Catholic Church
Church of the Protection
of the Holy Virgin Mary

The siting of this church, in the vicinity of Hollywood's early twentieth-century Krotona colony of Theosophists was no accident. The history of the Liberal Catholic Church, founded in the early twentieth century by Theosophists and others sympathetic to Theosophy, has been closely entwined with that of the Theosophical Society from whose adherents the church has over the years drawn, and continues to draw, a large percentage of its members. The elaborate rituals of its liturgy reflect Liberal Catholicism's firm rooting in the gnostic tradition, and hence its sympathy to mystical esotericism in general.

In 1921, for this vibrant and fast growing congregation, architect John Chard of Santa Barbara designed a Mission-style church to seat some 400 worshippers. Architect Harold B. Dunn of Los Angeles developed the working drawings and supervised construction. The starkly plain structure stood outlined against the Hollywood Hills to the north, and opened through a

cloister-like loggia onto a walled garden to the south. By the mid-twentieth century, the Liberal Catholic community of Los Angeles ranked among the world's largest. Its prosperity began to wane, however, when a schism resulted in a decade of litigation throughout the 1950s and 1960s. St. Alban's was subsequently acquired by a Russian Orthodox congregation and renamed the Church of the Protection of the Holy Virgin Mary. The conversion entailed construction of a tower, inspired by Muscovite architecture of the fifteenth century that dramatically expresses the church's new affiliation but almost completely conceals its original architecture.

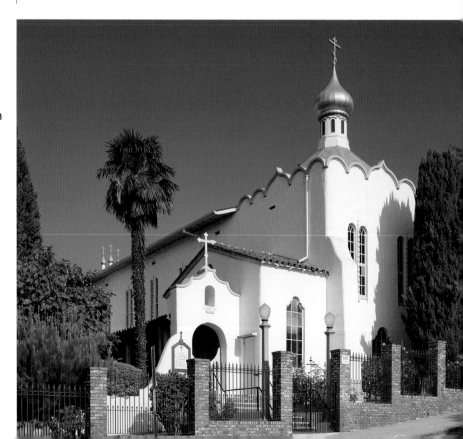

List of Structures by Location

SILVERLAKE/LOS FELIZ/ECHO PARK	Address	Date	Architect
Holy Virgin Mary Russian Orthodox	650 Micheltorena St.	1932	Alexander A. Tolubeyev (also Toluboff)
St. Mary of the Angels Anglican Church	4510 Finley Ave.	1930	Carleton M. Winslow
Angelus Temple	1100 Glendale Blvd.	1923	William Wheeler, Brook Hawkins & Adolph F. Leicht

BOYLE HEIGHTS/EAST L.A./LINCOLN HEIGHTS			
St. Mary's Roman Catholic Church	407 S. Chicago St.	1924	Thomas Franklin Power
Our Lady of Lourdes Roman Catholic	3773 E. 3rd Street	1930	L. G. Scherer
Breed Street Shul	247 N. Breed St.	1914-1930	O. M. Werner, Pacific Portable Construction Co., Abram M. Edelman & Leo W. Barnett
Church of the Epiphany	2808 Altura St.	1888-1913	Ernest Coxhead & Arthur B. Benton

DOWNTOWN LOS ANGELES			
St. Vibiana Cathedral	114 E. 2nd Street	1871-1876	Ezra F. Kysor, Walter J. Mathews & John C. Austin
Koyasan Buddhist Temple	342 E. 1st Street	1938-1940	Yoshihiro Hirose & Lyle Newton Barcume
Nishi Hongwanji Buddhist Temple	355 E. 1st Street	1924	Edgar H. Cline
Japanese Union Church	120 N. San Pedro	1923	Henry M. Patterson & Glenn Togawa
Temple Sinai/Welsh Presbyterian	12th & Valencia	1909	S. Tilden Norton
Our Lady Queen of Angels	535 N. Main St	1822-1923	Jose Antonio Ramirez

MID-WILSHIRE	Address	Date	Architect
Wilshire Boulevard Temple	3636 Wilshire Blvd.	1927	Abram M. Edelman, S. Tilden Norton, Allison & Allison
Immanuel Presbyterian Church	3300 Wilshire Blvd.	1927	Chauncey Fitch Skilling
Temple Sinai East	407 S. New Hampshire	1926	S. Tilden Norton & Frederick Hastings Wallis
St. Brendan's Roman Catholic Church	310 S. Van Ness	1927	Emmett G. Martin
St. Sophia Greek Orthodox Cathedral	1324 S. Normandie	1951	Gus William Kalionzes, Charles Arthur Klingerman & Albert R. Walker
Wilshire Boulevard Christian Church	634 S. Normandie	1922	Robert H. Orr
St. James Episcopal Church	3903 Wilshire Blvd.	1925	Benjamin D. McDougall
First Baptist	760 Westmoreland	1930	David Clark Allison & George B. Allison
Ninth Church of Christ, Scientist	433 S. Normandie	1924-1927	Meyer & Holler, Inc.
First Congregational Church	540 S. Commonwealth	1933	David Clark Allison & George B. Allison
Church of the Precious Blood	435 S. Occidental	1926	Henry Carlton Newton & Robert Dennis Murray
First Church of Christ, Scientist	1366 S. Alvarado	1912	Elmer Grey
First Unitarian Church	2936 W. 8th Street	1927	David Clark Allison & George B. Allison
Angelica Lutheran Church	1345 S. Burlington Ave.	1926	G. S. Larson

EXPOSITION EAST			
St. John the Episcopal	514 W. Adams	1924	Francis Pierpont Davis & Walter S. Davis
St. Vincent de Paul	621 W. Adams	1923-1925	Albert C. Martin
Second Church Of Christ, Scientist	948 W. Adams	1910	Alfred F. Rosenheim & Albert C. Martin
St. Cecilia	4360 S. Normandie	1927	Ross G. Montgomery
Theosophy Hall	245 W. 33rd Street	1927	Abram M. Edelman & Archie C. Zimmerman
Holy Cross Catholic Church	4705 Main St.	1912	Albert C. Martin
Pilgrim Congregational Church	4607 Normandie	1910	Lester S. Moore, Carleton S. Winslow Sr., Hilliard Kerr & T. E. Harrison
First AME Zion (West Adams Presbyterian)	1445 W. Adams	1931	Henry M. Patterson & George W. Kelham & Roscoe L. Warren
Temple Tifereth Israel	1561 M.L.King Blvd.	1932	Rudolf Falkenrath
Bethlehem Baptist Church	4900 Compton Avenue	1944-6	Rudolf M. Schindler
Second Baptist Church	2408 Griffith Avenue	1925	Norman F. Marsh, Paul R. Williams

List of Structures by Location

EXPOSITION WEST

	Address	Date	Architect
St. Paul's Roman Catholic Church	4112 W. Washington Blvd.	1938	John C. Austin
Church of the Advent	4976 W. Adams	1924	Arthur B. Benton
McCarty Memorial Church	4101 W. Adams	1931	Thomas P. Barber & Paul Kingsbury
Emanuel Danish Evangelical Lutheran	4254 3rd Avenue	1937	Edith Mortensen Northman

BEVERLY HILLS/WEST L.A./SANTA MONICA

St. Alban's Episcopal Church	580 Hilgard	1931-1940	Reginald Johnson & Percy Paul Lewis
St. Monica's Roman Catholic Church	725 California	1925	Albert C. Martin
Good Shepherd Catholic Church	505 N. Bedford Dr.	1924	Sidney Eisenstadt

HOLLYWOOD

First Methodist	6817 Franklin Ave.	1926-1930	Thomas F. Barber
Thirteenth Church of Christ, Scientist	1750 N. Edgemont	1930	David Clark Allison & George B. Allison
Krotona Inn	2130 Vista del Mar	1912	William S. Mead & Richard S. Requa
Vedanta Temple	1946 Vedanta Pl.	1938	Unknown
St. Alban's Liberal Catholic Church	2049 Argyle	1921	Harold B. Dunn, John Chord
First Presbyterian Church, Hollywood	1760 Gower	1924	Henry M. Patterson, George B. Allison & Ulysses Floyd Rible
Church of the Blessed Sacrament	6657 Sunset Blvd.	1927	Thomas Franklin Power & J. Earl Trudeau
Self Realization Fellowship Temple	4680 Sunset Blvd.	1942	Swami Parmhansa Yogananda
Temple Israel of Hollywood	7300 Hollywood Blvd.	1948	Samuel E. Lunden & S. Charles Lee

Selected Bibliography

General References

A Pictorial Review of Buildings Built by Wurster Construction Company.
Los Angeles & San Diego: [Wurster Construction Company, n.d.].

"The Scientists' New Churches." *Los Angeles Times*
25 July 1909, pt. 5, pp. 16-17.

Wicher, Edward Arthur. *The Presbyterian Church in California,* 1849-1927.
New York: Frederick H. Hitchcock, 1927.

Cram, Ralph Adams. *American Church Building of To-day.*
New York: Architectural Book Publishing Company, Inc., 1929.

Palmer, Edwin O. *History of Hollywood.* 2 vols.
Hollywood: Arthur H. Cawston, 1937.

The Centennial, 1840-1940. [Los Angeles: 1940?].

Faulkner, Charles Draper. *Christian Science Church Edifices.* 2nd ed.
Chicago: [Charles Draper Faulkner], 1946.

Vorspan, Max & Lloyd P. Gartner. *History of the Jews of Los Angeles.*
San Marino: The Huntington Library, 1970.

*Los Angeles: A Guide to the City and its Environs, Compiled by Workers
of the Writers' program of the Work Projects Administration in Southern
California* (1941). Rept. New York, Hastings House, 1972.

Weber, Francis J., ed. *The Religious Heritage of Southern California.*
Los Angeles: Interreligious Council of Southern California, 1976.

Grenier, Judson A., ed. *A Guide to Historic Places in Los Angeles County.*
Dubuque: Kendall/Hunt Publishing Company, 1978.

Gleye, Paul. *The Architecture of Los Angeles.*
Los Angeles: Rosebud Books, 1981.

Moore, Charles, Peter Becker, & Regula Campbell.
The City Observed: Los Angeles. New York: Vintage Books, 1984.

Aleman, Richard. *The Movie Lover's Guide to Hollywood.*
New York: Harper & Row, 1985.

Reed, David. "A Tour of Hollywood Churches."
Travel & Leisure 14, no. 6 (June 1986), pp. CA1-CA3.

Melton, J. Gordon, ed. *Encyclopedia of American Religions.* 4th ed.
Detroit: Gale Research Inc., 1993.

Smith, Leon. *Famous Hollywood Locations: Descriptions and Photographs
of 382 Sites Involving 289 Films and 105 Television Series.*
Jefferson, NC: McFarland & Co., 1993.

City of Los Angeles, Cultural Affairs Department,
Cultural Heritage Commission. *Historic-Cultural Monuments 1-588.*
Los Angeles: Cultural Affairs Department, 1994.

Gebhard, David & Robert Winter. *Los Angeles: An Architectural Guide.*
Salt Lake City: Gibbs-Smith, 1994.

Hayashi, Brian Masaru. *'For the sake of Our Japanese Brethren': Assimilation,
Nationalism, and Protestantism Among the Japanese of Los Angeles, 1895-1942.*
Stanford: Stanford University Press, 1995.

Apostol, Jane. *Painting with Light: A Centennial History of the Judson Studios.*
Los Angeles: Historical Society of Southern California, 1997.

Pitt, Leonard & Dale Pitt. *Los Angeles A to Z: An Encyclopedia of the City
and County.* Berkeley: University of California Press, 1997.

Ivey, Paul Eli. *Prayers in Stone: Christian Science Architecture in the United
States 1894-1930.* Urbana & Chicago: University of Illinois Press, 1999.

Smith, Leon. *Movie and Television Locations: 13 Famous Filming Sites in
Los Angeles and San Diego.* Jefferson, NC: McFarland & Co., 2000.

Mead, Frank S. & Samuel S. Hill. *Handbook of Denominations in the United
States.* 11th ed. rev. by Craig D. Atwood. Nashville: Abingdon Press, 2001.

Rojas, Marcela & Ted Shaffrey. "The 'Ecumenical Mile'." *Los Angeles Times*
15 April 2001, "Westside Weekly," pp. 1, 7.

Weber, Francis J. *Encyclopedia of California's Catholic Heritage 1769-1999.*
Mission Hills, CA and Spokane, WA: Saint Francis Historical Society and
The Arthur H. Clark Company, 2001.

Dawes, Amy. *Sunset Boulevard: Cruising the Heart of Los Angeles.*
Los Angeles: Los Angeles Times Books, 2002.

Angelica Lutheran Church

"Work on Church Starts." *Los Angeles Times* 8 February 1925, pt. 5, p. 2.

"New Church Finished in Week Ended." *Los Angeles Times*
11 October 1925, pt. 5, p. 3.

Angelus Temple (Foursquare Gospel)

Southwest Builder & Contractor 58 (29 July 1921), p. 19.

"To Build Great Church Center." *Los Angeles Times*
18 November 1923, pt. 5, p. 3.

Bisell, Shelton. "Vaudeville at Angelus Temple."
The Outlook 149 (23 May 1928), pp. 126-127, 158.

Ramirez, Margaret. "Ministers to Close Sanctuary in Fight Over
Historic Church." *Los Angeles Times* 19 July 2001, pt. A, p. 16.

"Angelus Temple Will Keep Historic Interior." *Los Angeles Times*
15 October 2001, pt. B, p. 3.

Irons-Georges, Tracy, ed. *America's Historic Sites.*
Pasadena & Hackensack: Salem Press, Inc., 2001, vol. 1, pp. 94-95.

Selected Bibliography

Bethlehem Baptist Church

"Community Church." *Interiors* 104 (January 1945), p. 82.

Gebhard, David, ed. *Architectural Drawings of R. M. Schindler.* New York: Garland Publishing, Inc., 1993, voil. 1, pp. 147-157.

March, Lionel & Judith Schein, eds. *RM Schindler: Composition and Construction.* London: Academy Editions, 1993.

Schein, Judith. *R. M. Schindler.* London: Phaidon, 2001.

Breed Street Shul

Southwest Builder & Contractor 55 (21 May 1920), p. 11.

"To Erect Church." *Los Angeles Times* 18 July 1920, pt. 5, p. 1.

Southwest Builder & Contractor 76 (19 December 1930), p. 58.

Kowsky, Kim. "They're Trying to Make Synagogue History." *Los Angeles Herald-Examiner* 27 January 1988, pt. A, p. 3.

Johnson, Reed. "The Afterlife of an East L.A. Synagogue." *Los Angeles Times* 31 December 2000, pt. E, p. 1.

Church of the Advent

Southwest Builder & Contractor 64 (10 October 1924), p.53.

1998 Membership Directory. Los Angeles: Church of the Advent, [1998?], pp. 2-3.

Church of the Blessed Sacrament

"Blessed Sacrament Builds Italian Renaissance Church." *Hollywood Daily Citizen* 28 November 1925, p. 9.

"Committees Are Perfecting Plans for $400,000 Structure." *Hollywood Daily Citizen* 7 December 1925, p. 7.

"Ground Broken for Church." *Los Angeles Times* 20 March 1927, pt. 5, p. 3.

"Church of the Blessed Sacrament in Hollywood." *Church Property Administration* 19 (July-August 1955), pp. 30-33, 121-126.

Church of the Epiphany

"Historic Church Bell to Ring Out Again Tomorrow." *Los Angeles Times* 16 October 1948, pt. 2, p. 3.

Emmanuel Danish Evangelical Lutheran Church

Southwest Builder & Contractor 89 (2 April 1937), p. 48.

First AME Zion

Southwest Builder & Contractor 71 (20 January 1928), p. 54.

Stewart, Jocelyn M. "Fire Damages First AME Zion Church." *Los Angeles Times* 22 July 1997, pt. B, p. 1.

First Baptist Church

"Edifice Near Completion." *Los Angeles Times* 31 October 1926, pt. 5, p. 6.

"Edifice Nears Completion." *Los Angeles Times* 12 June 1927, pt. 5, p. 1.

"Some Western Churches." *Pacific Coast Architect* 33 (July 1928), pp. 23-40.

Architectural Forum 50 (March 1929), pl. 93.

Sutton, Herbert L. & Patricia Henry Yeomans. *First Baptist Church of Los Angeles: Honoring the Past, Imagining the Future: 1874-1999.* Los Angeles: First Baptist Church, 1999.

First Church of Christ, Scientist

The Brickbuilder 24 (June 1915), pls. 86-88.

Grey, Elmer. "The Style of Christian Science Church Edifices." *Architect and Engineer* 47 (December 1916), pp. 62-72.

First Congregational Church

"Structure to Rise on West Side." *Los Angeles Times* 23 March 1930, pt.5, p. 12.

Architectural Digest 8, no. 4 (1931), pp. 16-19.

"Imposing Religious Edifice Designed in English Gothic Style." *Southwest Builder & Contractor* 80 (19 August 1932), pp. 36-37.

"Triumphant Campaign." *Time* 40 (3 August 1942), p. 38.

Davis, Royal G. *Light on a Gothic Tower: First Congregational Church of Los Angeles.* Los Angeles: First Congregational Church, 1967.

First Methodist Church, Hollywood

"Major Buildings to Rise." *Los Angeles Times* 23 May 1926, pt. 5, p. 1.

"New Hollywood Church an Interesting Example of Gothic Architecture."
Southwest Builder & Contractor 75 (30 May 1930), p. 32.

Kingsbury, Paul. "Two Churches of Modernized Gothic."
Architectural Concrete 1 (April 1935), pp. 5-7.

First Presbyterian Church, Hollywood

"Hollywood Presbyterian Church." *Los Angeles Times*
15 July 1923, pt. 5, p. 1.

"Dedication of Chapel to Be Held Tomorrow."
Los Angeles Times 16 July 1949, pt. 2, p. 3.

First Unitarian Church

"Five Projects Announced." *Los Angeles Times* 24 October 1926, pt. 5, p. 1.

Architectural Digest 6, no. 4 (1928), pp. 34-35.

Architectural Forum 50 (March 1929), pp. 395-396.

Perry, John D. K. *A History of the First Unitarian Church of Los Angeles,
California, 1877-1937*. Los Angeles: First Unitarian Church, [1937?].

Rolfe, Lionel. "A Congregation Where God's Not the Answer." *Los Angeles
Herald-Examiner* 28 November 1982, "California Living," pp. 11, 13-14.

Steigerwald, Bill. Religiously Anti-Establishment."
Los Angeles Times 13 December 1987, pt. 6, p. 1.

Good Shepherd Catholic Church

Southwest Builder & Contractor 63 (13 June 1924), p. 52.

Southwest Builder & Contractor 64 (11 July 1924), p. 59.

"Cinema Gifts Build Church." *Los Angeles Examiner*
22 December 1924, pt. 1, p. 14.

Kelly, Kitty. *Elizabeth Taylor: The Last Star.*
New York: Simon & Schuster, 1981, pp. 46-55.

Holy Cross Roman Catholic Church

"Blessing of Corner Stone for Holy Cross Church Next Sunday."
The Tidings 21 June 1912, p. 16.

"Historical Review of Holy Cross Parish."
The Tidings (2 September 1921), pp. 3-4.

Holy Virgin Mary Russian Orthodox Cathedral

"White Russians Meet at Shrine." *Los Angeles Times*
29 May 1932, pt. 2, pp. 1, 2.

Day, George Martin. *The Russians in Hollywood: A Study in Cultural Conflict*
(University of Southern California School of Research Studies, 4).
Los Angeles: University of Southern California Press, 1934, pp. 51-67.

Silver Jubilee, Holy Virgin Mary Russian Orthodox Church.
[Los Angeles: Holy Virgin Mary Russian Orthodox Church, 1953].

Golden Jubilee, Holy Virgin Mary Russian Orthodox Cathedral Parish.
[Los Angeles: Holy Virgin Mary Russian Orthodox Cathedral Parish, 1973].

Sixtieth Anniversary, Holy Virgin Mary Cathedral Parish.
[Los Angeles: Holy Virgin Mary Cathedral Parish, 1983].

Immanuel Presbyterian Church

Southwest Builder & Contractor 58 (22 July 1921), 15.

"Imposing Gothic Church for Los Angeles."
Southwest Builder & Contractor 58 (7 October 1921), p. 12.

"Edifice to Rise at Once." *Los Angeles Times* 18 September 1927, pt. 5, p. 1.

"Steel Completed for Church." *Los Angeles Times* 25 March 1928, pt. 5, p. 7.

Architectural Digest 7, no. 3 (1929), pp. 116-117.

Japanese Union Church

"Japanese Church." *Los Angeles Times* 23 July 1922, pt. 5, p. 3.

Southwest Builder & Contractor 60 (25 August 1922), p. 30.

"New Japanese Church Opens." *Los Angeles Times* 22 March 1923, pt. 2., p. 5.

Davis, Royal G. *Light on a Gothic Tower: First Congregational Church of
Los Angeles*. Los Angeles: First Congregational Church, 1967, pp. 66-68.

Holley, David. "Old Temple, Church Symbolize Efforts to Preserve Little Tokyo."
Los Angeles Times 4 September 1985, pt. 2, p. 6.

Koyasan Buddhist Temple

"New Buddhist Temple Planned."
Los Angeles Times 28 September 1938, pt. 2, p. 2.

Selected Bibliography

Krotona Inn

Krotona. Hollywood: Krotona Institute of Theosophy, [1919?].

Ross, Joseph F. *Krotona of Old Hollywood:Volume 1*, 1866-1913. Montecito: El Montecito Oaks Press, 1989.

Willis, Alfred. "A Survey of Surviving Buildings of the Krotona Colony in Hollywood." *Architronic* 8, no. 1 (January 1999), n. p. [http://www.saed.kent.edu/Architronic/v8n1/]

McCarty Memorial Christian Church

Southwest Builder & Contractor 76 (19 December 1930), p. 62.

"Memorial Church Completed." *Los Angeles Times* 24 April 1932, pt. 5, pp 1, 2.

Kingsbury, Paul. "Two Churches of Modernized Gothic." *Architectural Concrete* 1 (April 1935), pp. 5-7.

Ninth Church of Christ, Scientist

"Scientists Plan Fine Church Edifice." *Los Angeles Times* 6 April 1924, pt. 5, pp. 1, 2.

"Christian Science Church Moves to Equitable Building." *Larchmont Chronicle* (December 1997), pt. 1, p. 9.

Nishi Hongwanji Buddhist Temple

Southwest Builder & Contractor 65 (23 January 1925), p. 57.

"Home for Japanese Faith." *Los Angeles Times* 1 March 1925, pt. 5, p. 4.

Buddhist churches of America. Chicago: Nobart, Inc., 1974, vol. 1, pp. 197-206.

Holley, David. "Old Temple, Church Symbolize Efforts to Preserve Little Tokyo." *Los Angeles Times* 4 September 1985, pt. 2, p. 6.

"Things That Make Us Unique and Yet So American." *LA Architect* (June 1992), p. 11.

Our Lady Queen of Angels

Wey, Auguste. "Our Lady of Angels." *Land of Sunshine* 4 (December 1985), pp. 19-25.

Emery, Christian. "Plaza Church of Los Angeles." *Ave Maria Catholic Home Weekly* n.s. 51 (20 April 1940), pp. 501-505.

Woods, Will. "Nocturnal Adorers of the West." *Ave Maria Catholic Home Weekly* n.s. 75 (16 February 1952), pp. 209-211.

Owen, J. Thomas. "The Church by the Plaza: A History of the Pueblo Church of Los Angeles." (Part 1) *Historical Society of Southern California Quarterly* 42 (March 1960), pp. 5-28.

"A Delicate Problem in Reconstruction." *Westways* 58, no. 10, pt. 1 (October 1966), pp. 49-50.

Schuetz-Miller, Mardith K. *Building and Builders in Hispanic California 1769-1850.* Tucson: Southwestern Mission Research Center, 1984, pp. 22-25.

McClung, William Alexander. *Landscapes of Desire: Anglo Mythologies of Los Angeles.* Berkeley: University of California Press, 2000, pp. 85-87.

"City's First Church is a Beehive of Believers." *Los Angeles Times* 29 August 2002, pt. B, p. 2.

Poole, Jean Bruce & Tevvy Ball. *El Pueblo: The Historic Heart of Los Angeles.* Los Angeles: The Getty Conservation Institute and the J. Paul Getty Museum, 2002, pp. 110-111.

Our Lady of Lourdes Roman Catholic Church

"Cornerstone of Church Edifice Laid." *Los Angeles Times* 1 March 1931, pt. 5, p. 1.

"Ceremony Scheduled for Today." *Los Angeles Times* 21 June 1931, pt. 5, p. 3.

Architect and Engineer 108 (February 1932), pp. 25-27.

Architectural Forum 57 (July 1932), pp. 13-16.

Pilgrim Congregational Church

Southwest Builder & Contractor 58 (4 November 1921), p. 14.

Precious Blood Roman Catholic Church

Architectural Digest 6, no. 4 (1928), p. 61.

'Some Western Churches." *Pacific Coast Architect* 33 (July 1928), pp. 23-40.

Hodley, Homer M. "Concrete in Churches." *Architect and Engineer* 109 (April 1932), p. 37-43.

"The Church of the Precious Blood." *Liturgical Arts* 2 (2nd Quarter 1933), pp. 61-67

Murray, Robert D. "The Beauty of Monolithic Concrete." *Architectural Concrete* 1 (April 1935), pp. 15-17.

Architect and Engineer 123 (November 1935), p. 37.

Saint Alban's Episcopal, Westwood

Southwest Builder & Contractor 78 (24 July 1931), p. 61.

Saint Alban's Liberal Catholic Church

"Church of St. Alban to Be Dedicated Sunday Morning."
Hollywood Daily Citizen 6 May 1922, pt. 2, p. 1.

Saint Brendan's Roman Catholic Church

Southwest Builder & Contractor 64 (18 July 1924), p. 55.

"Church Framework to Be Constructed." *Los Angeles Times*
1 August 1926, pt. 5, p. 8.

"St. Brendan's Is Splendid Example of Gothic."
Southwest Builder & Contractor 71 (11 April 1928), pp. 35-36.

Architectural Record 65 (May 1929), pp. 453-459.

St. Brendan's 75th Anniversary, 1915-1990. [Los Angeles: St. Brendan's, 1990?].

Saint Cecilia Roman Catholic Church

"Two Churches Being Erected." *Los Angeles Times*
19 June 1927, pt. 5, p. 3.

"South Side Church Completed." *Los Angeles Times*
28 August 1927, pt. 5, p. 8.

Architectural Digest 6, no. 4 (1928), pp. 44-45.

"Catholic Church, Free of Debt. Consecrated." *Los Angeles Times*
2 May 1943, pt. 2, p. 1.

Saint James Episcopal Church

"Fine Church Home Assured." *Los Angeles Times*
25 January 1920, pt. 5, p. 1.

Southwest Builder & Contractor 55 (30 January 1920), p. 10.

Southwest Builder & Contractor 56 (22 October 1920), p. 12.

St. James Church: Wilshire Boulevard at St. Andrews Place, Los Angeles, California. [Los Angeles: St. James Church, 1925?].

Architectural Digest 6, no. 4 (1928), pp.50-51.

Architectural Forum 50 (March 1929), pp. 377-379.

Gourse, Leslie. *Unforgettable: The Life and Mystique of Nat King Cole.*
New York: St. Martin's Press, 1991, pp. 225-226.

Saint John the Episcopal Church

"Stately Church for St. John's." *Los Angeles Times* 13 April 1919, pt. 5, p. 1.

"St. John's Will Build New Home on West Adams." *Los Angeles Times* 21 November 1920, pt. 5, p. 1.

Southwest Builder & Contractor 56 (26 November 1920), p. 14.

Bergstrom, Edwin. *Architectural Competition, St. John's Church, Los Angeles.*
[Los Angeles: St. John's Church?], 1921.

Southwest Builder & Contractor 57 (6 May 1921), p. 16.

"Architectural Competition for St. John's Church."
Southwest Builder & Contractor 58 (4 November 1921), pp. 12-13.

"Ground to Be Broken Today." *Los Angeles Times* 21 January 1923, pt. 6, p. 3.

"New Church Thrown Open to the Public." *Los Angeles Times*
22 December 1924, pt. 1, p. 7.

"Newest Church Is Consecrated." *Los Angeles Times* 22 December 1924,
pt. 2, p. 8.

Architect and Engineer 89 (April 1927), pp. 71-73.

Bennett, T. P. *Architectural Design in Concrete.*
New York: Oxford University Press, 1927, p. 13, pls. 19-20.

Art and Architecture Notes. Los Angeles: St. John's Episcopal Church, [n.d.].

Saint Mary of the Angels Anglican Church

"Church for Actors." *Los Angeles Times* 4 January 1920,
pt. 5, p. 1.

"Church Edifice Designed for Hollywood Site." *Los Angeles Times*
2 February 1930, pt. 5, p. 6.

California Arts & Architecture 45 (February 1934), p. 8.

Wagner, Rob & Rupert Hughes. *Two Decades: The Story of a man of God –
Hollywood's Own Padre.* Los Angeles: Young & McAlister, 1936.

Saint Mary's Roman Catholic Church

Southwest Builder & Contractor 64 (28 March 1924), p. 51.

Southwest Builder & Contractor 62 (28 September 1923), p. 44.

Delis, Robert. *The Grand Lady of Boyle Heights: A History of St. Mary's Church,
Los Angeles.* Los Angeles: [Robert Delis], 1989.

"St. Mary's to Reopen as Repairs Wrap Up." *Los Angeles Times* 10 July 1994,
"City Times," p. 7.

Selected Bibliography

Saint Monica's Roman Catholic Church

"Santa Monica Catholics to Build a Church." *Los Angeles Times*
15 April 1923, pt. 5, p. 13.

Architectural Digest 6, no. 4 (1928), p. 26.

Saint Paul's Catholic Church

"Notable Edifice Completed in First Construction Stage."
Southwest Builder & Contractor 94 (20 October 1931), pp. 10-11.

California Arts & Architecture 56 (December 1931), pp. 18-19.
Brennan, Robert E. A Visit to St. Paul's Church.
[Los Angeles: St. Paul's, 1947?].

Saint Sophia Greek Orthodox Cathedral

"3000 Consecrate New Cathedral." *Los Angeles Times*
3 October 1952, pt. 2, p. 1.

"New Hagia Sophia." *Newsweek* 60 (6 October 1952). p. 70.

"A Cathedral for Charlie." *Life* 33 (3 November 1952), pp. 54-57.

St. Sophia Now a City Monument." *Los Angeles Times*
8 June 1973, pt. 2, p. 2.

Mosher, Jo. "A Jewel in Keeping with the Byzantine Tradition."
Los Angles Herald-Examiner 19 October 1975,
"California Living," pp. 10-12.

Akrotirianakis, Stavros Nicholas. B*yzantium Comes to Southern
California: The Los Angeles Greek Community and the Building
of Saint Sophia Cathedral.*
Minneapolis: Light and Life Publishing Company, 1994.

Saint Vibiana's Cathedral

Weber, Francis J. *Saint Vibiana's Cathedral: A Centennial History.*
Los Angles: [Francis J. Weber?], 1976.

"Archdiocese May Raze Cathedral." *Los Angeles Times*
5 January 1995, pt. B, p. 4.

"Sadness Among the Faithful." *Los Angeles Times*
9 January 1995, pt. B, p. 3.

"Still Standing But Empty: The Archdiocese in L. A. Wants to
Abandon Its Quake-Damaged Cathedral." *Preservation* 48
(September-October 1996), pp. 16-17.

"Battle Lines Drawn Over St. Vibiana's." *Los Angeles Times*
15 January 1995, "City Times," p. 11.

"St. Vibiana's Removed from Landmarks List." *Los Angeles Times*
18 July 1996, pt. B, pp. 1, 6.

"St. Vibiana's Bought by Developer." *Los Angeles Times*
2 November 1999, pt. B, p. 2.

Saint Vincent de Paul Roman Catholic Church

"Plans Superb Church." *Los Angeles Times*
3 February1914, pt. 5, p. 1.

"Sketches of Church Approved." *Los Angeles Times*
10 December 1922, pt. 5, p. 1.

"Architectural Plans Adopted." *Los Angeles Times*
18 November 1923, pt. 5, pp. 1, 2.

Architectural Digest 6, no. 2 (1926), pp. 84-85.

Schulte, G. H. "Massive Reinforced-Concrete Church in Los Angles."
Engineering News-Record 96 (29 April 1926), pp. 701-702.

Western Architect 36 (May 1927) pls. 73-76.

Architectural Forum 5 (May 1929), pp. 385-387.

Lunden, Samuel. "The Interiors of the Church of St. Vincent de Paul."
California Arts & Architecture 40 (August 1931), pp. 22-25, 49.

O'Donnell, Terence M. *St. Vincent de Paul Church, Los Angeles, California.*
Los Angles; Donahue Printing Co., [n.d.].

Second Baptist Church

Southwest Builder & Contractor 63 (22 February 1924), p. 51.

Southwest Builder & Contractor 65 (6 February 1925), p. 56.

"Ground Breaking for New Second Baptist Church Exercises Will
Take Place Sunday." *California Eagle* 10 October 1924, p. 1.

"Negroes to Dedicate Edifice." *Los Angeles Times*
3 January 1926, pt. 2, p. 1.

*A Treasury of Tradition, Innovation, and Hope: History of Second Baptist
Church, Los Angeles, California.* [Los Angeles: Second Baptist Church, 1975?].

"Declaring Second Baptist Church Historical Monument 200 By City ,
a Highlight of 1978." *Los Angeles Sentinel* 4 January 1979, pt. C, p. 1.

Hudson, Karen E. *Paul R. Williams, Architect: A Legacy of Style.*
New York: Rizzoli, 1993, pp. 42-43.

"Historic Black Church Dreams of Resurrecting Itself." *Los Angeles Times*
12 August 2001, pt. B, p. 2.

Second Church of Christ, Scientist

"Plan for Massive Church of Christ." *Los Angeles Examiner*
28 April 1907, pt. 5, p. 2.

"Marvelous Work in Reinforced Concrete Found in Local Church."
Los Angeles Times 13 September 1908, pt. 5, p. 1.

"Second Church of Christ, Scientist, Los Angeles."
Southwest Builder & Contractor 3 (15 May 1909), pp. 12-14.

The Brickbuilder 19 (April 1910), pls. 47-50.
"Christian Science Church 65th Year." *Los Angeles Herald-Examiner*
13 September 1975, pt. A, p. 9.

Self-Realization Fellowship Temple

Pictorial History of Self-Realization Fellowship.
[Los Angeles]: Self-Realization Fellowship, 1975, pp. 10-11, 53.

Temple Israel of Hollywood

"Plan New Temple Building for Hollywood."
Southwest Builder & Contractor 107 (24 May 1946), pp. 20-12.

"California Synagogue in Mission Tradition."
Architectural Record 100 (October 1946), p. 104.

Temple Sinai

"Temple Here Among Country's Finest."
Los Angeles Times 23 May 1909, pt. 2, p. 2.

The Inspiration of Sinai Temple. [Los Angeles: Sinai Temple, 1969?].

Temple Sinai East

Southwest Building & Contractor 64 (12 December 1924), p. 54.

"Start Temple on Fourth." *Los Angeles Times*
5 April 1925, pt. 5, p. 14.

"Congregation's Edifice Being Rapidly Finished." *Los Angeles Times*
7 February 1926, pt. 5, p. 1.

The Inspiration of Sinai Temple. [Los Angeles: Sinai Temple, 1969?].

"Congregation Seeks to Save Sinai Temple." *Los Angeles Times*
10 October 1971, pt. K, p. 7.

Temple Tifereth Israel

Samuels, Beth & William M. Kramer. "Temple Tifereth Israel of
Los Angeles." *Western States Jewish History* 28 (July 1996), pp. 417-441.

Theosophy Hall

The Theosophical Movement 1875-1950.
Los Angeles: Cunningham Press, 1951, pp. 316-318.

Thirteenth Church of Christ, Scientist

Southwest Builder & Contractor 64 (10 October 1924), p. 53.

Southwest Builder & Contractor 65 (20 February 1925), p. 55.

"New Church Is Completed." *Los Angeles Times*
11 July 1926, pt. 5, p. 3.

Architectural Forum 46 (April 1927), pp. 373-379.

Architectural Digest 8, no. 2 (1931), pp. 23-25.

Vedanta Temple

"The Hollywood Center Today." *Vedanta and the West* no. 120 (1956),
pp. 15-37.

"How It All Started." *Vedanta and the West* no. 120 (1956), pp. 38-47.

Dunaway, David King. *Huxley in Hollywood.*
New York: Harper & Row, 1989, pp. 389-390.

Jackson, Carl T. *Vedanta for the West: The Ramakrishna Movement
in the United States.* Bloomington: University of Indiana Press, 1994,
pp. 116-117.

Wilshire Boulevard Christian Church

Southwest Builder & Contractor 65 (20 February 1925), p. 55.

"Contract Is Awarded on New Church." *Los Angeles Times*
30 August 1925, pt. 5, p. 5.

"New Church Dedication on Sunday." *Los Angeles Times*
21 May 1926, pt. 2, p. 14.

Braden, Arthur. "Impressions of the Wilshire Boulevard Christian
Church by an Architectural Layman." *Architect and Engineer* 91
(November 1927), pp. 67-77, 98.

Architectural Digest 6, no. 4 (1928), pp. 27-29.

Selected Bibliography

Wilshire Boulevard Temple

"B'nai Brith Structure to Be Monumental Structure."
Southwest Builder & Contractor 67 (1 January 1926), p. 40.

Southwest Builder & Contractor 54 (29 July 1927), p. 54.

Architectural Digest 7, no. 3 (1929), pp. 72-76.

"New B'nai Brith Temple in Los Angeles Beautiful and Imposing Structure."
Southwest Builder & Contractor 74 (5 July 1929), pp. 32-34.

Newmark, Marco R. "Wilshire Boulevard Temple: Congregation B'nai Brith
(1862-1947." *Historical Society of Southern California Quarterly* 38
(June 1956), pp. 167-184.

Magnin, Edgar Fogel. *The Warner Murals in the Wilshire Boulevard Temple,
Los Angeles, California.* [Los Angeles: Wilshire Boulevard Temple, 1975?].

Currick, Max A. "A Visitor's Report on the Wilshire Boulevard Temple,
Los Angeles, and on the Architecture of Temple Emmanu-El, San Francisco,
in 1937." *Western States Jewish Historical Quarterly* 13 (October 1980),
pp. 49-52.

Israelowitz, Oscar. Synagogues of the United States.
Brooklyn, NY: Israelowitz Publishing, 1992, pp. 122-125.

Morris, Dianne W. "Wilshire Boulevard Temple and the Golden Age
of Hollywood" (Unpublished thesis, University of California,
Los Angeles, 1996).

The Authors

The photographer would like to thank the Graham Foundation for Advanced Studies in the Fine Arts for their financial support. In addition, he would like to thank Mike Torrey and Sue Tirre for their dedicated assistance and unbridled enthusiasm, his wife for her patience, and Hamid Afrasiyadi of Custom Image.

ROBERT BERGER

Robert Berger has been photographing architecture and interior design for the past 18 years. Assignments for clients ranging from furniture and lighting manufacturers to residential, hospitality, and casino designers have taken him around the world. His images have been published in various books and periodicals and have been exhibited around the country. His previous book, *"The Last Remaining Seats: Movie Palaces of Tinseltown"*, done in conjunction with his former business partner Anne Conser, is now in its fourth printing. Limited edition prints of the images in Sacred Spaces are available from Berger/ Conser Photography in Santa Monica. More information and samples of his work can be found on the web at www.bergerconser.com.

ALFRED WILLIS

Alfred Willis leads a double life as both a librarian and an architectural historian. Holding a PhD in architectural history from Columbia University, he first specialized in late nineteenth-century Belgian architecture. In 1992 he was the founding editor of *Architronic*, the world's first electronic journal in architecture. His pursuit of new research interests while serving as Head of the UCLA Arts Library from 1992 to 1999 resulted in articles on Hollywood's Krotona Theosophical colony and the early twentieth-century Los Angeles architectural firm, Meyer & Holler. Now working in Hampton, Virginia, he is currently researching the modern architecture of his native South Georgia.

KEVIN STARR

Dr. Kevin Starr is the state librarian of California and a professor at the University of Southern California. He is the author of six volumes of California history the most recent being, *"Embattled Dreams: California in War and Peace, 1940-1950."* Kevin Starr is the acknowledged dean of California studies, the most eminent living authority on the Golden State and the winner of a Guggenheim Fellowship for his writing. Kevin Starr was appointed State Librarian by Governor Pete Wilson, a Republican, and re-appointed by Gray Davis, a Democrat. He graduated from the University of San Francisco and earned his M.A. and Ph.D. in American literature at Harvard University, where he was a senior tutor at Eliot House. He is a fourth-generation San Franciscan with residences in San Francisco, Los Angeles, and Sacramento.

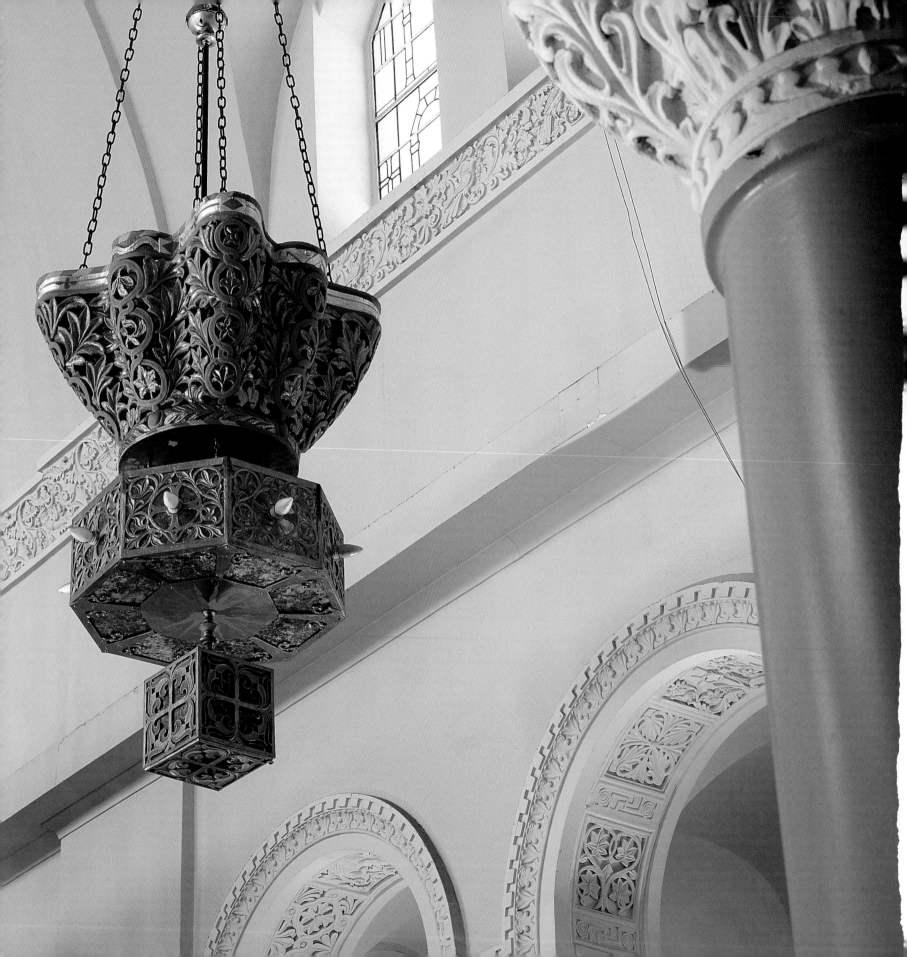